The Sitcom

TV Genres

Series Editors
Deborah Jermyn (Roehampton University)
Su Holmes (University of East Anglia)

Titles in the series include:
The Quiz Show
by Su Holmes
978 0 7486 2752 3 (hardback)
978 0 7486 2753 0 (paperback)

The Sitcom
by Brett Mills
978 0 7486 3751 5 (hardback)
978 0 7486 3752 2 (paperback)

Forthcoming titles include:

Reality TV
by Misha Kavka

The Sitcom

Brett Mills

Edinburgh University Press

© Brett Mills, 2009

Edinburgh University Press Ltd
22 George Square, Edinburgh

www.euppublishing.com

Typeset in Janson and Neue Helvetica
by Servis Filmsetting Ltd, Stockport, Cheshire and
printed and bound in Great Britain by
CPI Antony Rowe, Chippenham and Eastbourne

A CIP record for this book is available from the British Library

ISBN 978 0 7486 3751 5 (hardback)
ISBN 978 0 7486 3752 2 (paperback)

Contents

Acknowledgements vi

1 Introduction 1
2 Genre 24
3 Industry 50
4 Programmes 75
5 Audiences 100
6 The Future 124

Appendix 147
Bibliography 151
Index 173

Acknowledgements

The interviews with industry personnel which form the core of this book are the result of the Arts and Humanities Research Council-funded 'Funny Business' project (Ref: APN19118); some of the transcription was funded by the School of Film and Television Studies, University of East Anglia. I'm grateful to all those PAs, secretaries and other administrative and support staff at a range of broadcasting institutions who helped set up the interviews, including Sien Gocher at Baby Cow, Charlotte Hayes at Five, Cathy Mason at Channel 4 and Sharon Trickett at Objective. Also thanks to Andrew Higson for organising access to his brother. And thanks to all those industry personnel who agreed to be interviewed, even though they didn't know what they were letting themselves in for; their contribution is invaluable to what this book is about, and I got to meet many of my heroes.

The research on audiences undertaken at Central Missouri State University (now the University of Central Missouri) was funded by the exchange programme between that institution and the University of Glamorgan, and I'm grateful to Philip Mitchell and Sam Cox for finding the money and resources for it; similar research at Indiana University Kokomo was funded by that institution's American Democracy Fund, and I'm indebted to Jaime Howell for initiating and organising this.

Other thanks go to Julia Inthorn for being stuck inside writing too; Su Holmes for rescuing me from my television solitude and suggesting me for this book in the first place; and Mark Jancovich for ruining *Top Gear* for people who like cars. Special thanks to Sanna for three Very Important Words, and for putting up with British television and the nasty things it says about Germans: *Exterminieren!*

1 Introduction

There's something inherently small-time about sitcoms.
(Simon Nye 2005)

The quote above comes from Simon Nye, the writer of the sitcoms *Men Behaving Badly* (ITV/BBC1, 1992–9), *Is It Legal?* (ITV/C4, 1995–8), *How Do You Want Me?* (BBC2, 1998–9), *The Savages* (BBC1, 2001), *Wild West* (BBC1, 2002–4), *Hardware* (ITV, 2003) and *Carrie and Barry* (BBC1, 2004–5), among others. Indeed, with *Men Behaving Badly*, Nye created and wrote perhaps the defining British sitcom of the 1990s, which fed into debates about social changes as it was seen to promote the lewd and childish antics of the 'new lad' (McEachern 1999). Many of his series have been broadcast all over the world, and the scripts and formats have been bought by other countries so their own versions could be made; the American version of *Men Behaving Badly* (NBC, 1996–7) ran for two years. All in all, Nye is someone who has been highly successful in the sitcom industry and who might, therefore, be expected to sing the genre's praises from the skies, arguing for its cultural worth and insisting that it is taken seriously. So why does he refer to it as 'small-time'?

The term 'small-time' can be understood in a number of ways. Firstly, it could refer to the nature of the industry which produces it. Perhaps Nye is arguing that it's a cottage industry, made by small groups of people and without the investment and returns seen in other areas of television, such as drama. Secondly, this phrase could imply the kinds of events and stories that sitcom deals with, whose 'small'-ness might be something to with its domestic and 'recognisable, stock social situations' (Lovell 1982: 22), meaning it rarely covers 'big' issues that are the staple diet of high-budget drama, documentaries and news. Thirdly, sitcom's social value might be seen as 'small-time'; as entertainment intended as 'an alternative to work, education, serious-ness' (Curtis 1982: 11), its social role is more difficult to delineate

1

than might be the case for other television genres. Finally, the term 'small-time' could be seen to refer to the lack of artistry in the genre, a sense that sitcom is rarely groundbreaking or experimental and has instead 'behaved itself' (Tueth 2005: 25), pursuing a repetitive set of aesthetics and ideologies for decades. All of these interpretations of 'small-time' are commonly associated with sitcom. From them we can see it is a genre often perceived to be of less worth, of less invention and of less social value than many more 'serious' forms of programming. Its entertainment value is thought of as worthwhile escapism after a hard day at work, but which renders the genre nothing more than a diverting amusement that, 'As a rule, one does not talk about' (Attallah 2003: 92).

This book aims to demonstrate that the sitcom is anything but small-time. It does so by drawing on a variety of approaches associated with genre analysis, showing how the sitcom can be thought about in terms of the industry that produces it, the texts which constitute it, the audiences that watch it and its relationship to ongoing technological developments. Chapter 2 looks at sitcom as a genre, and explores the difficulties of analysing television programmes generically. To do so, it engages with ongoing debates about the usefulness of genre as an analytical tool, and sees sitcom as a fertile terrain for developing these. The aim in this chapter is to show that while sitcom may often be assumed to be a self-evident category, it is instead, like all genres, reliant on many cultural factors for its 'meanings'.

Drawing on the theoretical tools outlined in Chapter 2, Chapters 3 to 5 explore the three main approaches to media analysis: production, texts and audiences. Chapter 3's focus on the television industry examines the importance of the sitcom to television production, and does so through detailed analysis of interviews with members of the British terrestrial television industry carried out for this book. These interviews were all relatively informal, sometimes taking place in offices but more commonly in bars or the interviewees' homes, and help give a first-hand account of the motivations and working practices of those who make sitcom. These interviews are in no way representative of all of those who work on comedy in Britain, and certainly don't offer insights into sitcom production in other parts of the world. They do, however, show that ways in which the industry itself talks about what it does and why it does it is, like all cultures, a 'dynamic, ongoing process' (Holliday 2007: 12). In this way, these interviews demonstrate that the term 'sitcom' is a category open to negotiation for those who produce it while simultaneously being the primary definer of their labour. This shows how television workers function *within* genre, altering

their behaviour and working practices in response to the norms and conventions associated with sitcom. Chapter 4 moves on to offer a range of approaches appropriate to the analysis of sitcom texts. To do so, it gives an overview of theories of humour, suggesting that the primary way in which sitcom should be explored is through analysis of the comedy which is at its core. Using those theories, a number of programmes are analysed in detail, showing how the sitcom as a programme results from the conventions of comedy and the needs of broadcasting. Chapter 5 outlines how audiences make sense of sitcom and what pleasures we get from it. One of the main ways in which it does this is through examination of debates which arise when sitcom causes offence; that is, when some viewers *don't* get pleasure from it. Such moments show how sitcom is seen to have some kind of social value, as well as demonstrating the perception that there are limits to what sitcom should and shouldn't do. In drawing on audience under-standings of sitcom, this chapter aims to show how the meanings of programmes result from the interplay between audiences and the texts they watch, with genre a key factor in such readings. Chapter 6 ends the book by looking at how sitcom has changed in the past decade or so, and explores how the genre might continue to develop. It firstly highlights the state of the contemporary sitcom, particularly in terms of concerns that the genre might be 'dead'. In looking at the future of the genre, the chapter examines online sitcoms and comedy program-ming delivered through newer technologies, which open up a whole new range of possibilities for the genre. In noting the various ways in which sitcom has developed, it demonstrates that genres are always flexible categories whose characteristics are never stable or concretely defined.

In carrying out the analysis in this book, a large number of sitcoms are referred to, with many explored in detail. While it's impossible to discuss genre without discussing programmes, selecting *what* to examine and *how* to do so is one the difficulties of genre analysis. No programme is wholly representative of a genre and, because of the serial nature of television, it's likely that no single episode of any pro-gramme is representative of all of its episodes. In discussing television – and in discussing genre – there is always a problem in relating the specific to the general. The vast majority of the examples in this book are contemporary ones; if you want more detail on the history of the American sitcom you should look at Gerard Jones's *Honey I'm Home!* (1992) and David Marc's *Comic Visions* (1989), while Mark Lewisohn's *Radio Times Guide to TV Comedy* (2003) is the most exhaustive survey of comedy on British television. The Anglo-American focus of the

programmes explored here unfortunately downplays the significance of sitcoms made in other countries; see Yeidy M. Rivero (2002), Dana Heller (2003), Alexander Dhoest (2006), Giselinde Kuipers (2006), Peter Pugsley (2007) and Sue Turnbull (2008) for analyses of Puerto Rican, Russian, Flemish, Dutch, Singaporean and Australian sitcom respectively. That said, all of these authors note that while sitcoms in different countries may differ in response to local cultural contexts, they are similar enough for the term 'sitcom' to retain meaning. That is, the genre of sitcom is one whose flexibility can encompass the specifics of international cultural contexts. It is hoped, then, that the Anglo-American prejudice apparent in this book is not taken as suggesting that sitcom is a genre apparent in those nations only: quite the contrary, it is hoped that the analysis here is one from which more extensive studies of the genre can develop.

As a whole, then, this book shows how the sitcom is not small-time, and is instead a multifarious genre made up of a range of programmes produced by a complex industrial system and consumed by audiences in a variety of ways, and whose future suggests change and stability. The question remains, though: if a book such as this can be written on the sitcom, drawing on a wealth of literature from a number of fields, why should someone as closely connected to the genre as Simon Nye refer to it as 'small-time'?

The remainder of this chapter will use trying to answer that question as a way into thinking about a number of contexts central to analysis of sitcom as a genre. For example, answering that question might be made easier if the phrase is thought about in a different way. Even if the sitcom is seen as 'small-time', I would see this as a positive phrase rather than a negative one. While high-profile drama and landmark documentaries can be seen to make up those programmes which broadcasters often define themselves by (especially in public service regimes such as that in the UK), sitcom has quietly and consistently given pleasure to millions for decades, rarely occupying the rarefied space which makes up the landscape of television history. There's something about sitcom which makes it 'feel' short-term and disposable, and able to be consumed with little attention. It's a genre whose lack of pomposity means it rarely makes grand claims for itself, and whose pleasures are reliant on this. As Frances Bonner has argued in *Ordinary Television*, much of what makes up the majority of broadcasting is indeed 'small-time' and 'mundane' (2003: 44); but all this means is that television often goes out of its way to fit into the lives of its viewers, giving the *appearance* of simplicity when it is actually highly complex. Richard Dyer argues that entertainment culture

is commonly seen as an 'end point in discourse' (1992: 2), offering pleasures which rarely question society and social norms. This means that all entertainment, including the sitcom, plays a role in society whose effects are deemed incompatible with critical thinking and rigorous analysis; a sitcom is good entertainment, by this argument, precisely because it *doesn't* require us to think. Yet this book aims to show that the pleasures of sitcom are not simple, and certainly require an understanding of complex social conventions and generic rules in order for them to be enjoyed. The 'small-time'-ness of sitcom is, then, one of the attributes of the genre; the sitcom is a genre which is highly complex but which must pretend it isn't. In itself, this says something highly significant about the social role entertainment culture is often required to play.

It might seem obvious to say, but the sitcom's primary aim is to be funny; it is defined by its humorous content and audiences come to it with the expectation of laughter (Rubin 1981: 159). A sitcom with no jokes is not a sitcom and instead becomes something else; as Barry Curtis asks, 'what sort of drama does the failed sitcom become?' (1982: 9). Yet when reading the existing scholarly literature on sitcom it is noticeable how the comic aspect of the genre is often sidelined, or taken as read, or incompletely examined. Why and how certain forms of communication are categorised as 'funny' while others are deemed 'serious' has been a long-standing question since the dawn of civilisation. For example, the Greek playwright Aristophanes (456–386 BC) explores the question, 'What is the relationship between comedy and tragedy?' (Silk 2000: 53) in his plays, while scholars have attempted to reconstruct the lost *Poetics II*, Aristotle's answer to the same question (Cooper [1922] 1969; Janko 1984). Approaches to this conundrum are various: Sigmund Freud employed psychoanalysis ([1905] 1997); Victor Raskin (1985) and Graeme Ritchie (2004) have examined linguistics; Christie Davies uses anthropology (1990, 2002); Michael Billig (2005) and Phillip J. Glenn (2003) explore sociology; John Morreall (1983, 1987), John Allen Paulos (2000) and Simon Critchley (2002) collect a range of philosophical approaches. Yet the nature of humour – as opposed to its consequences – has been marginalised in analysis of sitcom, and much of the research listed above has been notably absent from the examination of the genre. Yet the sitcom is only meaningful – and explicable as a genre – if its comic intent is understood; it is this which drives and defines it.

This book therefore argues that the sitcom has what can be called a 'comic impetus'. That is, sitcom is a genre defined by its association with the comic; while it may do other things, and audiences might

enjoy it for a variety of reasons, its humour is always of paramount concern. The term 'impetus' is carefully chosen; it suggests that there is a force which drives sitcom as an industrial product and as a genre, but it does not suggest that that impetus is necessarily understood by all or that it cannot be read in a variety of ways. This book examines such an impetus through analysis of industry, texts and audiences, arguing that this motivation is crucial to the conventions, development, production and reception of the genre. The development of 'traditional' sitcom aesthetics (as outlined in Chapter 2) attempted to better capture comic performance, and so the look of sitcom is one defined by its comic impetus; more recent developments in sitcom aesthetics (see Chapter 6) can be seen as newer ways of fulfilling the same function in response to changes in programming styles across television as a whole. Audiences seek out sitcom for its comic pleasures (as discussed in Chapter 5), and quickly turn away from programmes which don't fulfil that purpose. Overall, the 'comic impetus' of sitcom is its primary generic aspect, not only helping define it but also justifying 'sitcom' as being seen as something distinct from other fictional forms on television. As will be shown, the 'situation' of 'situation comedy' has often been the focus of academic analysis, because of what it can tell us about the ideologies present in such programming: this book, on the other hand, argues that 'comedy' is the important word in the genre's name, not only because it is the form's defining feature, but also because the sitcom's comic aspect is an important factor in exploring how sitcom 'works' and what it 'means'.

This is not to say that sitcom is nothing more than its humour, nor that the only thing that should be examined is its jokes. The pleasures on offer from sitcoms are various, and not all of them involve laughing. Deaths of characters in sitcoms are invariably moving; while there are jokes in the episode of *The Royle Family* (BBC2/1, 1998–2000, 2006, 2008) where the family's grandmother dies, just as there are in the episode of *Last of the Summer Wine* (BBC1, 1973–) which contains the funeral of Compo Simmonite (a character who had been in the series for twenty-seven years), they are also incredibly moving pieces of television whose emotional aspects are paramount. So, arguing that sitcom is defined by its comic impetus is not to say that everything in it is funny. But it is to say that each of those deaths works in a particular way because of the comic impetus of the sitcom; this is partly because of the limitations placed upon the genre because it must never stray too far from humour for too long, and partly because upsetting the structure of any series too much could change the programme into something else. So, in *Last of the Summer Wine*, the hole in the programme's format left

by Compo's demise is quickly filled by the similar character Tom, fittingly played by the son (Tom Owen) of the actor who played Compo. Through this method, the structure of the programme remains intact, showing how the series requires a particular configuration to maintain its comic impetus. The episode of *The Royle Family* which contains Nana's death is a one-off special, marked as not being part of the usual series. It's important in that episode, however, that the narrative does not end with the death; instead there is a coda, in which the family celebrate Nana's life, and the programme returns to the comedy which defines it. In doing so, it reiterates its comic impetus, which has been disrupted only momentarily (though extremely movingly) by the death of a key and long-standing character.

Furthermore, the poignancy of the deaths of such characters in sitcom is heightened because they have been giving so much comic pleasure for so long. The death of Compo is heartbreaking for the audience because it is a consequence of the death of the actor who played him. The grief evident over the loss of one of the nation's 'favourite actors' (Daily Mirror 1999: 6) relies on the assumption that comedy is pleasurable and not usually equated with death. The representation of these deaths in sitcom is 'allowable' precisely because they are clearly a momentary respite from the programmes' comic impetus and don't instead signal a permanent movement into ongoing tragedy. So, while 'comic relief' is an accepted part of tragic theatre, the opposite can be seen for sitcom; such 'tragic relief' doesn't undermine or destroy the comic impetus of sitcom, it instead helps reassert and define it precisely by being a respite from the ceaselessness of the comedy. Furthermore, it is understood as a respite, as something which is 'unexpected' for the sitcom, which, while adding to the pleasures of the genre, is meaningful because of its difference. It's therefore no coincidence that Nana's death took place in a 'special' episode of *The Royle Family* six years after the programme was thought to have ended, for the unusual nature of the episode requires its special-ness to be clearly marked.

It is this comic impetus which places sitcom as different to other forms of broadcasting. Significantly, documentary has often been explored in terms of its 'discourse of sobriety' (Nichols 1991: 3), that is, as a genre which in all of its aspects makes its seriousness clear, for it relies on its sober analysis of social phenomena not only for its meaning but also for its cultural value. Sitcom can be positioned as an entirely different kind of discourse, for it is one which, even when dealing with 'serious' subjects, does so through what can be termed a discourse of frivolity. We can read *M*A*S*H* (CBS 1972–83) as a treatise on the horrors of the Vietnam War; we can see *The Fall and Rise of Reginald*

Perrin (BBC1 1976–9) as a critique of the inanities of suburbia and work; the ending of *Blackadder Goes Forth* (BBC1 1989) might be one of the most powerful anti-war statements in the history of broadcasting. But each of these series is first and foremost *funny*, and the 'messages' which each of them contains is forever communicated via the comedic 'mode' (Neale and Krutnik 1990: 19) which defines them. As Chapter 3 shows, programme-makers intend sitcoms to be funny and measure the success of their series using this yardstick. To this end, the sitcom is a genre which employs a range of elements that clearly signal humour and aim to make that funniness more powerful, and audiences come to such programmes expecting to be amused. The conventions of the sitcom mark it out from many other forms of broadcasting, and the genre's comic impetus is the primary motivation behind such conventions.

This is not to say that examining the comic aspect of sitcom is simple and straightforward, however. Indeed, many people argue that examining comedy is a fruitless task which not only makes little headway into its subject, but also destroys the pleasures comedy has to offer. The children's author E. B. White once said, 'Analyzing humor is like dissecting a frog. Few people are interested and the frog dies of it' (quoted in Gale 1996: *xi*). Similarly, the sitcom director Gareth Carrivick insists that 'As soon as you deconstruct the joke it doesn't sound very funny at all' (2005). The reluctance to explore the workings of comedy shows that it is not only perceived to be 'small-time', but also that there is something about the topic which encourages people to wish it was kept that way. As a response to White's comment, the online comedy blog and comedian database written and maintained by Todd Jackson, who is the editorial director for Comedy Central's website, is called 'Dead Frog' (http://www.dead-frog.com). On the page titled, 'Why this blog is a bad idea' (http://www.dead-frog.com/blog/entry/why_this_blog_is_a_bad_idea), Jackson quotes White, and responds with the statement, 'But I'm going to do it anyway'. Like Jackson, this book is 'going to do it anyway', seeing the reluctance to examine comedy and the sitcom as redundant and limiting. Furthermore, it will be argued that exploring the sitcom and comedy is a necessary activity, for the genre offers valuable insights into broadcasting, media industries, television audiences, and contemporary society. While the frog may die, its demise will have been worthwhile.

Examining Sitcom

So if there is a resistance to examining comedy, how *has* sitcom been written about? At the outset, it's valuable to give an overview of the ways

in which sitcom has hitherto been explored, and what such approaches tell us about how sitcom is perceived by those who write about it. As noted above, a wealth of literature examining how comedy works, as a textual form and as a social convention, has been often ignored by writing on television sitcom. There are, perhaps, institutional reasons for this; much of the academic writing on comedy comes from the fields of philosophy, drama, psychology and literature studies, and so are not within the usual range of books reached for when exploring television. Furthermore, the majority of this literature is many centuries old, so its application to contemporary broadcasting might not seem a logical move at first. Finally, this literature commonly deals with *social* humour, working in detail to examine what roles jokes play between friends and colleagues and why comedy should exist within all human societies; it is therefore often not analysis of cultural and media forms. Perhaps this literature has been sidelined because the ways in which media texts work are often seen to be predicated less on such social phenomena and more on the specifics of the media industries and the technologies and distribution systems they employ. In this sense, the important part of the term 'television sitcom' is seen to be the first word, with sitcom being a worthy site for academic attention because of what it can tell us about broadcasting rather than because it can tell us anything about the workings of humour and comedy as a whole.

But I want to suggest that there's another reason why this literature has been ignored. That is, such writing attempts to explain *why* and *how* certain things are funny, and does so through detailed analysis of comedy within cultural forms such as novels and plays as well as social instances of humour such as jokes told between friends. The aim of much of this analysis is to move towards constructing what might be termed a 'universal theory of humour' (Ritchie 2004: 8); that is, some kind of formula or schema which can explain why certain bits of communication are understood to be comic while others are not. Such theories are often grouped into three major categories – those of superiority, incongruity and relief – and each of these is explored in terms of sitcom in Chapter 4. More recent work, which can most readily be seen in the ongoing debates in the journal *Humor: International Journal of Humor Research*, has suggested that there might not be one Grand Theory of Humour: instead joking works in a variety of ways depending on circumstances, texts and content (Bell 2007a, 2007b; Wimer and Beins 2008). That said, it is commonly agreed that there is something about comedy which marks it as a coherent though 'varied phenomenon' (Neale and Krutnik 1990: 1); indeed, this must be the case in order for any text intended to be funny to be read as such by

audiences. So, while debates will doubtless persist over such theoris-
ing, many have argued that for comedy and humour to be worthwhile
and meaningful categories they must have something approaching a
'unitary quality' (Palmer 1994: 7) which marks them as distinct from
other classifications such as seriousness (Mulkay 1988; White 1993:
122–34; Wickberg 1998: 170–218).

For broadcasting, the distinction from seriousness marks comedy
and the sitcom out as entertainment. As Jonathan Gray notes, enter-
tainment 'is one of the most automatically moralized concepts' (2008a:
4) which is seen as deeply problematic as it stands in opposition to
the more culturally valuable activities of information and education
(Dyer 1992: 13). Gray goes on to note how entertainment is equated
with 'metaphors of narcosis' (6), which assume that understanding and
responding to entertainment is a straightforward process that is not as
difficult (or as worthwhile) as making sense of 'informative' or 'edu-
cational' programming. The justification for studying popular culture
has always required demonstrating that such culture has a 'political
dimension' (Turner 1990: 6). For the sitcom this has often resulted in
examining issues such as representation, with a programme like *The
Cosby Show* (NBC, 1984–92) being critiqued for its representations
of race (Fuller 1992; Jhally and Lewis 1992; Staiger 2000: 141–59;
Coleman 2000: 95–104, 189–98), while a series such as *Will and Grace*
(NBC, 1998–2006) has been repeatedly discussed because of its por-
trayal of sexuality (Battles and Hilton-Morrow 2002; Castiglia and
Reed 2004; Mills 2005: 93–9). By these accounts, the sitcom is often
presented as a *problem*, whose humour contributes (unwittingly?) to
stereotyped representations of underprivileged groups, turning such
social issues into nothing more than something worthy of laughter.
Running through such accounts is an assumption that the comedy in
sitcom is easily understood, and that the pleasures which sitcom offers
help such problematic representations be laughed away resulting in
'the separation of humour from other phenomena' (Palmer 1994:
27). The main approach taken towards examining sitcom is one, then,
which aims to demonstrate that the 'harmless' nature of comedy is
instead highly problematic and troubling, and so the role of the person
exploring sitcom is to make explicit that which might, at first glance,
seem trivial and of little social consequence.

This has led to much work in terms of comedy and gender, which
demonstrates the complex nature of definitively demonstrating what
a comic representation is 'about'. So, while some have celebrated
the feminist possibilities of the 'unruly woman' (Gray 1994; Rowe
1990, 1995) and seen in comedy the potential to disrupt conventional

representation of gender, others have bemoaned the recurring familial and domestic portrayals of women and the lack of series with female stars (Porter 1998; Bathrick 2003; Dalton 2005). What is noticeable about such analysis is the different approaches each takes towards comedy. The former, in seeing comedy as a site ripe for ambiguous depictions, places humour at the core of its analysis and, sometimes, attempts to make sense of the way in which that comedy works: the latter, on the other hand, often sidesteps the nature of comedy completely, and instead reads television representations in sitcom using the same techniques and assumptions as would be employed for non-comic forms. In the domestic sitcom *Butterflies* (BBC2, 1978–83), for example, a recurring comic moment results from the family's weary responses to the cooking failures of the mother, Ria. Such a representation could be read as a powerful feminist critique of the 'naturalness' of women's domestic abilities, or as a condemnation of her failure to fulfil her domestic duties. The two opposing readings seem to rest on a different weighting being applied to the *funniness* of this aspect of the character, with the radical potential supported by the celebratory, 'carnivalesque' (Bakhtin [1965] 1984) nature of comedy, while the patriarchal reading prioritises the similarities between the representation of Ria and that of housewives across a range of cultural forms (Andrews 1998). The fact that this depiction can be read in two entirely contradictory ways demonstrates the difficulties in discussing what comedy *means*.

Perhaps more significant is that this difficulty means that *Butterflies* is at least a programme that gets written about. *Butterflies* is deemed interesting because it is problematic; it is precisely not a 'simple', 'straightforward' sitcom that conforms to the genre's conventions and expectations completely, even if it does rely on them for much of its meaning. Indeed, the sitcoms which have commonly been the focus of academic analysis have precisely been those which it is assumed do something other than that which is 'normal' for sitcom, even if that 'normal' is never explicitly defined. The work on *The Cosby Show* and *Will and Grace* mentioned above exists precisely because it's argued that these series are doing something that 'ordinary' sitcom does not, and so it is their status as 'special cases' which results in academic attention. But programmes can only be seen as 'special cases' if assumptions are made about what 'ordinary' sitcom is and, as Chapter 2 on genre shows, this is difficult in itself. The fact that much writing assumes that we all know what sitcom is shows how the genre is one whose straightforwardness is one of its characteristics. It also means that sitcom is seen to become 'interesting' when it engages with topics or depictions outside of its perceived usual realm. For genre studies this is

highly problematic, partly because it means the generic markers of this category are never fully outlined, but mainly because it means the texts which come to make up the canon of that genre are ones which are noticeably different, 'radical' or significant in terms of other debates.

For example, it's noticeable how a massive range of long-running, internationally successful programmes with high viewing figures has never troubled the study of sitcom. A list of such programmes in Britain would include *The Rag Trade* (BBC1, 1961–3; ITV, 1977–8), *On the Buses* (ITV, 1969–73), *Last of the Summer Wine* (BBC1, 1973–), *Rising Damp* (ITV, 1974–8), *Terry and June* (BBC1, 1979–87), *Only Fools and Horses* (BBC1, 1981–2002), *Sorry!* (BBC1, 1981–8), *Bread* (BBC1, 1986–91), *One Foot in the Grave* (BBC1, 1990–2000), *The Vicar of Dibley* (BBC1, 1994–2007) and *My Family* (BBC1, 2000–); in America a similar list would include *Make Room for Daddy/The Danny Thomas Show* (ABC/CBS, 1953–64), *Get Smart* (NBC/CBS, 1965–70), *The Monkees* (ABC, 1966–68), *Happy Days* (ABC, 1974–84), *Home Improvement* (ABC, 1991–9), *Mad About You* (NBC, 1992–9), *Frasier* (NBC, 1993–2004), *The Drew Carey Show* (ABC, 1995–2004), *Everybody Loves Raymond* (CBS, 1996–2005), *Scrubs* (NBC/ABC, 2001–) and *Two and a Half Men* (CBS, 2003–). Each of these can be described as 'traditional' sitcom, and Chapter 2 discusses what is meant by this term. Each of these programmes consistently garnered significant audience ratings, and while academic interest should not necessarily be dictated by audience interest, there is a question to be asked concerning why it is that analysis focuses on those programmes which are not the 'normal' television landscape for the majority of viewers. This is perhaps more of a concern for sitcom than might be the case for other forms of broadcasting considering comedy's assumed social value and the ways in which sitcom is a mass appeal genre. Of course, academics and critics have always shown an interest in particular kinds of texts, and these have rarely matched those which are the most popular. Indeed, maintaining the 'cultural elite' role which goes with those positions requires such approaches. And I wouldn't count myself out of this accusation; in writing about *The Office* (BBC2/1, 2001–3) (Mills 2004) and *Peep Show* (C4, 2003–) (Mills 2008a) I've selected series which have a large amount of 'cultural capital' (Bourdieu 1979: 12) because they can be seen as doing something 'new' and 'different' with sitcom, even though many other contemporaneous series had much higher viewing figures.

Of course, there are some programmes which manage to be long-running, highly rated *and* deemed worthy of academic interest. The majority of these are American: *M*A*S*H* has been explored both for

its depiction of medicine (Jacobs 2001: 25) and for debates about the differences between sitcom and comedy drama (Morreale 2003: 152); *The Cosby Show* (NBC, 1984–92) is the touchstone for popular representations of African Americans, and is one of the few sitcoms to have whole books devoted to it (Fuller 1992; Jhally and Lewis 1992); *Roseanne* (ABC, 1988–97), like *Butterflies*, has been explored in terms of its representations of women; *Seinfeld* (NBC, 1989–98) is seen as a watershed in Jewish comedy in mainstream broadcasting (Brook 2003; Zurawik 2003; Mirzoeff 2008), and has also been related to debates about philosophy (Irwin 2000). Janet Staiger calls such programming 'blockbuster' (2000) and argues that, with advances in multi-channel broadcasting, we're unlikely to see their like again. That said, *My Family* and *Two and a Half Men* show that 'traditional' sitcom continues to be made which is watched by mass audiences, and the interviews with industry personnel outlined in Chapter 3 demonstrate broadcasters' desires that this should be maintained. What all of this shows is the sheer *range* of programming which sits under the rubric of 'sitcom', and the variety of approaches which can be taken towards it. The sitcom is both popular *and* niche, progressive *and* conservative, traditional *and* groundbreaking, serious *and* funny, straightforward *and* complex. While this is not to suggest that it is the only genre that can be thought of this way, it is to note that such complexities should be acknowledged at all times when thinking about sitcom. In offering a variety of approaches to its study, this book keeps these complexities in mind, suggesting that a range of approaches is required if a fuller understanding of the genre is to be reached. The rest of this chapter will therefore examine two key contexts relevant to the study of sitcom: sitcom and broadcasting, and the domestic context of the majority of television consumption.

Sitcom and Broadcasting

Important to the analysis of broadcast sitcom is that it is made for, and distributed on, television. This may seem like a truism, but the television-ness of sitcom is something which has an impact on all aspects of it. This is not to adopt a technologically determinist stance and argue that 'the medium is the message' (McLuhan 1964: 7–21), but it is to accept that television is, whether due to technological factors or historical and cultural ones, a form of communication that has its own particular conventions, expectations, production practices and modes of reception. Indeed, while these aspects of the medium might open up communicative possibilities which mean that television occupies a social and domestic role unavailable to many other media,

they also result in challenges for all kinds of programming. Sitcom can therefore be seen as the answer to the question: how can comedy be made effectively for broadcasting?

The problems of making humorous programming for broadcast are many. Firstly, comedy is a communicative mode which existed prior to television; it has a rich and diverse history in all cultures, in a range of forms such as literature, theatre, art, oral narratives and song (Bremmer and Roodenberg 1997; Harper 2002; Klein 2007). Television comedy, then, is merely a more recent development of a tradition which has a long and socially significant heritage. Indeed, as Chapter 2 shows, the shooting style which television sitcom adopted, and which has defined it throughout much of its history, is one which attempted to best capture the live theatrical experience of comedy performance for the broadcast medium. In that sense, the aesthetics of sitcom evolved as a solution to a problem, and so the traditions from which the form arose are consistently apparent in the majority of programming. In remaining 'a peculiar, theatrical hybrid' (Wiliam 2005), much sitcom not only acknowledges its heritage, it also distinguishes itself from the majority of television programming.

That said, Jérôme Bourdon argues that much television continues to be influenced by the possibility of liveness (2000). That is, the aspect of television which most obviously marked it as different to other media – and which continues to do so – is its ability to show viewers events which are happening elsewhere simultaneously. Liveness remains most obviously important to television in terms of news and sport, but 'is nevertheless latent in the medium at all moments and under all sets of circumstances' (Marriott 2007: 58). For Philip Auslander, television's goal has always been 'to *replace* live performance' (1999: 19, italics in original), destroying older forms of culture in the process, while retaining the appearance of being somehow 'live'. Considering contemporary television fiction has often been seen as attempting to ape the 'cinematic' (Pearson and Messenger-Davies 2003) pleasures of film, it's telling that sitcom is one genre that retains, and foregrounds, its theatrical origins. Many sitcoms are filmed in a manner which mirrors the theatrical experience, in front of a studio audience. This results in a shooting style which differs from that of much television fiction as all the cameras have to be placed on one of side of the action. Because of the studio audience, actors in sitcom are required to offer a performance which is appropriate for theatre, ensuring that their lines and gestures can be seen by everyone present. And the laugh track in sitcom is a record of the 'live' responses of those who witnessed the event, recorded and transmitted to viewers at home. All of these

aspects are extremely uncommon in the majority of television, and have instead become associated with the sitcom genre. In addition, a number of sitcoms have broadcast live episodes: *The Drew Carey Show* did so in 1999, and incorporated many improvisational games which drew on the stand-up skills of some of the cast; *Will and Grace* (NBC, 1998–2006) had live episodes in 2005 and 2006; *Two Pints of Lager and a Packet of Crisps* (BBC2/BBC Choice/BBC3, 2001–) did the same in 2008. It was noticeable in the *Two Pints . . .* episode that the writer (Susan Nickson) included in the narrative many sequences which displayed their liveness because of their possibility of going wrong; the performers had to carry out juggling tricks, song and dance routines, stunts and tongue-twisters, all of which add an extra frisson to a live episode. Because of the various time zones in America the live episodes of *Will and Grace* had to be performed twice, doubling the potential for mishap; furthermore, Megan Mullaly, who plays Karen Walker in the series, injured her knee shortly before the episode, requiring last minute rewrites to incorporate her crutches into the episode's narrative. While drama series have similarly had live episodes (*ER* (NBC, 1994–) in 1997; *Coronation Street* (ITV, 1960–) in 2000; *The Bill* (ITV, 1983–) in 2003 and 2005) these remained technical exercises whose pleasures did not rest so keenly on the possibility of the cock-up. Live sitcom episodes, on the other hand, have made a display of their liveness, and offered up as pleasurable the possible consequences of live performance.

A second problem for television comedy is that broadcasting is inherently about communicating with large, diverse, unconnected audiences, whereas comedy has traditionally relied on close relationships between joke tellers and audiences. While individual jokes can be understood as communicative acts which are told by a teller and received (and hopefully laughed at) by an audience, the success of humour is usually also attributed to the 'joking relationship' (Radcliffe-Brown 1952: 90–116; Palmer 1994: 11–23) between those in a comic exchange. This means that people who know each other well can find particular things funny which those outside of the group don't. Such 'in-jokes' rely more on the workings of that group dynamic than the specifics of the joke that was uttered. It's not uncommon for someone recounting a hilarious event which happened to them, and which those with them at the time also found extremely funny, to be faced with a mass of blank responses and so have to utter the resignation, 'You had to be there'. In such instances, the funniness of the moment rests on a whole set of contextual factors which are absent in the retelling. This means that finding things funny often relies on a number of aspects which are not contained within the

actual comic moment itself, and so humour can be seen as a communi-
cative act whose context is vital to its success.

Stand-up comedians know this, and spend much of their time being
'as friendly and attention-grabbing as possible' (Double 1997: 122) for
'creating an atmosphere of community in the room is almost as impor-
tant as having well-crafted punch lines' (Carr and Greeves 2006: 108)
for the success of a comic performance. Because of this, comedians
might change their routines in response to the specifics of the place
of performance; as William Cook notes, when stand-up gigs go badly,
'the most common scapegoat is not the audience but the room' (1994:
166). All of this shows how successful comedy relies on the relationship
and setting of the comic event, with the audience not only responding
to humour but also helping define the comic exchange through their
very presence. Now, for television this is a problem; the millions of
viewers sitting at home watching a sitcom are very definitely not in
the same place as the comic performance and are likely to be viewing
months, if not years, after the event took place. It is for this reason
that 'traditional' sitcom is filmed in front of a studio audience, which
immediately signals to the production crew what is funny and what
is not, giving impetus to the actors' performances. This audience is
signalled to the viewers at home through the laugh track, which, as the
'electronic substitute for collective experience' (Medhurst and Tuck
1982: 45), helps align domestic viewers with those who were present
at the live recording. These might be useful attempts to deal with the
difficulties of capturing the essence of comic communication, but they
remain responses borne out of the particularities of broadcasting.

All broadcasting by its very nature can be seen as yoking together
mass, diverse groups of people as a 'taxanomic collective' (Ang 1991:
33–8) called 'an audience', and this is usually given an explicitly
national inflection via public service broadcasting. Indeed, many have
noted how television forms such as news and drama offer 'normalised'
representations which audiences can only get pleasure from if they
acquiesce to the position the programme requires of them (Holtzman
2000; Thornham and Purvis 2005: 74–92; Johnson 2008). In its explicit
acknowledgement of its audience sitcom has been seen to be the wor-
rying exemplar of this process. That is, while most types of program-
ming offer certain audience positions, they don't incorporate audience
responses which legitimate those positions. Indeed, it is usually the
case that when audiences are given space to respond to programme
content, they offer a range of viewpoints and often question and criti-
cise what has been offered them; this can be seen in daytime program-
ming such as *This Morning* (ITV, 1988–) as well as more 'traditional'

political programmes such as *Question Time* (BBC1, 1979–). Yet sitcom never offers an onscreen space for audiences to disagree with comic content or critique the ideologies the comedy espouses. While audiences at home hear the studio audience guffawing at the comic content of a series, we never hear if an audience member tutted at the lameness of a joke or stood up and yelled outraged abuse at the production crew because they felt a joke was sexist, racist or otherwise offensive. To be sure, laugh tracks make it clear that studio audiences find some moments funnier than others; but never that they found some moments completely lacking in comic worth. This is important because in live performance this possibility is available to the audience and stand-up comedians have to learn to deal with hecklers as part of their job (Cook 1994: 215–32). Television sitcom audiences never get to heckle, and so sitcom can be seen as a form which, while attempting to adopt the audience interaction vital for comic success, does so in a manner which robs the audience of the voice it has in other comic arenas.

Finally, the serial possibilities of broadcasting are quite at odds with the ways in which comedy has historically been consumed. While one-off dramas and programmes make up a noteworthy proportion of television broadcasting, the dominant form of programming is the recurring series. This can take the form of drama series or serials, sitcoms and sketch shows, as well as documentary strands, quiz shows, chat shows and so on. There are obvious economic reasons for television to adopt this format: series can, in the long term, be cheaper per episode to make due to economies of scale; it's easier to sell serial programmes to home and international broadcasters; series can be sold as DVD box-sets. But the series format can also be seen as a response to the domestic nature of broadcasting, in which audiences can regularly tune into programmes, usually on a weekly basis. It is in this way that television has placed itself within the routines of the home and is one of those domestic aspects of the medium which is discussed below.

The serial nature of broadcasting offers considerable opportunities for comedy programming, for it allows audiences to build up a rapport with comic characters. This means that performers and writers don't have to tell the audience what kind of humour they're viewing at the outset of each episode as viewers will bring a set of expectations to the programme from previous viewings; this is explored in detail in the section on 'setting-specific' and 'category-routinised joking' (Handelman and Kapferer 1972) in Chapter 4. This is quite unlike the historical relationships of performer and audience in a lot of stand-up, where audiences were unlikely to have encountered every performer before. It is precisely this aspect which allows sitcom to have narrative;

the serial demands of broadcasting require known characters to be involved in a different series of comic events each episode, and histories of sitcom outline the ways in which early series evolved from a sequence of unrelated sketches to narratively driven texts whose comedy relies on story for its effect (Jones 1992: 7–47; Mills 2005: 37–42; Neale and Krutnik 1990: 209–47). In that sense, sitcom is a genre that can only exist in broadcasting; sitcom does not exist in novel form, or in the theatre or in cinema. To understand sitcom, then, it is vital to examine and accept the particularities of broadcasting and the opportunities and limits that system allows.

Sitcom, then, can be seen as an excellent example of what Raymond Williams calls 'flow' (1974: 86–118). For Williams, television offers a radically different sequence of texts than is the case for other cultural forms, precisely because while we usually think of television as based around programmes, its structuring principle is really a sequence or schedule of programmes, within which each particular episode plays a part. This means that the 'real' narrative is broadcasting, and so no individual programme exists on its own. The serial nature of television – and sitcom – troubles conventional understandings of the text and means that series, or episodes of series, are not the primary way in which television can be understood. For example, broadcasters have commonly constructed schedules of sitcoms in which a number of series come together to create a television text which is more than each individual episode; NBC's 'Must See' Thursday night line-up is probably the most famous instance of this and included programmes such as *The Cosby Show*, *Cheers* (1982–93) and *Seinfeld*. It's noticeable that, as each of these series ended they were replaced by others, showing how the schedule can exist and be promoted in exactly the same way, even if the programmes within it change. In Britain, Channel 4 has often constructed schedules of comedy programming on Friday nights, while BBC2 has tried comedy schedules on a number of different days; at the time of writing, it insists that 'Thursdays are Funny'. The sitcom, then, needs to be understood as a part of broadcasting as a whole; while DVD box sets may trouble assumptions about flow a little as they allow viewers to watch programmes removed from the schedule, the numbers of people watching in this way are still miniscule compared to those who watch such series as a part of 'traditional' broadcasting.

As has been shown, then, sitcom conventions are significantly affected by the nature of broadcasting, and it is that nature which helped bring the genre into being, in both radio and television. All of the aspects outlined above are textual ones, though, and represent textual responses to the problems of moving comedy into television.

What also needs to be explored are the aspects of consumption which help inform debates about sitcom; as will be shown, some of the textual conventions of sitcom can be seen to be a response to the domestic nature of the majority of television consumption.

Sitcom and the Domestic

A key decision early on in the history of television was that it would be a domestic medium. This was not always going to be the case; for example, Germany experimented with television screens in public places, seeing it as a social medium capable of bringing communities together (Smith 1995: 78). After all, pretty much every other form of culture works in this way (theatre, cinema, art) and broadcasting's movement to the home is an aspect of television that shouldn't be underestimated. As Lynn Spigel (1992, 2001) shows, television played an important role in the ways in which domesticity was transformed in the twentieth century, as the house became a site of leisure and there was a gradual movement away from community activities in public spaces. Despite this, the BBC defines broadcasting as 'a civic art' (2004: 6), with the assumption that television's domesticity is a powerful tool for engaging all citizens in democracy and social activities both within and outside of the home.

The domesticity of television remains one of its principal features, and newer technologies have strengthened this. VCRs and DVDs mean that consumers now have access to material they would previously have been required to leave the home and go to the cinema to see; online broadcasting gives access to more texts but merely shifts viewing from one domestic technology to another; and as more people own more and more television sets (BARB 2008; Open Society Institute 2005: 21; Nielsenwire 2008), the medium becomes one available in more and more rooms of the house, dividing households up even further. As has been noted above, comedy has traditionally been a form which requires a communal, social aspect in order to be effective; its movement to television, then, requires it to adapt to the domestic nature of television consumption.

It's usually argued that television texts very quickly came to be about the home, in order for programming to reflect, and fit into, the domestic context most of its viewers occupied. Quiz shows were aimed at a 'daytime, and largely female, audience' (Boddy 2001: 79); news programmes make links between the domestic and the nation (Conboy 2007: 140–73); soap operas rapidly normalised the 'domestic terrain' (Lacey 1995: 118) of the 'ordinary' street as the most suitable setting

for ongoing drama. And comedy programmes quickly established the family and the home as a ripe site for humour. Indeed, such a transition had occurred in radio comedy, in which the conventions of sitcom were first established. So while *Band Waggon* (1938–40) began as a series of unrelated sketches, it evolved into a programme with a narrative and a setting in which Arthur Askey and Richard Murdoch lived in a flat at the top of the BBC's Broadcasting House. Other early domestic radio sitcoms include *Educating Archie* (BBC Light Programme, 1950–9) and *Meet the Huggetts* (BBC Light Programme, 1953–61), both of which make the family the key site for humour. The appearance of the Glums on *Take It From Here* (BBC Light Programme, 1948–60) is seen as a watershed in sitcom representations of the family; Nathan (1971: 14), for example, links the Glums to both the Garnetts in *Till Death Us Do Part* (BBC1, 1965–75) and the father and son in *Steptoe and Son* (BBC1, 1962–74), and their argumentative, less cosy portrayal of the domestic scene can be seen as a precursor to a whole host of British sitcoms whose most recent apotheosis is probably *The Royle Family*. In all, 'the family or domestic sitcom [is] perhaps the bedrock of broadcast television' (Hartley 2001: 66). This places sitcom as a genre that attempts to replicate the experiences of its viewers, which is unsurprising in a domestic medium.

This also means that television stars are usually very different from those associated with other cultural forms such as cinema. Film stars are marked by their 'specialness' (Dyer 1979: 50), not only in terms of their talent, but also because they are more attractive, more interesting, more exciting than us; the pleasures we get from them is access to a world beyond our own which 'combines the spectacular with the everyday' (39). The word 'star', however, has never sat comfortably with television, and it's much more common to hear the words 'celebrity' or 'personality' used. These words clearly have quite different connotations, and Sean Redmond suggests that the discourses surrounding celebrities utilise a 'language of intimacy' (2007: 36). The success of many people who appear on television rests on their being 'like us', and the relationship we have with them is one quite different to that for film stars. More recent analysis of celebrities whose fame rests on appearances in reality television shows how this works, but it's clear this has been as aspect of television 'stardom' since its inception. The fact that one of television's earliest comedy stars, Milton Berle, was colloquially known as 'Uncle Miltie' shows how television performers were seen to be part of the family; the BBC's nickname 'Auntie' demonstrates this for the broadcasting system as a whole.

Of course, comedy actors, in whatever medium, are admired for their skill and talent, and this is true of television. However, it is significant that the kinds of characters which such actors are required to play on television are more 'normal' and 'everyday' than those in cinema, and the personas of such actors often rests on their averageness too. For example, when Tony Hancock, Britain's first television comedy star, was interviewed in 1960 on *Face to Face* (BBC, 1959–62, 1989–98) he was, to all intents and purposes, a millionaire with as much clout as any film star. Yet he is keen throughout to present himself as an ordinary person who likes to be left alone and is clearly uncomfortable talking about fame, success, money and power. Now this reticence may, of course, have something to do with Hancock's off-screen personality, which was clearly troubled. That said, though, it's significant that a television audience is willing to accept such a personality on television, for this representation of himself did not render him unacceptable for broadcasting. The two greatest sitcom stars of British television – Ronnie Barker and David Jason – have been similarly reticent about their private lives, and in the few interviews that do exist, they were at great pains to present themselves as ordinary and domestic. It seems that comedy audiences like actors and characters that are 'just like us'; this has significant implications for the content of comedy on television, and can be seen as a consequence of the domestic, ordinary, everyday nature of the medium.

The depiction of the domestic has significant ideological implications, however. For the majority of the sitcom the home is equated with the family, and the kinds of family which are presented can be critiqued as disturbingly traditional. An early American series such as *Father Knows Best* (NBC Radio, 1949–54; CBS Television, 1954–60) demonstrates its patriarchal leanings in its title, and has been criticised for a 'limited social subjectivity for homemakers in the 1950s' (Haralovich 2003: 72). This has especially been the case for feminist critics, who see in sitcom a masculine form of humour in which women are ridiculed unless they conform to a 'humble but noble calling in life – housewife and mother' (Marc 1989: 56). The dominance of masculine comedy can be seen by the tiny proportion of sitcoms which have women as the leading roles, and a minority of sitcom writers, producers and performers are female. Anthropological and sociological studies show that social constraints limit women's access to humour in mixed groups, and it's clear that it is harder for women to be accepted as funny than it is for men (Levine 1976; Pollio and Edgerly 1976). This was clearly shown in the series of interviews with funny women (including Kathy Burke, Catherine Tate, Joan Rivers and Victoria Wood) carried out by the comedian

Dawn French for the series *Girls Who Do* . . . (BBC4, 2006); each of the interviewees recounted their realisation in their teenage years that in order to be popular and attractive they had to stop being the funny person in their group, especially as men were threatened by this and felt it was their role to make people laugh. Sitcom's placing of humour in the domestic sphere has clear implications for the social roles which characters are cast in and, for women, this places significant limits on the comedic possibilities open to them.

This is not to say that certain series haven't attempted to break out of this mould, however. Sitcoms written by Carla Lane, such as *Butterflies*, *Solo* (BBC1, 1981–2), *The Mistress* (BBC2, 1985–7) and *Luv* (BBC1, 1993–4) repeatedly lambaste the restrictive roles women are required to play in families and demonstrate the frustrations these cause. In America *Roseanne* is probably the most obvious example of the 'unruly woman' who refuses to conform to the social and physical expectations of femininity; *Grace Under Fire* (ABC, 1993–8) offers a similar treatment of femininity, and *I Love Lucy* (CBS, 1951–7) is an important precursor of such a development (Mellencamp 1992: 322–33). That said, it's noticeable that as each of these series critiques the domestic role of women it still places women within that sphere; that is, the representation of women within other arenas is much less common. Sitcom's domestic focus means that it can comedically examine women in the home (often in a much more thoughtful and radical way than drama and documentary can), but this precludes a more detailed examination of other aspects of women's social roles in society and broader debates about gender and society. Thus the murdering, duplicitous, obsessive sociopath Jill in *Nighty Night* (BBC3, 2004–5) is solely motivated by the desire for heterosexual union and her antisocial behaviour is never placed in a socio-political context; indeed, she is marked as comically different because of her failure to conform to the passive expectations for women.

It is for this reason that many critics bemoan the ways in which the radical, critical nature of comedy has been blunted by the domestic needs of television broadcasting. The economics of television requires regular sets to be used, and this means that sitcom usually places its characters within one social sphere alone, ignoring the multiple roles that most people play in society. For many programmes this is the home, but it can also be workplaces, such as in *The Office*, *Nice Day at the Office* (BBC1, 1994) or *Spin City* (ABC, 1996–2002), in pubs and bars, such as *Early Doors* (BBC2, 2003–4) and *Cheers* (NBC, 1982–93), or other, more outlandish locations, such as spaceships for *Red Dwarf* (BBC2, 1988–99) and *Come Back Mrs Noah* (BBC1, 1977–8). While

each of these settings allows for different social interactions to be displayed, they still place characters within one location, thus failing to explore the range of social pressures which affect the individual. For David Grote (1983), this means that sitcom is never about change and development, which *was* the key theme of classical comedy such as that written by the ancient Greeks. In all, the placing of television as a domestic medium clearly has significant effects upon the kinds of comedy which audiences are presented with, and these routinely ignore the wider social circumstances of everyday existence, and instead focus on the local, the small-scale, the familial and the domestic.

By this reading, sitcom is a highly problematic genre, whose social consequences are negative and whose radical potential is muted. Yet I want to suggest that while comedy may have particular limits placed upon it by the needs of the broadcasting, the conventions of broadcasting have been repeatedly satirised and mutated in response to the needs of comedy. To condemn sitcom for failing to fulfil the roles humour plays in other media and cultural forms is to normalise those roles as the correct and only ones for comedy. Instead I want to argue that sitcom is the result of the interplay between the comic impetus of all comedy and the specifics of television, both of which must adapt in order to meet the needs of the other. It is this interplay which results in sitcom as a specific genre, with its own expectations, conventions and norms; and so it is to this aspect of sitcom which we now turn.

2 Genre

I think there is a common misconception that sitcoms are made up of jokes: they're not.
(Sioned Wiliam 2005)

I'm not sure people look to sitcom for 100% reality, do they?
(Sophie Clarke-Jervoise 2005)

This book – and the others which accompany it in this series – all work from an assumption that genre is a worthwhile critical tool for making sense of television. This is an approach with a long-standing tradition, for 'genre is one of the principal ways in which audiences, producers and critics routinely classify media' (Branston 2006: 44). To talk about different kinds of television – such as sitcoms, quiz shows, news programmes, drama series and children's programmes – is to talk in terms of genre, carrying out the process of classification which Branston notes. This means that genre study is interested in defining multiple texts as 'a class of like objects' (Harris 1995: 509) whose similarities can be spotted and recognised. It can often seem that categorising programmes in this way is an obvious and straightforward process; as will be shown below, sitcom has often been understood as an 'obvious' and 'straightforward' form of programming which is east to spot and simple to define. Yet studies of all forms of genre have noted that such classification is rarely a clear-cut activity, and Glen Creeber warns on the opening page of his book on genre that 'it would be wrong to suggest that the use of genre is always this simple' (2008: 1). This chapter will therefore use genre to examine sitcom at the same time as using sitcom to examine genre, demonstrating the difficulties in thinking through the worth of both of these terms. After all, 'sitcom' only has any meaning if it is assumed that 'genre' is a valid analytical framework, while 'genre' is only useful for the examination of 'sitcom' if it's assumed 'sitcom' is a meaningful category.

The quotes from Sioned Wiliam (Controller of Comedy at ITV) and Sophie Clarke-Jervoise (Head of Comedy at the BBC) at the start of this chapter demonstrate that definitions of sitcom are far from straightforward. As was discussed in Chapter 1, sitcom can be thought of as a genre defined by its comic impetus, for it is its comic aspect upon which, it was argued, all of its textual elements rely. However, Wiliam here takes to task the idea that sitcom is nothing other than jokes, and instead argues that factors such as narrative, character and representation all help define the genre too. Clarke-Jervoise, on the other hand, notes how sitcom is often distinct from 'reality' precisely because the need to make audiences laugh is so paramount. It's not necessary to engage in lengthy discussions about which of these definitions of sitcom is the 'best' or 'truest'; the significant thing here is that two professionals, with many years' experience of working hands-on in the production of sitcom, offer differing takes on the key components of the genre. Indeed, the majority of the interviewees I spoke to were extremely wary of defining any of the work they produced, repeatedly rejecting the idea that, because they were involved in the production of such programming, they had some kind of better insight into what made them 'work'. For these professionals, making sitcom was always an ongoing process, and different writing, acting and shooting styles, as well as content, might arise at any time, taking the sitcom off into a different and unexpected direction. If the people who make sitcom can't decide what it is that defines their output, what value is there in thinking about such programming generically, then?

Steve Neale examines genre in terms of 'repetition and difference' (1980: 48), suggesting that all media texts must be similar enough to existing ones to be understood, while different enough from existing ones in order to be interesting. Such an approach allows for different understandings of genre, suggesting that while different people may have various definitions of a genre, these work within a context of similarities. This means that while sitcoms such as *Arrested Development* (Fox, 2003–6), *That's So Raven* (Disney Channel, 2003–7), *The Big Bang Theory* (CBS, 2007–), and *The Sarah Silverman Program* (Comedy Central, 2007–) might all deal with different kinds of subject matter, have different shooting styles and appeal to different audiences, they nevertheless remain sitcom because they have enough similarities to those programmes already understood as belonging to the genre. Debates about genre are therefore *not* about constructing watertight definitions which outline the characteristics a programme must have in order to be granted the designation 'sitcom'. Instead, the key question is, 'why is such a programme understood to belong to this particular

genre?' Of course, different people might categorise particular programmes in different ways; I've written elsewhere about my problems in deciding whether *The Flintstones* (ABC, 1960–6) is a sitcom, a cartoon, a children's programme or something which incorporates aspects from all of these (Mills 2005: 29). This book, then, attempts to encompass the range of ways in which sitcom has been thought about, seeing genres as 'cultural categories that circulate around and through television programming' (Mittell 2008: 12).

To examine this circulation, this book looks at industry, texts and audiences. In doing so, it draws on approaches developed within media studies which see genre as applicable to '(1) the system of production, (2) structural analysis of the text, and (3) the reception process' (Feuer 1992: 144) of all cultural forms. This means that rather than genre being something we apply solely to texts, we can also think about it in terms of the industries which produce programmes and the audiences who consume them. For Jason Mittell, genres are therefore 'practices that categorize texts' (2004: 13) which means that genre 'should be viewed as a fluid and active process' (16). By this account, genre is always *ongoing* and therefore always open to reinterpretation, development and mutation. And the 'process' which results in genre is one which arises from the negotiations between producers, audiences and programmes. The task of the student of sitcom is therefore not to attempt to define what sitcom *is*: instead it is to explore the ways in which sitcom *comes into being*.

Distinguishing the Sitcom

Exploring the ways in which sitcom comes into being might be usefully achieved less through demonstrating that sitcom is a coherent category and more about distinguishing it from *other* genres. Making sense of the sitcom as a genre is as much about *not* placing it in some categories as it is about acknowledging the links the genre makes to those characteristics associated with it. This means the sitcom can be understood, for example, as *not* factual, *not* news and *not* documentary. The social value of entertainment was explored in Chapter 1, and this argued that more worth is commonly placed on more 'serious' forms of television than those whose role is to amuse and entertain. The fact that sitcom often distinguishes itself from those 'serious' forms as actively as possible can be seen as evidence that these different kinds of programming need to be kept apart. Of course, news and documentary are themselves situated within genre, and may be explored as texts with recurring characteristics and audience expectations as much as

the sitcom (Creeber 2008: 104–33). However, Jonathan Gray shows that this 'social construction of entertainment as distinct from information' (2008a: 5) plays a vital role in mirroring cultural distinctions outside of television, especially those which define the boundaries between the necessary and worthwhile connotations of 'work' and the inconsequential and superfluous aspects of 'leisure'. The concern that the frivolities of entertainment somehow cheapen and undermine the value of information and entertainment is consistently repeated in debates about 'infotainment' and the 'tabloidisation' of news (Hartley 2008), worries that television is 'dumbing down' (Mosley 2000) and critiques of entertainment television as a whole, such as Neil Postman's *Amusing Ourselves to Death* (1986). This distinction is bolstered by traditional sitcom's seeming artificiality; that is, the aesthetics of sitcom are ones which have often been read in terms of their '"actorly" performances' (Cook 1982: 16) and the genre has been described as making 'no concession to social realism' (Wagg 1998: 7). The regulatory and institutional regimes which foster generic categorisation can therefore be read as ones which encourage these distinctions to be upheld, and while there may be 'artistic' reasons for this, it's necessary to examine why it is that television texts need to be distinguished at all. Categorisation is never a neutral act and therefore genre analysis can be a useful tool for unpicking the assumptions which underpin cultural distinctions.

This is of particular importance because texts which most obviously signal their generic characteristics are commonly seen to be of low cultural value. Barry Langford notes that there is 'cultural privilege attached to "originality"' (2005: 8) which means the term 'generic' can often have negative connotations. Later in this chapter, it will be argued that sitcom has often been defined as an easily understood genre, whose characteristics are evident and unchanging. While this might make it a genre which is easier to 'place', it means the sitcom has often occupied a low cultural position, repeatedly criticised for its stability and lack of originality. Steve Neale shows that criticising genre texts for being formulaic is a relatively recent practice, for authors such as Shakespeare repeatedly worked within highly rule-bound forms such as the sonnet (1980: 2); this means there is nothing *inherently* limiting about genre, and so we can ask why it is that contemporary culture places such value on texts which are perceived to be more original than others. Chapter 6 examines this relative to sitcoms such as *The Office* (BBC2, 2001–3) and *Arrested Development*, which have been lauded for what has been seen as innovation and experimentation. This in itself is useful for debates about genre, for innovation can only be perceived if

there is a 'norm' for sitcom against which such programmes work. To this end, *this* book makes no evaluative claims about the value of different kinds of sitcom, even though, as shown, this is one of the purposes to which genre analysis has often been put.

Because of these debates about differences *within* sitcom, it's worth exploring the 'classic' or 'traditional' definition of the genre. A typical definition of sitcom is:

> a half-hour series focused on episodes involving recurrent characters within the same premise. That is, each week we encounter the same people in essentially the same setting. The episodes are finite; what happens in a given episode is generally closed off, explained, reconciled, solved at the end of the half hour . . . Sitcoms are generally performed before live audiences, whether broadcast live (in the old days) or filmed or taped, and they usually have an element that might almost be metadrama in the sense that since the laughter is recorded (sometimes even augmented), the audience is aware of watching a play, a performance, a comedy incorporating comic activity.
>
> The most important feature of sitcom structure is the cyclical nature of the normalcy of the premise undergoing stress or threat of change and becoming restored . . . This faculty for the 'happy ending' is, of course, one of the staples of comedy, according to most comic theory. (Mintz 1985: 114–15)

There are three aspects to this definition. The first examines sitcom's *setting*, which is focused on recurring places and characters; the second outlines sitcom's *aesthetics*, and notes the artificiality of the sitcom text; the third looks at *narrative*, with reference to the repetitive nature of sitcom stories. I've argued elsewhere how there are problems with this definition, not least that it could be used as a suitable summary of programmes not usually defined as sitcom, such as drama series (Mills 2005: 27). This doesn't necessarily negate Mintz's argument that such elements are common within sitcom; but it does beg the question as to what else is necessary for sitcoms to be distinguished from drama series. Indeed, attempting to produce an unarguable, dictionary definition of any genre is difficult, and it has increasingly been argued that a definitive 'repertoire of elements' (Lacey 2000: 133) is less meaningful than those 'practices that categorize texts' (Mittell 2004: 13). Instead, genres are 'composed relationally rather than in isolation' (Langford 2005: 18) placing particular series within the context of other programmes, audience expectations, industry practices, marketing and scheduling. This means that series can be understood by different people in quite different ways.

For example, *The Strange World of Gurney Slade* (ITV, 1960) is included in Mark Lewisohn's *Radio Times Guide to TV Comedy* (2003: 732), where it is defined as a 'sitcom', even though it fails to incorporate many of the characteristics outlined in Mintz's definition of the genre. The series consists of the picaresque adventures of the eponymous character who, in the opening scene, walks out of a television drama he's appearing in, much to the consternation of the production crew. Other than Slade, there are no recurring characters, and the episodic nature of the series means there is no regular setting or satisfactory denouements to his adventures; indeed, there's not much of what might usually be termed a 'plot' at all. The programme doesn't signal its comic intention through either its performance style or the use of a laugh track, and even though it may have aspects of what Mintz calls 'metadrama', this takes the form of avowedly surrealist and absurd moments – such as vacuum cleaner dance sequences – rather than the construction of a supposedly 'realist' world that is the case of much sitcom. Lewisohn notes the difficulty in generically placing the programme, calling it 'not so much a sitcom, more a way of life', and remarking that it 'wasn't really made for laughs' (ibid.). In that sense, why is it categorised as a sitcom at all?

The same question can be asked of a number of contemporary series. For example, *The Daily Show* (Comedy Central, 1996–) has a recurring location and recurring characters, and is clearly marked as a metadrama through performance style and audience responses being included in the text; yet *The Daily Show* is not usually categorised as a sitcom. In defining it as a 'fake news program', Paul Achter (2008: 274) prioritises the factual element of *The Daily Show*, as well as its relationship to news as a genre, while acknowledging the ways in which it signals its desire to be read as something quite different from traditional news texts. Indeed, in its impact upon the political landscape and voting behaviour in America (Brewer and Marquardt 2007; Feldman 2007; Morris 2008), *The Daily Show* can be seen to fulfil a social role not normally associated with the sitcom. This distinguishes it from a programme such as *The Day Today* (BBC2, 1994), which similarly mocks news conventions. However, this programme often incorporates plots with clear endings, which *The Daily Show* lacks, and could therefore more easily be categorised as a sitcom; Mark Lewisohn, however, categorises *The Day Today* as a 'satire' and a 'spoof' (2003: 533), with no mention of the word 'sitcom' in his summary. In Kim Akass and Janet McCabe's collection of essays on *Sex and the City* (HBO, 1998–2004) the programme is called a 'comedy series' (2004: 2), and a 'sitcom' (161): Dermot Horan, on the other hand, calls it a 'Half-hour comedy' (2007:

116) and distinguishes this from a sitcom because of the programme's 'quality' (which is a statement about genre assumptions in itself).

The aim here is not to argue whether a certain programme is or isn't definitively a sitcom; as genre theory argues, this is a problematic and ongoing task. Indeed, my experience of having conversations with non-academics about television genres suggests that these are much more fluid – and in some cases meaningless – terms. For example, I'm often asked how my research on 'soap operas' is going, and when I remind people that it's sitcoms that I study, the response I often get is, 'What's the difference?' For the academy, the distinctions between the two are obvious, and 'traditional genre analysis' (Mittell 2004: 2–11) saw its role primarily as defining and maintaining such distinctions. From my anecdotal experience, however, while 'ordinary' viewers distinguish between factual and entertainment programming, the concern over how to define genres, and fit specific programmes within genre classifications, is one of far less concern. That said, perhaps the reason why the majority of viewers don't engage in debates over generic specificity is because the 'systematic patterning' (Barry 2002: 49) necessary for genre to work is so normalised that the workings of types of programming become hard to spot.

While the accusation that genre analysis limits the field of study can be levelled at a range of programming, I want to suggest that this might have further implications for the study of sitcom. Running throughout analysis of sitcom is the critique that it is hegemonic and conservative. Some of these criticisms put this in a historical context, arguing that sitcom has abandoned comedy's traditionally radical purpose (Grote 1983); others bemoan issues of representation and stereotyping, arguing that comedy's pleasures normalise social divisions and differences (Jhally and Lewis 1992; Coleman 2000); others still critique it aesthetically, adopting a position which sees it as 'only entertainment' (Dyer 1992). Yet to criticise a genre while adopting a rigid categorisation of that genre is to ignore texts which might work in different ways and to insist on labelling programmes which might function differently as 'something else'. Considering it's often been argued that the preponderance of realism on much Western television has ideological consequences as it 'naturalizes' (Fiske and Hartley 1978: 161) social structures and media representations, it's surprising that an anti-realist programme such as *The Strange World of Gurney Slade* has not been explored more. Similarly, analyses of programmes like *The Daily Show* and *The Day Today* have repeatedly related them to issues such as politics and news programmes (Baym 2005; Fox et al. 2007; Mills 2007), which is a roundabout way of acknowledging the radical purpose they

might fulfil while refusing to let such an acknowledgement reflect on analysis of the sitcom.

Similar radicalism has been associated with animated sitcoms such as *The Simpsons* (Fox, 1989–) and *South Park* (Comedy Central, 1997–). Yet it's noticeable how the analyses of these series often use them as a starting-point for discussions on other topics, sidelining their status as sitcom. Indeed, considering the lack of writing on sitcom as a whole and the serious dearth of book-length analyses of specific programmes, it could be seen as surprising that *The Simpsons* has volumes devoted to its relationship to philosophy (Irwin et al. 2001), religion (Pinsky 2001), science (Halpern 2007), subversion and radicalism (Alberti 2003), society (Keslowitz 2006) and psychology (Brown 2006). Instead, only two books – one outlining the programme's relationship to parody (Gray 2005) and another exploring the history and cultural impact of the series (Turner 2005) – might be of obvious use to someone exploring sitcom and genre. It's also noticeable that books which explore the whole rise of 'adult animation' (Donnelly 2001) on television in the 1990s, such as that by Carol A. Stabile and Mark Harrison (2003), do so in a way which foregrounds the 'cartoonalness' (Wells 2002: 94) of the relevant series rather than their sitcom characteristics. It's as if the very fact of these series being animated overrides the ways in which they rely on sitcom; in doing so, such analysis reiterates the idea that whenever sitcom does anything beyond the 'coherent' and 'stable' definition applied to it, it becomes something else.

A similar problem arises in the examination of comedy drama. The links between sitcom and comedy drama are clear, as they both employ recurring characters in regular settings and 'tell stories in an entertaining, easily comprehensible fashion' (Thompson 2003: *ix*). Indeed, the only aspect of the traditional definition of sitcom outlined above that cannot usually be applied to comedy drama is the notion of metadrama, as comedy drama doesn't usually acknowledge the audience or use a laugh track. Of course, the fact that much contemporary sitcom doesn't use a laugh track either makes this distinction difficult. A series such as the long-distance romance *Gavin and Stacey* (BBC3, 2007–), for example, has an aesthetic drawn from drama, using real locations and only a few regular settings, meaning that in many ways it appears visually similar to soap opera rather than sitcom. Indeed, the ongoing narratives in the programme, with the first series centred on a wedding and the second on a birth, shows how the programme draws on narrative arcs commonly associated with drama. Yet the series triumphed at the *British Comedy Awards* in 2007 and won in the comedy category at the 2008 *British Academy Television Awards*, demonstrating

that, in industrial terms at least, it is generically categorised as comedy rather than drama.

This may be due to institutional factors rather than textual ones. *Gavin and Stacey* is broadcast on BBC3, which broadcasts a lot of comedy, such as *Ideal* (2005–), *Pulling* (2007–9), and *Nighty Night* (2004–5); it was also the first home for the television version of *Little Britain* (BBC3/1, 2003–6). The BBC describes the channel as 'dedicated to innovative British content and talent, providing a broad mix of programmes aimed primarily at younger audiences' (2007: 26), and notes that comedy is a 'crucial genre for the channel' (35). It is therefore a channel which foregrounds its comedy content, as it's assumed this is of more interest to younger viewers. Placing *Gavin and Stacey* within this context therefore aligns the programme with the comedy that surrounds it, especially as, in its second series, it was paired with *Pulling* as a Sunday night comedy strand. This demonstrates the industrial nature of genre and the importance that scheduling, marketing and other 'cultural practices' (Mittell 2004: 24) have in encouraging viewers to place a programme within a specific genre.

The sitcom writer, producer and director Andy Hamilton notes the difficulty promoters and schedulers had in making sense of his programme *Bedtime* (BBC1, 2001–3). This series dealt with three couples in bed in three neighbouring houses, cutting between their behaviour as they settled down for the night. In its domestic and familial setting, as well as its use of humour, the programme could be aligned with the sitcom; however, as the series was not shot in front of a studio audience and explored 'serious' issues such as parents struggling with a newborn baby, it adopted some of the characteristics of drama. As the programme refused to clearly distinguish itself in terms of a sitcom, Hamilton (2005) noted the difficulties broadcasters had in deciding how to promote it:

> It was always a problem. In the end I said, look, just call it a comedy, and let people make up their own minds about it. To be honest, the audience don't care, you don't sit down thinking you want to watch a comedy drama, you just want to watch a story usually. But 'comedy' is less off-putting usually; 'comedy-drama' is vaguely off-putting. I think there's something about that hybrid word that communicates insecurity. I like making stuff where people have a bit of a problem putting it in a genre.

This can be seen even more starkly with reference to *Ugly Betty* (ABC, 2006–). In America the programme was promoted as a comedy drama, and its roots to the Colombian telenovela *Yo Soy Betty, La*

Fea (RCN, 1999–2001) was foregrounded. In Britain, however, the programme was marketed differently, with posters defining it as a comedy, and trailers which highlighted the bitchy one-liners and slapstick comedy while downplaying other aspects of the series such as its examination of American immigrant communities. Perhaps more significantly, *Ugly Betty* was scheduled on a Friday night on Channel 4, in a slot with a tradition of American comedy, from *Cheers* (NBC, 1982–93) via *Friends* (NBC, 1994–2004) to *Will and Grace*. This means that expectations brought to the series were likely to be quite different than those brought to it by American viewers, which, in turn, suggests audiences may have read the series quite differently. It was certainly the case that American students in a class I taught on comedy in 2007 were surprised to hear British students referring to *Ugly Betty* as a comedy, just as, in return, the British students were surprised to hear the American ones insisting it was a drama.

In comparison, we can also explore the ways in which regulators define genres. For example, the British broadcasting regulator, Ofcom, makes a distinction between sitcom and comedy drama based on length. That is, a sitcom is 'usually of 25–30 minutes duration', whereas comedy drama is 'over 25 minutes' (2004: Appendix B). In this document, Ofcom defines no other genre by programme length, and it's difficult to see why duration should become associated with genre other than due to scheduling conventions. While Ofcom in no way suggests that this is a foolproof definition, it does raise the question as to how programmes which don't conform to this convention signal their desire to be read in particular ways. For example, Christmas specials of British sitcoms are often much longer then 30 minutes; the 1993 Christmas special of *One Foot in the Grave* (BBC1, 1990–2000) had the length of a feature film, at 90 minutes. It's clear that, in this case, the programme was read in the context of the existing episodes of the series which uses many of the conventions of sitcom; it would be interesting to discover, however, what reading a viewer without such knowledge would make of the episode. The length debate is relevant to the difficulties categorising *Sex and the City* which, when broadcast in the UK, was usually scheduled in a 30-minute slot, in the same way a sitcom would be.

Further complications in terms of genre arise because of individual factors any single viewer might bring to a programme, and these are likely to be non-textual ones. An example of this can be seen in my own responses to the series *Press Gang* (ITV, 1989–93), which concerns the exploits of a group of teenagers working on a newspaper for children and young adults. When I watched it as a teenager I categorised it as a

drama, even though it contains many comic moments and one-liners. Yet because its writer, Steven Moffat, went on to write sitcoms such as *Coupling* (BBC2/3, 2000–4), *Chalk* (BBC1, 1997), *Joking Apart* (BBC2, 1993–5) and episodes of *Murder Most Horrid* (BBC2, 1991–9), when I've recently rewatched *Press Gang* I've instead found the sitcom elements most obvious and have therefore recategorised it generically. This shows how genres can be understood in terms of authorship, even if authorship has repeatedly been seen as a problematic idea in the study of television (Coward [1987] 2000). It also demonstrates the temporal nature of genres and that readings of texts may alter over time.

All of these difficulties can be seen in the British programme *Love Soup* (BBC1, 2005–), which explores the difficulties of finding romantic love in contemporary Britain. The programme is written by David Renwick, the writer of *One Foot in the Grave* and co-writer of sitcoms such as *Hot Metal* (ITV, 1986–8), *If You See God, Tell Him* (BBC1, 1993) and *Whoops Apocalypse* (ITV, 1982). In its complex plotting and visual gags, *Love Soup* could be easily placed within the category of sitcom. Yet in the first series its scheduling (9 p.m. on a Tuesday) and its length (60 minutes) might more readily situate it as a comedy-drama, and the blurb on the DVD of the series defines it as such. Yet the second series of *Love Soup* was instead 30 minutes long and rescheduled to a Saturday evening, where comedy and entertainment programming is much more prevalent on British television. In these ways the marketing and scheduling of the series are likely to encourage different genre expectations in audiences, and the reduction in episode length clearly altered the ways in which narratives could be told in the series. In addition to this, individual readings once again come into play; as someone who has always admired and enjoyed Renwick's sitcom writing, *Love Soup* has always seemed to me to be a sitcom, albeit one shot without a laugh track. The recurring characters, cyclical plots and regular settings, coupled with the lack of narrative development across the series, means it remains much more episodic than might be expected for a comedy drama or drama. Yet discussions with my colleagues found that they placed the programme as a drama or comedy drama, with many seeing it as the former rather than the latter. This is not to suggest that the programme results in generic confusion; everyone I've discussed the programme with appears to have a clear understanding of how the programme should be read in terms of genre. But it does show how individual viewers read programmes in different ways and the number of factors that such categorisation relies on; the ways in which audiences make sense

of genre will be discussed in Chapter 5. It also shows that sitcom is a *flexible* category, just as all genres are.

Sitcom Flexibility

While the flexibility of genres has been repeatedly noted when 'newer' forms of broadcasting, such as reality television, appear, this is less apparent in the analysis of genres whose characteristics seem 'self-evident'. Yet the current attempt to define and make sense of new genres mirrors the ways in which sitcom was thought about when it first developed. Sitcom arose from the broadcasting industries' desire to make comedy programmes using existing stars, most of whom came from the stage and had worked in vaudeville in America and the music-hall in Britain (Marc 1989: 28–33; Neale and Krutnik 1990: 209–33; Murray 2005; Stober 2007). Broadcasting simply imported those stars' acts wholesale, which meant that early television comedy resembled a 'video approximation of theatre' (Marc 1996: 11). Yet the serial nature of broadcasting created two problems: firstly, that material which could be toured around hundreds of venues on the theatre circuit was used up in one go when broadcast; secondly, that acts which made sense in the one-off encounter of the theatre seemed shallow and repetitive in the domestic, serial arena of television. Comedy performers, therefore, slowly developed recurring characteristics, back stories, sidekicks and settings which allowed audiences to develop a more in-depth relationship with the characters and exploited the serial nature of broadcasting. The sitcom did not arrive on television as a fully-fledged form, and instead mutated out of other types of broadcasting, bringing together the realist settings and narrative structures of drama and the performance styles and audience interaction of theatre. Indeed, in its early days sitcom adopted a number of forms and structures, showing how it worked fruitfully as a flexible genre. Widely regarded as some of the earliest American exponents of the genre, both *The Jack Benny Program* (CBS/NBC, 1950–65) and *The Burns and Allen Show* (syndicated, 1950–8) incorporated a wide range of material not usually included in a classic definition of sitcom, such as vaudeville performances, direct address to the camera, a disregard for plot and a refusal to create characters distinct from the performers' personalities; as Lewisohn notes for *The Burns and Allen Show*, 'Despite the domestic setting, and the sitcom trappings and plots involving neighbours and family, the couple still seemed to be playing a sophisticated stage routine' (2003: 130). In Britain, *Hancock's Half-Hour* is usually regarded as the first successful home-grown sitcom, in which

characteristics such as character, narrative and performance were fully in place (Goddard 1991; Wall 2007). Yet to present history in this way is to engage in a retrospective reading of the genre, ignoring other less well-known programmes which might fruitfully demonstrate the flexibility of sitcom as a genre.

For example, the history of British sitcom is often traced through 'classic' series such as *Steptoe and Son*, *Porridge* (BBC1, 1974–7), *The Good Life* (BBC1, 1975–8), *Fawlty Towers* (BBC2, 1975–9), *Yes, Minister/Yes, Prime Minister* (BBC2, 1980–8), *Only Fools and Horses* (BBC1, 1981–2002), *The Vicar of Dibley* (BBC1, 1994–2007) and *The Royle Family* (BBC2/1, 1998–2000, 2006, 2008). It's worth noting how all of these series were broadcast by the BBC; ITV sitcom has rarely received the attention it might deserve, and it's telling that Catherine Johnson and Rob Turnock's (2005) volume celebrating fifty years of the broadcaster does not mention sitcom at all. As a commercial broadcaster, which has often styled itself as 'the people's channel' (Cherry 2005), ITV has produced many sitcoms, though few of them are given the 'classic' status afforded to BBC productions. While Mark Lewisohn sees *Rising Damp* (1974–8) as 'ITV's finest and most enduring sitcom' (2003: 653), he calls the long-running and highly rated *On the Buses* (1969–73) 'vulgar' (592) and the similarly successful *Mind Your Language* (1977–9) is called '*very* dodgy' (517, italics in original) because of its portrayal of various ethnic minorities. Making qualitative judgements about media forms is always problematic, but it's apparent here that ideas of 'good' and 'bad' sitcom are in some way related to different channels, and the BBC has certainly been more successful at presenting its heritage of programming as 'classic' in a manner untried by ITV. The fact that academic analysis of the sitcom has similarly focused on BBC output also shows how examination of the genre is filtered through contexts outside of the texts themselves.

While it's impossible for the analysis of any genre to cover all related programmes, the study of sitcom has rarely seen the examination of series which might be difficult to place generically as central to its remit. So, a programme such as *Kelly Monteith* (BBC2, 1979–84) was broadcast in Britain at the time that the sitcom was a prevalent and successful genre, and even though its placing on BBC2 meant it reached a particular rather than mass audience, its domestic setting and shooting style places it within 'classic' sitcom. The programme is about a stand-up comedian making sense of his life and so mixes stand-up routines to camera with scripted scenes which dramatise the events being discussed; it can therefore be seen as a precursor to programmes such as *It's Garry Shandling's Show* (Showtime, 1986–8)

and *Rob Brydon's Annually Retentive* (BBC3, 2007–). For sitcom analysis this might be seen as problematic as it mixes two different kinds of programming. Yet, as has been shown, this interplay between stand-up and scripted drama was the essence of sitcom at its inception and, for a short while, the dominant way in which performed comedy was structured on television. It's significant that programmes such as *Rob Brydon's Annually Retentive* are now broadcast on the more niche BBC3, showing how that which was 'normal' for a genre during its initial development soon becomes experimental once genre definitions and analysis become more 'settled'.

Wes D. Gehring organises comedy in a different way, arguing that there is a 'clown genre' (1997: 1) which can be read in terms of character and performance rather than aesthetics, narrative or 'metadrama'. For Gehring, comedy is signalled through characters defined by six characteristics: shtick; physical/visual gags; incompetence; nomadism/outsiderness; sidekicks; downtrodden background/upbringing. According to this analysis, the format or structure within which comedy exists is less important than the need to signal a character is intended to be read as comic in the first place. These characteristics help distinguish comedy characters from serious and/or tragic ones, all of whom might have some of these attributes but not all. It's quite straightforward to apply this schema to many characters, such as Basil Fawlty, Homer Simpson, Victor Meldrew and Lucille Ball. In noting that comedy must be signalled as such, Gehring makes a useful point about genre, which reiterates its value as encouraging certain kinds of reading practice. However, in avoiding elements such as narrative and aesthetics, he posits comedy as a broader category within which a range of possible formats exist. Comedy can, then, be seen as a mode of expression rather than a form, and sitcom is only one possible way in which that mode can be articulated within broadcasting. Acknowledging the modal links between sitcom and other comedy genres might, then, offer useful insights into the ways in which its characteristics draw on and influence those of other forms.

Nick Lacey (2000: 137) instead offers six aspects of genre which can be used to examine all aspects of it: setting; character; narrative; iconography; style; stars. For some genres some of these aspects are more important than others, and these differences are one of the ways in which categories are distinguished. It might be argued that character and narrative are the most important attributes of sitcom, and the classic definitions of it clearly draw on these ideas. What about the other factors, though? While the domestic nature of sitcom has been noted in Chapter 1, it's apparent that a wider range of settings

is available for sitcom than many other genres. So, while the setting is essential to the Western, sitcom can be set in many locations, such as the past – *The Black Adder* (BBC1, 1983) – or in space – *Red Dwarf* (BBC2, 1988–99). Sitcom also draws on a star system, and certain performers are associated with comedy and the promotion of new series relies on such connotations; the careers of people such as Ronnie Barker, Dawn French and Bill Cosby attest to this. However, that star system may not be as apparent for television as it is for cinema, and there certainly hasn't been an industrial generic production line in television to match the classical Hollywood system (deCordova 1990; McDonald 2000). The star system has been explored in terms of comedy via 'comedian comedy' (Seidman 1981), which argues that humorous texts are often nothing more than loose narratives whose purpose is to display the comic talents of a particular star. While sitcoms named after certain stand-up performers – such as *Roseanne* (ABC, 1988–97), *Sean's Show* (C4, 1992–3) and *The Sarah Silverman Program* (Comedy Central, 2007–) – show that comedian comedy is one form of sitcom, it certainly does not account for all of it. So, while sitcom does draw on a star system, it is not as prevalent as might be the case for some genres, and there are plenty of series without an obvious 'star' at all.

What might open up debates about sitcom and the study of it as a genre is the consideration of issues such as iconography and style. Iconography is difficult to spot for sitcom, and it certainly does not have as rigid a repertoire of props and visual elements such as those which can be listed for science fiction (Wolfe 1979; Cornea 2007) and the Western (French 2005). Yet, in stretching the definition of iconography, we could examine the stings (short pieces of music to link scenes) and incidental music within sitcom to show how these signal generic intent. Timothy E. Scheurer (2008) shows how important music is to genres, helping to define them not only textually but also positioning audiences emotionally towards specific texts. Barry Curtis notes the '"bright" montage style introductions' (1982: 5) sitcoms conventionally have, and such cues are vital at the start of programmes in order for audiences to place programmes generically. Yet sitcom also often uses music within an episode, though in ways quite different to other genres. While soap operas and dramas might use incidental music which 'transforms the viewing experience from a purely observed (viewed) . . . thing to a felt thing' (Scheurer 2008: 20), the music in sitcom is rarely employed for emotional purposes. Instead, music stings signal the transition between scenes and often accompany exterior shots of the location within which action is about to take place;

perhaps the most obvious use of this device is the slap-bass within *Seinfeld* (NBC, 1989–98), which is so iconic it was deliberately over-used in the British parody *I'm Bland . . . Yet my Friends are Krazy!* (C4, 1997). However, stings accompany many kinds of programming, most notably quiz shows and news programmes, and fulfil a similar, if not identical, function. Furthermore, lots of more recent sitcom has abandoned the use of such stings, demonstrating that it is not a necessary component of sitcom as a genre.

To think about style is also to examine the ways in which sitcom is shot. The shooting style for sitcom developed in its early stages in response to the genre's theatrical roots and attempted to capture such performance in a manner suitable for television. The 'classic' form of sitcom shooting is generally seen as the 'three-headed monster' (Putterman 1995) developed by the cinematographer Karl Freund for *I Love Lucy* (CBS, 1951–7). Freund used three cameras to capture a scene involving two characters: the first covered a wide, establishing shot while the other two were each mid-shots of each performer. These shots allowed for fast editing between the two performers in any conversation scene, and also meant that the text offered as much weight to reaction shots as it did to those of speech. It was Freund that first noticed how important the reaction shot is to comedy, for two reasons. Firstly, in seeing a character's astonished reaction to the behaviour of another character, the audience is cued into reading such behaviour as abnormal and, therefore, comic. Secondly, while a shot of comic behaviour would get a laugh from an audience, a subsequent shot of a reaction to that behaviour would get another laugh, meaning that a programme could get two laughs from the same joke. This shooting style placed viewers in a position 'from which the operations of the narrative and the "points" of the jokes make sense' (Curtis 1982: 9), and the rhythm of the editing often supported the fast nature of much comic dialogue. This can still be seen in more recent series such as *Will and Grace*, where fast cross-cuts between speedy, short lines of dialogue create what might be called a 'comic rhythm'. While much contemporary sitcom might have abandoned some of these characteristics, this has merely resulted in different ways of capturing similar elements; both the British and American versions of *The Office* (BBC2/1, 2001–3; NBC, 2005–), for example, repeatedly employ reaction shots, even if, within their diegesis, these are captured accidentally by the documentary camera crews purportedly filming those locations. Similarly, as *Peep Show* (C4, 2003–) uses point-of-view shots to place the audience in the same position as its characters, this simply means that reaction shots are face-on to the audience, and their

comic importance is still paramount. As has been shown, then, there might be something which we can term 'sitcom style', and it may be this characteristic within Lacey's (2000: 137) list which is of the most importance when considering sitcom generically.

Sitcom Hybridity

The fact that sitcom can be signalled in a variety of ways is a consequence of its comic impetus; as Steve Neale and Frank Krutnik note, comedy 'seems especially suited to hybridization' (1990: 18). For Neale and Krutnik comedy is a 'mode', and the genres which employ it – such as the sitcom – are simply particular narrative structures and aesthetic styles told through that mode. By this analysis, there is nothing to define comedy other than its comedy-ness, even if comic genres have developed characteristics and conventions which help signal the mode. These signals will be explored in Chapter 4, where it will be argued that examining the ways in which comedy is 'cued' is perhaps the most useful approach for thinking about how sitcom texts work.

Noting that sitcom is amenable to hybridity is not the same as pinpointing those programmes which are difficult to place within genre. *Sex and the City*, for example, draws on traditions of television and cinema, demonstrating the porous relationship between the two media (Creeber 2008: 84). Sitcom hybrids, on the other hand, draw on more than one conventional genre, offering the pleasures of multiple forms which have traditionally been seen as discrete. *The Kumars at No. 42* (BBC2, 2001–3), for example, draws on the conventions and pleasures of both the sitcom and the chat show. It concerns the fictional Kumar family, who just happen to have built a television studio in their back garden from which Sanjeev broadcasts a chat show. This chat show is real and conforms to that genre's 'unspoken rules' (Timberg 2002: 3); the guests are themselves and are asked questions about their lives and 'lay experience' (Thornborrow 2001: 117) in a similar manner to that used on 'conventional' chat shows such as *Parkinson* (BBC1, 1971–82, 1998–2004; ITV 2004–7) and *The Late Show with David Letterman* (CBS, 1993–). However, the Kumar family are played by actors, and the programme offers comic pleasure in the interactions between them. We see the backstage planning for the chat show as Sanjeev's family prepare food for the guests, and these segments are scripted and have the aesthetics of traditional sitcom. While the programme has similarities with *The Larry Sanders Show* (HBO, 1992–8), it is more obviously a hybrid because, unlike in *Larry Sanders*, the programme does not suggest that the interviewees know what is coming next, nor

are they playing a purely scripted role. That is, *The Kumars at No. 42* offers the kind of access to stars and celebrities which viewers are likely to search out in chat shows: this is not on offer in *The Larry Sanders Show*, which instead offers the pleasure of seeing well-known faces willingly go along with scripted performances which play with their celebrity status and identity. *The Kumars at No. 42* therefore retains a link with the factual, 'real' aspects of chat shows, and so offers a range of pleasures which are conventionally associated with different kinds of programming.

This blurring of the distinctions between factual and fictional programming can be seen in many other programmes too. For example, Nick Lacey defines *Driving School* (BBC1, 1997) as a 'docu-sitcom' (2000: 226), which is a hybrid between the sitcom and the docusoap, which itself has 'hybrid qualities' (Kilborn 2000: 112). Kilborn notes that the success of docu-soaps on British television in the 1990s led to changes in the way in which drama was shot as well as the kinds of subjects and characters it focused upon (117); in doing so it found a way to marry the informational and factual aspects of the 'traditional' documentary with the pleasures of soap opera and sitcom. While the soap-like nature of series such as *Driving School* has been noted (Winston 2000: 54), the sitcom aspects they adopted have been less commonly explored. Most significant is the way in which such a programme signals itself as entertaining; that is, while maintaining the kudos applicable to factual broadcasting, *Driving School* offers audiences the pleasures of comedy. This is most noticeable in the ways in which reaction shots appear in the programme. As has been noted, the 'three-headed monster' shooting style of sitcom was effective because it married the need for directors to capture the action with the desire to signal moments as comic through reaction shots. A series such as *Driving School* places much emphasis on its participants' reactions. The star of the show is Maureen Rees, whose driving mistakes make up much of the programme; vital to the pleasure of the programme, however, is Maureen's husband's reactions to her behaviour, as he yells at her as she performs a dangerous manoeuvre, his exasperated face matched by his screaming voice. The reaction shot helps signal the programme as comic, and in the inter-cutting between action and reaction *Driving School* adopts an aesthetic common to the sitcom, cueing audiences into a comic response to events.

Such reaction shots are vital to other forms of programming too, such as talent shows and other programmes using 'ordinary' members of the public. The singing competition *The X-Factor* (ITV1, 2004–), for example, showcases the auditions of both good and bad singers,

and, through the reaction shots of the judging panel, makes clear which auditions are to be read as comic. As we see the contestants sing, the programme repeatedly cuts to shots of the judges, who might be nodding in admiration or attempting to stifle a giggle. It's clear that audiences at home would likely be able to judge whether a singer is good or not without such prompting from the judges; indeed, the later stages of the programme require audiences to make such judgements and vote accordingly. The inclusion of the reaction shots in the auditions is narratively redundant and serves the purpose instead of framing what we are witnessing as comic or serious. The inclusion of the judges as an audience is similarly unnecessary; we could simply be shown the auditions. The judges, however, function in a manner similar to the studio audience of the sitcom, and their laughter and other responses have links to sitcom's laugh track which helps cue a moment as funny. There are, then, as many similarities between such talent shows and the sitcom in *The X-Factor* as there are between documentary and the sitcom in *Driving School*; however, the latter has been explored in terms of this relationship whereas the former hasn't. This is presumably because in its mixing of the factual and entertainment, *Driving School*'s hybridity more obviously transgresses the 'fact/fiction divide' (Beattie 2004: 146) integral to genre classification; *The X-Factor*'s utilisation of sitcom tropes, however, is understood as a logical progression for entertainment programming. In these ways, certain kinds of genre mixing are defined as hybridity while others might instead be seen as simply a development or a progression.

This interplay between reality television and the sitcom can also be seen in *The Osbournes* (MTV, 2002–5). Jonathan Bignell classifies *The Osbournes* as a 'Reality TV sitcom' (2005: 162), while Derek Kompare calls it a 'reality sitcom' (2004: 99); both of these classifications neatly coalesce the two different forms of programming. The aspects of *The Osbournes* which align it with sitcom concern both content and aesthetics. In its domestic setting and interest in the interplay between family members, *The Osbournes* covers similar terrain to many sitcoms; indeed, via its narratives which show that while families may annoy and anger one another they will, in the end, come together to support each other, *The Osbournes* has a morality with noticeable similarities to the domestic sitcom which characterised the early years of the genre. The programme aligns itself with such programming in its opening titles, where each of the family members is introduced in terms of the familial relationship, with Ozzy Osbourne, for example, 'playing' the role of 'the dad'. These opening titles take stills of each family member and place them in photo frames, which similarly defines each person in a

familial role. Like the programmes cited above, *The Osbournes* places a lot of emphasis on reaction shots, finding humour in the ways in which each family member, as well as the family's employees, respond to the 'outrageous' behaviour the family finds 'normal' because of their rock-star lifestyle. In contrast, however, the programme also finds funny the incongruity between such a lifestyle of excess and the very mundane and everyday behaviour of much of the family, with arguments about food, pets and television. In that sense, *The Osbournes* becomes compre-hensible as comedic through its use of the everyday, domestic aspects of its narratives, and the shooting style and opening titles help place the programme within the genre of sitcom, thus cueing audiences into finding aspects of it funny. Like the programmes cited above, it there-fore adopts the format and tropes of a fictional genre in order to make comprehensible content which has been garnered through techniques associated with factual programming. In doing so, it is therefore indic-ative of the problems that repeatedly arise when trying to categorise genres in a manner which suggests their boundaries are not porous.

The Sitcom as an 'Obvious' Genre

In a postmodern age in which media and cultural texts are defined by 'hybridity' (Casey et al. 2008: 136), generic 'mixing' (Mittell 2001: 7) and 'mutations' (Turner 2001: 6), the analysis of sitcom has often remarked on the genre's remarkable rigidity and straightforward-ness. So, while it's commonly argued that long-standing boundaries between information and entertainment have blurred (Biressi and Nunn 2008; Riegert 2007), and reality television draws from a range of genres (Murray and Ouellette 2004: 19–116; Holmes 2008), analysis of sitcom has usually assumed that its characteristics remain apparent and unchanged, arguing that it is one of the most obvious and consist-ent television forms. Barry Curtis calls sitcom a 'self-evident category' which has a discernible 'formula' (1982: 4). While this analysis was carried out over two decades ago, similar critiques have been offered in more recent work; John Hartley, for example, calls sitcom 'remarkably stable' and argues that it has undergone 'few fundamental changes' (2001: 65) since its inception, while W. James Potter notes we 'have no trouble recognizing the character types' (2008: 197) of sitcom. Joshua S. Wachman and Rosalind W. Picard select sitcom to test technol-ogy which can analyse television images because its 'characters have distinctive movements' whose 'mannerisms are exaggerated' (2001: 257), showing that the performance styles within the genre is so dis-tinct it can be recognised by computers. By these accounts, sitcom is,

therefore, a readily recognisable genre whose key characteristics are apparent and straightforward.

Because of this, sitcom is a useful form of programming for thinking through the concept of genre, as the complexities which beset a range of other forms are assumed to be absent. This means that any sitcom can be selected at random and the qualities which define it as 'sitcom' will be apparent and tangible, with a notable lack of confusion about how to make sense of it. Indeed, while it's clear that many people have spent much time thinking through how to define a number of television forms, the sitcom has not been blessed with such an approach. This suggests that even though it's worthwhile examining the generic characteristics and boundaries of the documentary (Beattie 2004; Ward 2005), 'quality' drama (Jancovich and Lyons 2003; McCabe and Akass 2007) and reality television (Holmes and Jermyn 2004; Bignell 2005; King 2005), the sitcom does not lend itself to such analysis because of its assumed transparency.

This assumed transparency is demonstrated by broadcasting regulators' rulings on sitcom. For example, the British broadcasting regulator, Ofcom, received thirty-five complaints about the swearwords 'shag', 'crap', 'bollocks' and 'tits' in *After You've Gone* (BBC1, 2007–8), broadcast in January 2007. The episode was originally broadcast at 8.30 p.m. on a Friday, but was repeated two days later at 5.10 p.m., and it was the second broadcast which engendered the complaints. The viewers complained that while the language may have been acceptable for the first broadcast, the second was at a time when many children might be watching and that this was therefore an inappropriate use of language. While Ofcom took the context of scheduling into account, it's noticeable that genre also played a significant part in their ruling. So, the original broadcast was deemed to be acceptable because of 'the editorial context of the programme, a light-hearted comedy' (Ofcom 2007b: 12–14). The BBC, in its response to the complaints, supported the use of the words because of their 'comic effect'; similarly, Ofcom notes that its research shows that audiences are willing to allow such language if it is within a 'comedic context', and so does not uphold the complaints. In defining programme acceptability in terms of genre, both Ofcom and the BBC assume that what sitcom is, and how it is understood by audiences, is a fairly straightforward matter. This shows how genre functions as a 'cultural category' (Mittell 2004: 1–29), which both producers and consumers can draw upon. Furthermore, such a ruling ignores the idea that genres might change, or be read differently by different audiences. Indeed, in ruling that the content of *After You've Gone* was acceptable, Ofcom denies the alternative

readings of the programme made by those viewers who complained; for Ofcom, the generic specificity of the series trumps the particular and specific readings made by a small number of people. In that sense, these viewers are defined as having made a *wrong* viewing and the offence they felt is rejected. Ofcom would not be able to make such a ruling unless it insisted that the sitcom is a recognisable and coherent genre and its adjudication clearly assumes that audiences should similarly be able to make such judgements.

The marketing of sitcom is similarly structured around genre, whether this is for programmes being broadcast or merchandise such as DVDs. Listings magazines make it clear the genre programmes belong to, and the first information given about series on accompanying websites such as radiotimes.com is genre; in this way, an episode of a programme such as *Will and Grace* (NBC, 1998–2006) is described under the heading of 'sitcom'. Blurbs on the back of DVDs similarly make such claims and there's interesting work to be done on analysing the aesthetics of DVD design and it relationship to genre. For example, the BBC uses a standardised design format for its packaging of the 'best of' compilations of what it calls 'classic sitcoms', which includes such series as *Steptoe and Son* (BBC1, 1962–74), *Hancock's Half-Hour* (BBC1, 1956–60) and *Sykes* (BBC1, 1972–9). Each of these DVD covers sports an image of the main performers in the top two-thirds and a coloured banner across the bottom third with the programme's name, a very brief description of its contents and the 'classic comedy' logo. In the simplicity of its design, such packaging attempts to foreground the 'classic' nature of these series, eschewing the brash, colourful covers of many entertainment DVDs. More significant, though, is that in adopting a house style for all these DVDs, their producers situate them squarely within genre (sitcom) and, more than that, what may be seen as a sub-genre ('classic comedy') which defines them as being of historical and generic importance. The assumption here is that a consumer might come to recognise such design as signalling the kinds of sitcom they prefer, which assumes buyers define their tastes generically too. And in the simplicity and regularity of their design, these products lend themselves to 'curatorial consumption' (Tankel and Murphy 1998), becoming a *collection* of DVDs rather than simply an accumulation of them; for the consumer they become products in which 'capital, desire, and identity converge' (Hillis et al. 2006: 1).

The marketing and analysis of new series similarly places programmes within genre. This process, however, rarely makes explicit what constitutes a genre's characteristics, and instead demonstrates how a programme belongs to a particular genre by comparing it to

other programmes assumed to belong to that genre. For example, Jack Dee, the star and co-writer of the British series *Lead Balloon* (BBC4, 2006–), was mocked at the *British Comedy Awards* (ITV, 13 December 2006) for too closely basing his series on the American series *Curb Your Enthusiasm* (HBO, 2000–); the audience cheered this accusation, clearly comfortable with placing both series within the same genre. Similarly, the blurb on the back of the DVD of the first series of *Coupling* calls it 'the British *Friends*', a comparison which has dogged the series since it began. It's clear that audiences make such comparisons and use them in order to select new programmes. This is shown in the entry for *Coupling* on www.tv.com, where one American reviewer notes that 'if you like *Coupling*, you'll like *Friends*'. Running throughout such statements is an acknowledgement that genre is a useful tool for selecting programmes from the mass of options on offer, which shows how categorising series becomes a vital technique for making sense of broadcasting as a whole. However, it's also important to note that such statements rarely pinpoint the *differences* between such series, and so instead work from an understanding of genre that is more interested in the ways in which programmes are similar than how they are not. This means that even though genres work through 'repetition and difference' (Neale 1980: 48), the former has far more often been the focus of scrutiny than the latter.

Television Channels and Genre

This idea of similarity and repetition can be seen in the ways in which channels organise themselves too. The development from broadcasting to narrowcasting (Bennett 2005: 91) has involved the movement from a range of genres and types of programming attempting to reach a mass audience to broadcasters having to '[a]ccept the fact that *niche* is the new normal' (Harris 2008: 93, italics in original). One of the first channels the BBC joint venture UKTV broadcast was UKTV Gold, which showed repeats of a mix of genres such as drama and sitcom. Yet UKTV quickly spawned a number of channels, all of which signalled their generic specificity in their names; UKTV Documentary, UKTV Drama, UKTV Food and so on. For Jonathan Gray, this shows how television is understood through 'paratexts', which are 'all those elements surrounding a text that are not perceived as wholly *of* the text' (2008b: 37, italics in original). A channel devoted purely to comedy and sitcom never appeared, even though UKTV G2 (formerly UK Gold2) always broadcast a lot of comedy. That channel was rebranded in 2007 as Dave, in what has been seen as one of the most successful rebrands

of a television channel in British broadcasting history; the channel share of 16–24 year olds rose from 0.6 per cent to 2.6 per cent within a month of the change, even though the majority of the schedule was not altered (Ofcom 2008a: 153). Dave broadcasts comedy and entertainment programmes such as *Red Dwarf* (BBC2, 1988–99), *Never Mind the Buzzcocks* (BBC2, 1996–), *I'm Alan Partridge* (BBC2, 1997, 2002) and *Dead Ringers* (BBC2, 2002–7), and signals its comedic aspects in its slogan; 'the home of witty banter'. There are clear assumptions about the kind of audience which is interested in comedy, here; the name 'Dave' gives the channel a masculine focus, while 'witty banter' suggests not only masculine chatter, but also something which is slightly more sophisticated in its humour than 'jokey banter' or 'funny banter'. In making connections between comedic programming and masculinity, the channel confirms a wealth of research which suggests humour is gendered (Cantor 1976; Levine 1976; Pollio and Edgerly 1976; Barreca 1992).

Other channels similarly signal their comic intent; the names of Comedy Central and Paramount Comedy place their programming within genre and cue certain kinds of expectations in their viewers. It could be argued that this system is necessary within a multi-channel environment, as viewers need simple cues in order to make decisions between the wealth of options on offer. What's significant here, though, is that these distinctions are generically formed. It's rare for other possible categorisations to be taken into account; while children's television takes the age of the viewer as its defining principle, it's uncommon for channels for adults to similarly cue their demographic in such ways. In addition, while some regional programming exists in most broadcasting systems (though this is usually a consequence of regulations rather than market forces), television channels rarely signal where their audience is, and instead assume a geographical unity which conforms to Benedict Anderson's notion of 'imagined communities' (1983). This means that while television may be a system which brings people together, it's quite comfortable with dividing such communities generically, and the assumption that those people who like comedy might not be the same kind of people that like, say, documentaries is something the market (though not public service broadcasting) takes as read. This is despite research which shows audiences' desire for mixed-schedule programming and 'plurality' in television, either because of the merit of this for citizenship (Ofcom 2008: 8) or because it demonstrates value for money (Anstine 2001). Genre therefore works to divide mass audiences into demographically defined consumers.

The fact that channels are often predicated on genre specificity shows how discrete such categories are assumed to be. That said, the 'rules, norms and laws' (Neale 2000: 32) which help define all genres may be seen as more apparent and more confining for sitcom than is the case for other categories. This could be seen as a consequence of the specificity of humour, that is that comedy only works if it is uncomplicated and clearly signalled as humorous. Certainly, the characteristics which often define the traditional sitcom – the laugh track, the performance style, the convoluted plotting – all add up to a genre whose intent is signalled within every aspect of the text, from its aesthetics, to its narrative, to its relationship to its audience. Yet, as Chapter 6 on the future of sitcom demonstrates, the genre has recently begun to adopt different aesthetics, abandoning many of the characteristics which perhaps most clearly signal its comic intent. Despite this, audience confusion has rarely been reported, and sitcom has demonstrated that it can attain its comedic goals without employing those characteristics which not only most clearly define it, but which were also assumed to be essential for a programme's success. What this suggests is that those characteristics are artificial and unnecessary, which then raises the question concerning their prevalence and survival. In essence, why is television sitcom a genre which is so clearly marked, and what can this tell us about the functions humour plays in our society?

So, what is a sitcom?

This chapter has shown the difficulties in defining the sitcom as a genre; it has also suggested that such difficulties are apparent for all genres, and are not indicative of anything particular about the sitcom. The examination of hybrids shows how the conventions and characteristics of the sitcom can be employed by a range of other media forms, suggesting that these are not exclusive to it. Rick Altman argues that genre hybrids are often seen as problematic because they undermine cultural value (1999: 4); that is, in blurring distinctions between cultural forms, hybrids are seen to ignore categorisations which help define cultural hierarchies, suggesting a wilful disregard for how culture is 'traditionally' and 'conventionally' understood. It is therefore unsurprising that in the debates about the mixing of sitcom and factual forms it is the sitcom which is seen to have tainted the documentary rather than the other way round; this shows how the sitcom is perceived to be a less valuable form than factual programming, and its interest in the comedic is seen to undercut the 'serious' intent of documentary. It's worth examining, then, *why* factual programming chooses to engage

in such hybridity when, in doing so, it opens itself up to criticism about cultural worth. Central to all the hybrids discussed above is their intention to be found funny; that is, while they may also aim to fulfil other purposes such as informing audiences, they demonstrate a comic impetus which results in the adoption of sitcom characteristics.

This means that the sitcom can be most usefully defined as *a form of programming which foregrounds its comic intent*; these characteristics are so aligned with the genre that when other programming signals its desire to be read comedically it often becomes defined as a sitcom hybrid. The comic impetus of the sitcom is therefore its most obvious and significant genre characteristic, and it is one which can be employed by other genres for similar purposes. The other aspects of sitcom which are commonly noted in definitions of it – its length, its domestic setting, its character types, its shooting style – can therefore be understood as conventions through which that comic impetus is expressed and demonstrated rather than tropes which define and characterise the genre. In understanding the sitcom as genre, then, we need to think through the ways in which its comedy works, seeing its other conventions as results of that impetus rather than its causes. To place 'comedy' at the heart of debates about sitcom as a genre might seem reductive and tautological: on the contrary, this is the aspect from which all other characteristics of the sitcom arise.

3 Industry

I work in comedy because I've not really done anything else. I can't put up shelves and I can't garden. I have no other skills, so it's a survival technique for me.
(Henry Normal 2005)

As a stand-up comedian and writer, as well as managing director of the independent television production company Baby Cow Productions (co-established with Steve Coogan), Henry Normal has been involved in the production of series such as *Human Remains* (BBC2, 2000), *Marion and Geoff* (BBC2, 2000–3), *Saxondale* (BBC2, 2006–), *The Mighty Boosh* (BBC3, 2004–) and *Gavin and Stacey* (BBC3/1, 2007–). He is therefore a highly qualified and well-respected industry figure, with much experience and an impressive ability to work with new talent. Yet, in the quote above, he refers to his abilities as nothing more than a 'survival technique', suggesting that working in comedy only came about because of a lack of ability to do anything else. This chapter examines what it is that those who work within the sitcom industry do, as well as exploring the ways in which the industry is talked about, especially by those who work within it. It does so through detailed analysis of interviews undertaken with members of the British terrestrial television comedy industry (see appendix for full details). As will be shown, many comedy professionals refer to their work and abilities in this self-deprecating manner for, as the sitcom writer Brian Dooley put it, 'there's a fear with comedy that if you intellectualise it too much you get away from just being funny' (2005).

In analysing the ways in which industry professionals talk about their work and the industry that employs them, this chapter aims to show that understandings of genre can be deepened through industrial analysis. If genres are cultural contexts within which texts make sense, then those who produce programmes must similarly use genre in order to make sense of what they do. This is not to prioritise the

statements of industry professionals as necessarily 'correct', or to imply that in order to find out what sitcom 'is' all we have to do is ask those who make it. But it is to show that those who write, produce and direct sitcoms have an awareness of the contexts within which their output circulates, and this context is one which is likely, therefore, to influence their working practices.

These contexts are various and specific, and the interviews drawn upon here give access only to a partial view of how the industry works. For example, the interviews include only those working in the British industry and so the findings may be difficult to apply to nations with other production models. Todd Gitlin (1994) draws on industry interviews in his overview of the American broadcasting industry, and encounters with similar creative personnel can be found in William F. Fry and Melanie Allen's *Creating Humor* (1998) and Robert Kubey's *Creating Television* (2004). Such interviews are methodologically problematic because of the relationship between interviewee and interviewer; the selection procedure I've employed in deciding what material to include and exclude in this chapter means that what the interviewees said is inevitably skewed to fit the needs of my argument, no matter how ethically I've tried to use the data (Mills 2008b). The aim in this book is therefore not to give an exhaustive, definitive overview of industry practices; it is instead to show how genre is a category within which industry personnel function, contributing to the 'cultural system' (Beals et al., 1967: 5) within which their work is situated.

Indeed, genre is integral to the analysis of the television industry because, in the vast majority of countries, programme production is categorised generically. In Britain, all of the major broadcasters have programme commissioners and commissioning structures defined by genre. Such categorisations clearly make assumptions about audience needs and employee ability, and help 'demarcate "entertainment" from such areas as drama, sports and news' (Tunstall 1993: 138). Co-production between these categories becomes problematic, in both budgetary and organisational terms. Sitcom personnel usually spend all of their careers working on comedy and entertainment, while employees from, say, factual television rarely stray into the realm of comedy. This means that genre is, the world over, the dominant schema by which television production is organised.

While there's a logic to such structures which assumes employee expertise, the categorisation of creative personnel into genres could be seen to place limits on the possibilities for experimentation in television. As will be shown in this chapter, all of the writers, producers and directors I interviewed saw themselves defined purely in terms of

comedy; this may be seen as odd for someone like Simon Nye who has also written drama programming such as *Pride* (BBC1, 2004) or Steven Moffat who has written the drama *Jekyll* (BBC1, 2007) and episodes of the reimagined *Doctor Who* (BBC1, 2005–).

The television industry is also organised into channels, and this is another way in which comedy programming can be categorised. For much of its history, for example, the British commercial channel ITV has defined itself as 'the people's channel' (Cherry 2005), and this has been reflected in 'working-class' (Wagg 1998: 10) sitcoms such as *On the Buses* (1969–73), *Rising Damp* (1974–8), *Up the Elephant and Round the Castle* (1983–5), *Bottle Boys* (1984–5) and *Benidorm* (2007–). The BBC, on the other hand, has been seen as more comfortable portraying middle- and upper-class sitcom settings, such as those in *The Good Life* (BBC1, 1975–8), *To the Manor Born* (BBC1, 1979–81), *Absolutely Fabulous* (BBC2/1, 1992–6, 2001–4) and *My Family* (BBC1, 2000–); this is despite the working-class settings of series such as *Steptoe and Son* (BBC1, 1962–74), *Only Fools and Horses* (BBC1, 1981–2003) and *The Royle Family* (BBC2/1, 1998–2000, 2006, 2008). In accordance with its remit to 'champion alternative voices and fresh perspectives' (2008: 2) and be 'the most ethnically diverse of the major channels' (17), Channel 4 has broadcast sitcoms featuring under-represented groups, and, in *No Problem!* (1983–5) and *Desmond's* (1989–94), has broadcast the only successful British sitcoms with black casts. Channel 4 has repeatedly attempted to experiment with the sitcom format leading to formally inventive series such as *Spaced* (1999–2001), *Peep Show* (2003–) and *Green Wing* (2004–7) (Greig 2008). In America, networks have similarly defined themselves by their comedy: Fox marked itself as different from the existing networks through sitcoms with black performers such as *In Living Color* (1990–4) and *Roc* (1990–4) (Zook 1999: 5) while Lisa Williamson shows how HBO's rejection of the traditional sitcom aesthetic in series such as *The Larry Sanders Show* (1992–8) and *Curb Your Enthusiasm* (2000–) 'acts as a badge of prestige that helps differentiate each show from its network competitors' (2008: 109). Sitcom is therefore a useful genre by which competing channels can demarcate themselves, drawing on the pleasures the genre offers while utilising aesthetics or content which differentiate *types* of sitcom from one another.

The multi-channel era has required broadcasters to distinguish themselves from one another even more, for they cannot rely on audiences having an understanding of the kinds of programming associated with them. The BBC's expansion into digital television, with the addition of BBC3 and BBC4, has offered new markets for sitcom, but it's apparent that the content of these is quite strictly defined. The

difficulties that new programmes face in garnering large audiences on the mainstream BBC1 mean that series are often tested on BBC2 first and are moved to BBC1 once they have built up a significant audience; this happened with *Absolutely Fabulous*, *The Royle Family* and *The Office* (BBC2/1, 2001–3). BBC3 appears to have become the channel which houses programmes deemed too experimental even for BBC2, with programmes switching to BBC2 or BBC1 once successful; the sketch show *Little Britain* (2003–6) moved from BBC3 to BBC1 for its final series, *Gavin and Stacey* has done the same and the sci-fi drama series *Torchwood* (2005–) had, by the end of its third series, been on BBC3, BBC2 *and* BBC1. BBC3 has therefore become a training ground for new writers and performers and contains many slots for one-off comedy pilots; similar slots used to be on BBC1 and BBC2, as in the *Comedy Playhouse* (BBC1, 1961–74) series and anthologies such as Ronnie Barker's *Seven of One* (BBC2, 1973). Indeed, as Heads of Comedy at the BBC, both Jon Plowman (2005) and Sophie Clarke-Jervoise (2005) noted that the idea that no new comedy should begin on BBC1 has been mooted within the Corporation, with the intention of giving all series a chance to develop an audience on the less mainstream channels before having to face the 'glare' of the BBC1 audience.

The awareness of channel identity is shown by many in the British television industry, and it's clear that programmes are restructred and reinvisaged once it becomes apparent on which channel a series will be broadcast, as this example from the comedy producer Bill Dare (2005) shows:

> I did a show called *Mr Charity* [BBC2, 2001]. That was created with such high principles and high expectations, because we really thought we were tackling something that had never been tackled before, which was charity. And we thought we would expose it for being actually, full of, often quite selfish people. And it was really aimed at being a really quite hard-hitting satire. Because it was originally destined for BBC1 we thought, 'Well, let's sugar the pill, and have two dotty old ladies in the charity shop, and have a lot of *Carry On . . .* humour with them bringing out dildos and not knowing what they are, and condoms, and thinking the condoms are chewing gum and all this kind of thing. And we thought this is going to be the perfect show; you've got hard-hitting satire, popular slapstick, fantastic. Everyone hated it. I think it got the worst reviews of any show on television. . . . It was originally destined for BBC1, it looked like a BBC1 show, it felt like one, but BBC1 thought it was too edgy. So BBC2 took it. And it never really became a BBC2 show.

It always looked like a BBC1 show, which is one of the reasons it didn't work.

The production process outlined here is one in which audience assumptions are defined by channel as well as by genre, with 'slapstick' and '*Carry On* . . . humour' deemed appropriate for a BBC1 audience. Of course, it is impossible to know whether the programme would have been more of a success if it had been broadcast on BBC1 – it may be the case that there are comedy topics for which no suitable channel exists. The working of genre here can be seen to be circular; audience expectations derive from knowledge of a channel's typical output, yet this output is itself a response to perceived audience expectations.

The idea that 'channels want a particular type of comedy to be identified by' (Dooley 2005) can be demonstrated through analysis of the British broadcaster and programme-maker, Five. This channel began in 1997, but only started comedy production, in conjunction with the American producer Paramount, in 2004. Graham Smith was appointed as Commissioning Editor for Comedy in 2004 and, when I spoke to him, he noted how he had to make it clear to prospective programme-makers that the channel desired to produce comedy that was notably different from that of other broadcasters:

> The only way it can work is . . . you have to lay down rules. You know, don't bring me a sitcom set in an office for obvious reasons. Or in a hospital, because in the past few years there's been *Green Wing*, there's a BBC1 sitcom in a hospital [*Health and Efficiency* (1993–5)] and a BBC2 one [*TLC* (2002)]. It's just like, 'do something else'.
>
> We have to try and find an original area to work in. Just because if I did a sitcom set in an office it would be, 'Yeah, it's not *The Office* though, is it?' And so don't go down that route. Or in a pub, just because of *Early Doors* [BBC2, 2003–4] and *Two Pints of Lager* . . . [BBC2/Choice/3, 2001–]. Don't set something in a pub, you know; let's do something *different*.

This notion of difference is a significant one, and it shows the ways in which sitcom, as a genre, works through repetition and difference (Neale 1980: 48). Smith's remit resulted in the sitcoms *Respectable* (2006) and *Suburban Shootout* (2006–7); with the former set in a brothel and the latter about gun-toting housewives, the idea that Five's programmes should have a setting unlike existing series had clearly borne fruit. Furthermore, both series adopted a single-camera shooting style and did not contain a laugh track, giving them a look which marked

them as distinct from traditional sitcom. The notion that channels and broadcasters new to comedy production might necessarily invest in series with a marked difference from existing programmes suggests the free market of multi-channel broadcasting could be a spur to generic experimentation; on the other hand, in order to be read as sitcoms programmes must signal their comic impetus as clearly and quickly as possible, drawing on known generic conventions to do so. This means that genre remains the organising principle for series which try to foreground their novelty; to be *too* different is to cease to be sitcom at all. By this account, genre is read through audience understandings of broadcasters and programme-makers, and this means 'reputation offers the most reliable guarantee of viewer appeal' (Havens 2006: 6).

Working Practices

Television sitcom is an industrial product, resulting from the interactions between the creative processes of individuals, the specifics of organisations and institutions that employ them, and the genres and conventions which inform mass communication. Yet the stages that make up sitcom production mean that different players in that process fulfil quite different roles, even though genre remains the overarching principle which organises such labour. For example, writers such as Simon Nye (2005) and Steven Moffat (2005) pointed out the lonely nature of writing, in which self-motivation is the most important personality trait. While commissioned by large institutions such as the BBC and ITV to write sitcoms, the actual moments of labour that writers carry out are usually conducted alone and outside of traditional workplaces; they write at home. Producers and commissioners, however, often work in-house, employed by a broadcaster or production company to develop and make a range of programming, and therefore their labour is often carried out within an institution. This distinction was shown by the locations my participants suggested for their interviews; the majority of writers met me in their homes, while the majority of producers and commissioners met me in their offices. What this suggests is a geographical and institutional division which marks television sitcom production and which many participants were happy to uphold; while many of the producers and commissioners I spoke to saw their role as one which was defined by the organisation they worked for, writers, on the other hand, appeared to find pleasure in their distance from such corporate pressures, placing the creative process as one best carried out in a less institutional space. The writer, producer and director Andy Hamilton (2005), for example, noted that

not being permanently employed by a broadcasting institution meant that he could develop projects which meant something to him while simultaneously maintaining control over their development and production. That a multitude of individuals should be able to engage in a range of working practices whose cumulative output is nevertheless recognisable as 'sitcom' shows the dominance of genre and the normalised working practice of the creative community which produces them.

This is not to suggest, however, that television production industries are the same the world over. For example, it has been noted that while American television prioritises the producer (Pearson 2005), 'In the British context especially, television has been considered a writer's medium' (Bignell 2007: 158). The start of British sitcom was seen by all my interviewees as the inspiration and ideas which emanate from the writer, showing how 'Creativity in such an environment, tends to get reified' (Berkeley 2003: 104). As Sioned Wiliam (2005), the Controller of Comedy at ITV, put it:

> Always the script, always the script. [. . .] Believable, rounded characters, a narrative thrust that makes me want to know what happens next, dialogue that sparkles, a distinctive writing style, something that is surprising occasionally, something that feels original, that has its own internal logic, that makes you feel that the world exists in a very rich and complex way. It doesn't always translate to the screen, but those are the things that I look for.

Indeed, producers appeared keen to note that their job was simply to ensure that the 'vision' and 'idea' of the original script was translated faithfully and appropriately to the screen. In that sense, the role of the producer was seen as a less creative one than that of the writer, and producers usually spoke of their jobs as if they were facilitators rather than creative personnel in their own right. This is not to say that the job of production is not a creative one; indeed, in being the ultimate arbiter in decisions about casting and choice of director, producers clearly work from a 'vision' of the programme which can only be achieved if this can be adequately expressed to all of those involved in its production. Yet while the British television system reiterates a discourse in which the writer is the ultimate creative worker, it is producers who are employed on long-term or permanent contracts, with writers usually having to sell their ideas and scripts to broadcasters on a piece-by-piece basis. Of course, this has not always been the case in British broadcasting, and in its early days the BBC sometimes employed writers as an 'in-house corps' (McCann 2006: 97), not least

in order to prevent them working for the commercial ITV. This movement to 'casualization' (Murdock 2003: 22) means that much of the sitcom production in the British system relies on writers producing scripts with the hope of them being bought; that is, carrying out labour for which there may be no reward. This can be seen as emblematic of contemporary global economic models, in which 'the risk regime involves an individualization of work' (Beck 2000: 70) which renders collective labour practices an exception rather than the rule. This is not to deny the ways in which producers search for writers and offer support and advice for those working on ideas, but it is to note that broadcasting's organisational structures are ones which assume writers will do work that they may never get paid for.

In making decisions about scripts and ideas that are 'worth' pursuing, writers, commissioners and producers draw on expertise and knowledge which is generically inflected. The 'rules' which govern good sitcom go some way towards defining the genre, and creative personnel clearly draw on such tendencies or norms in their creative process. Jon Plowman made clear that such 'rules' inform his decision-making process when he reads a new script:

> So, comedy's about surprise, and there are certain rules you can observe and when you see that they haven't been observed, you therefore go, 'Ooh, we shouldn't make this'. What are they? Comedy's about character, it's not about jokes, so I will quite often say to writers, 'Look, just take the jokes out and see if it still works'. I think there has to be a deeply serious thing in there as well. If you look at all the great sitcoms, there is a fundamental question to answer which is, 'What's it about?' And what it's about should be something quite straightforward and serious. *Fawlty Towers* [BBC2, 1975–9] is about a man who, wherever he is, his aspirations will never be met by the world. He could be running the Ritz, and he'd still be upset by the customers. *Absolutely Fabulous* is about a mother looking after a daughter and a daughter looking after a mother. *The Office* is about life in an office run by somebody who's incompetent. There has to be a fundamentally serious thing which is the thing, if you like, that gives it legs.

The idea that comedy is about character rather than jokes is one often applied to British sitcoms, and Jeffrey S. Miller (2000: 139–68) notes the difficulties Norman Lear had in transferring this approach in series such as *Steptoe and Son* (BBC1, 1962–74) for American audiences. Yet this works from a particular notion of what a 'joke' is; here it is defined as a self-contained piece of humour which doesn't necessarily rely on

its context for its funniness. In encouraging writers to remove 'jokes' and see if the programme still works, Plowman is working from the assumption that the resulting script will still be 'funny', but that its humour will rely on context and characters specific to that script. That is, the resulting script will still contain jokes, but ones which work in a different way from those which he asks to be excised. The distinctions between such kinds of humour can be seen as central to the genre characteristics of the sitcom; while stand-up and the sketch show may contain self-contained jokes which are less reliant on context and character, the fact that sitcom has recurring characters and locale encourages humour which draws on these for its funniness. Indeed, in asking 'what's it about?', Plowman places the location and relationships between the characters at the core of sitcom, both narratively and in terms of its humour. This mirrors the quote from Sioned Wiliam at the start of Chapter 2. It's noticeable that in his descriptions of the programmes he mentions, Plowman describes what they're 'about' without explaining why such settings or relationship should be funny or lend themselves to humour. In that sense, acknowledging the sitcom must be based on a premise that has 'legs' does nothing to reveal why such a premise would lead to comedy. So even though the sitcom is a genre defined by its predilection for humour, the industry which produces it sees that outcome as best achieved through character, narrative and setting rather than jokes. This further demonstrates that the sitcom is a genre which can be defined as having a comic impetus, and that this is not the same as saying everything in a sitcom must be funny.

This question of what a sitcom is 'about' is one which is asked by audiences too. Simon Nye (2005) discussed the confused reaction audiences had towards *Carrie and Barry* (BBC1, 2004–5) because Barry had an ex-wife whose role in the programme was never made fully clear. He notes that, 'You're not supposed to leave social complexity lying around because you'll just trip over it'. Bill Dare (2005) put it another way:

> One of the most important things about any comedy is that it has to be clear. One of the reasons why jokes don't work is that people don't understand them, they don't get them. They're not phrased in an immediate enough way. There's a wrong signal there somewhere. So clarity is absolutely crucial.

Comic failure is something relatively unexplored in the academic literature on humour, even though 'any theory of humour, jokes and comedy which does not have the principle of potential failure

built into it, as one of its fundamental axioms, is a defective theory' (Palmer 1994: 147). After all, there is a long and distinguished heritage of comedies which failed to elicit the desired response in audiences, and the industry regularly acknowledges that 'all hits are flukes' (Bielby and Bielby 1994: 1290). The notion of 'clarity' was one expressed by a number of interviewees and demonstrates the necessity for programmes to express their generic affiliations. While this clarity can be related to the 'social complexity' Nye refers to, it can also be thought of as a generic one, in which programmes must convincingly signal their comedic intentions for their humour to be successful: failure to do so might result in generic confusion, which itself undermines the processes within humour. Even though these interviewees did not use the word 'genre', their assumptions about clarity are indicative of programme categorisations, which result in normalised expectations for sitcom in both audiences and programme-makers. It also shows how the comic impetus of sitcom is central to the industry's working practices, for here creative personnel are making decisions which are 'correct' for the jokes within comedy to work as well as possible.

Ensuring that clarity is apparent in sitcoms meant that many professionals had developed strategies which they adopted during their working processes. Most of these were presented in an anecdotal way, and certainly didn't amount to anything as defined as rules or formulae. That said, the producer Stephen McCrum (2005) noted for *Two Pints of Lager and a Packet of Crisps* that he and his writers were 'quite logical in our approach to storytelling', ensuring that each episode had a question or problem raised early in the narrative in order to pique viewers' interests. They therefore always constructed episodes around three questions; 'one silly question, one hard question, and one kind of emotional question'. Here McCrum is offering a version of storytelling which conforms to ideas of conflict and resolution and which means sitcom has 'always the same basic structure' (Jones 1992: 3), with narrative drive motivated by the desire for the characters and the audience to find a solution. This idea that a sitcom script has a structure which each episode must conform to was noted by many writers. For example, Simon Nye (2005) noted that he knew if an idea for a new series would work 'if I can write ten plots very quickly'. Here, the notion of the plot is placed as more important to the construction of the sitcom than the jokes or the characters, even though the interplay between all of these facets is important to a programme's meaning. The need to quickly develop a number of plots is, of course, a consequence of the serial nature of the sitcom, in which each episode

requires a set of narratives which utilise the regular characters and setting; without this, a comedy becomes a one-off, seen as either a pilot or a single comedy-drama. This demonstrates the ways in which genre conventions can arise from the needs of the industry that produces and broadcasts it, showing how genre is not purely a textual element. The serial nature of broadcasting logically lends itself to certain kinds of storytelling, which itself is likely to be best achieved with particular kinds of characters and settings. The sitcom is therefore not just narrative comedy that happens to be on television; it is rather narrative comedy whose norms and expectations are the result of the interplay between humour and the specifics of broadcasting. This shows how examining the industry which produces television can illuminate the range of factors which contribute to what is understood to constitute a particular genre.

The Pleasures and Difficulties of Working in Sitcom

Considering that so many in the television industry 'have to develop strategies for dealing with rejection' (Hamilton 2005), and the long and convoluted processes involved in making television programmes, the question arises as to why so many would continue working in it. This is particularly the case for writers, directors and actors, who are rarely on permanent contracts and so must perpetually develop new ideas to maintain employment. Such motivations were various, but for all interviewees a deep enjoyment and admiration for comedy was clear; the writer Paul Mayhew-Archer said he 'absolutely adored sitcom, and adored talking about it' (2005), while Susan Nickson insisted that all people who work in sitcom are 'comedy geeks' (2005). For the producer Sophie Clarke-Jervoise pleasure was to be found in unearthing new writers, and receiving scripts that exceeded expectations. For writers such as Simon Nye and Andy Hamilton the creative process of coming up with ideas and working out how to make them succeed was a key motivation. For producers such as Stephen McCrum and Bill Dare, pleasure came from getting a programme finally broadcast, as well as the privilege of being permanently employed to make comedy programmes, which they both described as 'lucky'. Sitcom and comedy have often been discussed in terms of their pleasures (Bakhtin [1965] 1984; Herbert 1984; Mills 2005: 139–43), but these have usually been understood as textual elements enjoyed by audiences. These interviews, on the other hand, show that the pleasure of sitcom can also reside in its construction and therefore the pleasures of genre don't necessarily require audience assent.

Yet concomitant with such pleasures are the *dis*pleasures caused by a whole range of factors, many of them institutional. This relationship between the elements of the creative process and the industrial and organisational structures within which such activity takes place is summed up by Andy Hamilton (2005):

> I like the collaborative process of making programmes. If you get a chance to make something and you're working with a crew and artists and an editor, I enjoy all of those things. I enjoy the writing phase, and then the execution of it, filming it, recording it, whatever, and then the editing, if it's a show that has editing, I enjoy that as well. Exploring the plasticity of what you've made. It's always interesting. It always throws up new things. Like anything, you know, experience only tells you so much, it doesn't tell you everything. You still find things out. So I enjoy it. It's having to work in television that I don't like. Because the gruelling side is not the making of stuff. It's the getting it on and getting it out there.

This makes clear the distinctions between the collaborative and ongoing nature of television sitcom production and the organisational pressures necessary to broadcasting. That is, *making programmes* is different from *getting programmes broadcast*; the former is a creative process, while the latter is an industrial and economic one. This means that thinking through genre in terms of the industry needs to acknowledge the sequence of processes which any creative endeavour goes through. Discussing television requires exploration of both the processes by which programmes get made and those which ensure broadcast; these two processes are linked, but not one and the same. As Chapter 6 shows, newer technologies have allowed people wishing to make sitcoms to do so outside traditional broadcasting structures, for programmes can now be distributed online. The fact that one of the industrial processes through which all sitcom has hitherto had to travel can now be avoided is a useful testing-ground for debates about genre, for if this leads to mutations in the sitcom this demonstrates that industrial processes have a significant impact upon the conventions of a television form such as the sitcom.

A recurring theme within the displeasures that many interviewees recounted concerned reviews. Sioned Wiliam noted that 'within the critical world comedy is greeted with disdain' and that critics 'use "sitcom" as a pejorative term' (2005). Recurring within such discussions was the realisation that critics had fairly little understanding of the ways in which sitcom is made and how it can be thought about. Clarke-Jervoise remarked that many critics deride the use of canned

laughter in sitcoms, even though, for most programmes, 'it isn't canned laughter because there's an audience there' (2005). For many interviewees, critics' failure to use terms 'correctly' was indicative of the lack of expertise of such writers and, worse, their refusal to gain expertise in a subject which they are paid to write about. There appears to be a mismatch here between what critics and television industry personnel perceive criticism to be *for*; certainly many interviewees made clear the extra work which had been required of them in order to deal with bad reviews and the ways in which such writing had an effect upon the industry and those who worked within it.

Such an analysis acknowledges that 'television critics occupy an important role in the production and circulation of cultural goods' (Lotz 2008: 21). That is, critics contribute to the ways in which programmes are understood and, as their views are recorded in print, become part of the ways in which programmes are remembered. This means critics are one of the ways in which understandings of genre are circulated, even though there is no requirement for critics to be representative of audiences and bad reviews may not in any way marry with low viewing figures or a lack of audience pleasure. While broadcasters collate various kinds of responses to their programming and have a number of standards – both commercial and social – by which programmes are judged, it's clear that what is written about programmes is a highly visible way in which a series might be understood and evaluated. Such understandings also have an effect upon what kinds of programmes are produced. Getting good reviews is one of the ways in which series with low viewing figures can continue to be made and can help broadcasters define their output as worthwhile. The problem, of course, is that critics are not representative of the populace, nor do they necessarily see their job as reflecting widespread views on programmes. Instead they exist within 'taste cultures' which, in her analysis of Dutch comedy, Giselinde Kuipers demonstrates are 'always strongly linked to identity and the drawing of social boundaries' (2006: 375). Many interviewees cited *My Family* as an exemplar: it is a highly-rated, long-running programme with respected actors which popular audiences respond to but which had been dismissed by critics from the outset because it is highly 'traditional'. While the extent to which critics have an effect upon programme production is debatable, it stands to reason that their visibility is likely to influence future creative decisions. That is, if critics repeatedly lambast traditional sitcom, it would not be surprising if less of it is made; this shows how what constitutes the genre can result from elements outside of the text.

Furthermore, interviewees felt that sitcom made for mass audiences was inevitably criticised by critics, while more niche, experimental, untraditional fare was lauded, no matter whether it was actually funny or not:

> There's a real snobbishness about audience sitcom. And because you're making it for as broad an audience as possible you get criticised for dumbing down. (Clarke-Jervoise 2005)

and:

> I think comedy is really important but it is, particularly within the critical world, greeted with almost complete disdain, unless it is perceived to be something that is pushing the envelope. So therefore if it is obscure, if its form is seen to be something substantially different and innovative – usually I have to say it isn't particularly innovative and it's usually mock documentary or understated naturalism – critics perceive that as something different and original, whereas in fact there is a long tradition of that going back, not just in television, but film-makers like Ken Loach and Mike Leigh have been doing it for decades. But critics like that sort of thing; what they can't bear is the notion that comedy might be entertaining more than a million people, and the thought of doing a kind of situation comedy or a sketch show that actually brings in a large group of people is anathema to them. Whereas I think it's a very serious and a wonderful aspiration to want to entertain a lot of people and I don't think you should necessarily do that badly, I think you should be able to do that rather brilliantly. (Wiliam 2005)

While 'The most obvious aspect of criticism is evaluation' (Watson 1985: 67), the distinctions made between different kinds of comedy are precisely those which Pierre Bourdieu sees as evidence of the 'cultural capital' (1979: 12) by which 'our cultural knowledge can be translated into resources such as wealth, power and status' (Longhurst et al. 2008: 179). Furthermore, the fact that critics such as F. R. Leavis (1933) see culture made for mass audiences as evidence of 'cultural decline' mirrors arguments that 'art and cultural consumption are predisposed, consciously and deliberately or not, to fulfil a social function of legitimating social differences' (Bourdieu 1979: 7). For many interviewees the desire to make programmes was predicated on them reaching as large an audience as possible, and while they all acknowledged the wish to make programmes which were good 'art', they did not see a distinction between this and mass audiences. The anger which resulted from the discussion of critics therefore has two causes: critics' failure

to 'understand' programmes correctly, and the critical discourse with equates 'popular' with 'poor quality'. In adopting such a position, many interviewees placed the popular as a worthwhile aspect of cultural production, and this was not predicated solely, or even predominantly, on commercial factors. The ire over critics' responses resulted from a mismatch in assumption about what comedy and television are *for*, and this leads into debates about the social value of genres such as the sitcom.

Social Value

The academic analysis of television often works from questions of the social value of the media and the worthwhile uses mass communication can be put to. Public service broadcasting commonly assumes that television can be a place where 'people gather together as *citizens* to discuss matters of common interest' (Barlow and Mills 2009: 399, italics in original), which Jürgen Habermas called the 'public sphere' ([1962] 1989). Comedy continues to have a problematic relationship with public service broadcasting; Berkeley notes that all formats and genres occupy a position in a 'moral hierarchy' (2003: 106), and this means questions are repeatedly raised about the value of spending public money on entertainment. That said, BBC research shows that audiences feel that comedy makes an 'important contribution to the distinctiveness' (BBC 2008a: 22) of the Corporation's output; this might be the case especially because funding and slots for sitcom on ITV, for example, have diminished in the last decade. In that sense, the BBC remains a place where large amounts of comedy, purported to fulfil the needs of different sectors of the community, are made, showing that the sitcom is perceived to be of social worth. Indeed, the centrality of comedy to the British notion of public service broadcasting could be seen to reflect an assumption that a sense of humour is fundamental to the British notion of national identity (Easthope 2000). This is not, of course, to say that humour is not vital to other nations or communities, but it is to say that 'Britishness' is one of the few national identities in which humour has a 'central importance . . . in culture and social interactions' (Fox 2004: 61).

This relationship between comedy and society is something which those in the sitcom industry value highly. Interviewees repeatedly made claims for the social value of humour, and often cited this aspect when justifying their work. This could be read as nothing more than industry workers claiming value for their labour, even though this seems a rather churlish reading of the committed justifications many of the interviewees made for the production of comedy. The writer and

producer Henry Normal (2006), for example, made an impassioned case for the social consequences of mass, mainstream humour and the ways it can bring societies together:

> I would say comedy definitely does have a social impact and partly it's about values, it's about saying what's right and wrong with values and showing what a shared value is. And partly it's about power. For example, we're trying to do an Asian sitcom at the moment, and the reason why we're trying to do it is because I've seen the script and it's very funny. However, the extra benefit of that is that if you see people from different backgrounds and you look at them and you go, 'Well they're basically like me' and you laugh with them, therefore you give yourself over to them and you're saying that you like them. You don't just respect them, but you like them, which I think is a different thing. I think it does create a very cohesive civilisation.

This notion of 'shared values' has resonances in the BBC's remit to 'sustain citizenship and civil society' (BBC Trust 2007a) and to 'bring people together for shared experiences' (BBC Trust 2007b: 1). Normal offers here an 'imagined community' (Anderson 1983) in which a sense of 'us' is developed not only through laughing together, but also through a realisation of similarities. Yet such 'banal nationalism' (Billig 2005) can also be criticised for it assumes social norms which are usually defined by the powerful majority, and the values of minorities or less powerful communities are downplayed. Television must inevitably work in this way because of its national structures, even though regional programming goes some of the way to alleviating some of these issues. However, the links being made here between 'entertainment and utopia' (Dyer 1981) conform to 'the hope of a better world, and a better society, [which] has been present in popular culture throughout the twentieth century' (Hesmondhalgh 2002: 241). Significant in Normal's analysis of the social value of comedy is his distinction between 'respect' and 'like', with 'liking' having a stronger sense of shared values and community and of interaction than the rather distanced and objective 'respect'. While criticisms of sitcom are often predicated on the notion that they spread misunderstanding and ridicule (Olson and Douglas 1997; Littlewood and Pickering 1998; Brassfield 2006) rather than respect and liking, the idea that comedy can be a force for good shows the sitcom industry works to quite a different agenda than that of academic analysis, which demonstrates the value in examining the discourses within which creative communities function. It also shows that the definition of 'sitcom' which the creative community works from is one which incorporates an idea of social

worth, and this mirrors the ideals espoused by the broadcasting industry in the UK as a whole. There is a relationship here, then, between the regulatory structures within which the genre is produced and the kinds of programmes that are made, which suggests that regulation and policy have a clear hand in categorising genres too.

That said, this was the most impassioned case for the public value of comedy in all the interviews. For many, comedy's purpose was its entertainment value, for 'it's a gloomy, grim world and any small effort to reduce that is worth it' (Nye 2005). The value being attached to the sitcom here is one of enjoyment and pleasure rather than one more avowedly political and radical. Indeed, for many interviewees discussing the social worth of comedy was rather troubling, and they seemed wary of appearing to aggrandise something as 'trivial' as comedy. The writer Susan Nickson said she would never use sitcom to 'preach to young people about their aspirations' (2005), and found the idea that comedy might explicitly play this role to be quite reprehensible. So while the importance of laughter was reiterated in these interviews, this was repeatedly done within a discourse of embarrassment which inevitably acknowledged the 'frivolity' of the sitcom project. It is difficult to imagine people working in the newsrooms of television broadcasters having similar reluctance to demonstrate the purpose of their endeavours, which shows how sitcom as a genre is defined by assumptions about its social worth as much as it is by its textual elements.

Furthermore, it was noted by many how their output was deemed of less importance than that made by other broadcasting departments. As Andy Hamilton (2005) noted:

> I have a sort of chippiness about comedy. I remember being at an award ceremony once and there was some grandee from one of the broadcasters doing a little talk, an address beforehand. And he said, 'These awards are here to acknowledge and celebrate the whole spectrum of TV writing, from drama all the way down to comedy'.

Many interviewees had similar stories to tell, though they often added caveats to such statements. For a start, a number made it quite clear that as far as the broadcasting institutions were concerned, comedy was a vital part of their output, for a number of reasons. This is firstly because of audience need; Plowman noted that 'When the BBC does surveys about what the audience wants, news and current affairs come first . . . and comedy comes second.' Secondly, this is because, as noted above, comedy is a useful way for channels and broadcasters to define themselves and to construct a relationship with audiences. Finally, comedy is highly valuable as a product. It can be sold all over

the world, either as a format which another programme-maker can produce (Moran and Malbon 2006) or as a completed programme which another broadcaster can transmit (Steemers 2004). Sales of comedy DVDs are commonly higher than those of other television genres; *The Office*, for example, is 'the record holder for the fastest-ever selling DVD of a non-film title' (Roberts 2006: 34) in Britain. Sitcom is therefore certainly seen as a valuable *product* which neatly responds to both the commercial and public service demands of broadcasting. Yet none of these approaches take into account a *social* value for comedy or see it as having a purpose beyond either making money or pure entertainment. As Julian Petley notes, current broadcasting regulations in the UK mean that audiences are seen as 'citizens to be educated and informed as well as consumers to be entertained' (2006: 42): the notion that citizenship can be related to entertainment is thus regulated against. This may explain why many interviewees were comfortable discussing their work within an industrial and commercial context, as well as a domestic one, while they were clearly far less used to examining the cultural, political or social value of their labour. This is perhaps unsurprising, for writers who exist outside of institutions are constructed by the industry as 'merely' workers required to demonstrate 'flexible specialization' (Amin 1994: 16) in order to maintain employment.

This can be equated with the expansion of independent production companies in Britain in response to the start of Channel 4. Sylvia Harvey notes the complex social and political factors which led to the inauguration of Channel 4 in 1982, and its aim to be an experimental channel was mirrored in its innovative production structure; it was 'to commission or "publish" programmes, not to make them itself' (1990: 93). This led to the explosion of independent television production companies in Britain, many of which were set up and run by comedians, and comedy writers and producers. For example, TalkBack was founded by Mel Smith and Griff Rhys Jones, Hat Trick was founded by Rory McGrath, Denise O'Donoghue and Jimmy Mulville, while more recent companies such as Baby Cow (Henry Normal and Steve Coogan) and Jones the Film (Rob Brydon) continue this trend. Stephen Armstrong sees this development as one which ushered in a whole new range of comic performances and topics for British television, which 'contributed to an attitude change across the nation' (2008: 73) and rejected comic representations which had been central to the television sitcom for decades. What sitcom was therefore mutated in response to regulatory changes. Dorothy Hobson notes the complex and contradictory nature of structuring television production and broadcasting in

this way, for while the independence of creative workers means they aren't overpowered by 'faceless bureaucracies' (2008: 20), it also means they remained 'individuals' rather than collaborative workers.

As 'free agents' (Deuze 2007: 188), television professionals were thus encouraged to engage in 'a set of competitive institutional relationships' (Cottle 2003: 170) when they might previously have worked together. This is not to diminish the value associated with working in smaller companies and having some control over work, especially as 'Comedy series lend themselves particularly to that sort of ownership' (Nye 2005). But smaller production bases inevitably place pressures on those who work within them which differ from those of the larger broadcasting institutions. As Graham Murdock notes, 'independents are in the vanguard of casualization, insecurity, and the accelerated turnover of personnel' (2003: 25). Indeed, Ash Amin notes that such production structures came into being in the global economy in the 1970s in response to economic downturns across the world (1994: 15), and the economic model chosen for the funding of Channel 4 in 1982 should therefore be unsurprising. Janice Turner states that 'Today at least half of the [British television] industry's workforce is freelance' (2006: 76), which means job insecurity has become an industry norm. The fact that comedy has been one of the success stories of independent production can be seen as an indicator of the freedom and autonomy now on offer in the British television market: on the other hand, it could be seen as evidence of the lowly value placed upon entertainment, for it's less likely that genres and programming deemed of essential social worth would be opened up to market structures characterised by what Mark Deuze calls 'precarity' (2007: 20). So while Henry Normal (2006) sees comedy as essential to democracy because 'If people feel better they're probably better citizens', current industrial structures 'subordinate social policy to the needs of labour market flexibility and/ or the constraints of international competition' (Jessop 1994: 263). This means the global broadcasting industries don't lend themselves to programming, or worker behaviour, which consciously acknowledges the links between entertainment, the state and the public. For thinking about sitcom as a genre, this shows how matters of regulation, industry, text and society are linked and contribute towards how a genre such as the sitcom is understood.

'A Special, Lovely Job'

The roles that workers in the sitcom industry see themselves playing feed into debates about professionalism. As Gillian Ursell notes,

'Aspiring to and being treated as a professional is one major way in which individuals can claim an entitlement to practise a high degree of autonomy in their employment: they are the experts and they know best' (2006: 155). Yet the piecemeal nature of the working practices of many such people means that professionalism and expertise become commodities which support the sale of a product rather than an item seen to have social value. So while Steven Moffat noted that 'If you have any kind of success, in anything vaguely humorous, then people will be coming to you for more comedy', this remains a notion of expertise which is valued for its ability to get work done rather than for any kind of social purpose. Yet while broadcasting institutions such as the BBC and Channel 4 listen and respond to the expertise of such workers, the organisational structures of those institutions remain outside the remit and control of those who are forced to work within their strictures. The sense of professionalism which resides within the 'creative class' (Florida 2002) is thus one defined by its productive capacity alone, and this mitigates against such expertise having a wider social value.

It is therefore significant that the majority of the interviewees were confused by questions I asked about their professionalism and how they define what they do. Analysis of journalism has often distinguished between its status as a job, a career or a profession, with 'profession' having the implication of highly skilled workers carrying out activities with clear social values (Burns 1977; Hallin 1997). The complex and thoughtful process which many interviewees went through in attempting to define their activities is best demonstrated through this answer from Simon Nye (2005):

> I don't think 'career' works, really, as a word for it. I suppose careers are always dependent on other people, you can't decide your own career. It feels like you're so at the mercy of other people's decisions in this job that the word doesn't fit, because careers, to me, involve planning and steps and progression and promotion. Yes, promotion, maybe that's the key word that's lacking. I'm happy with 'job', actually, I think. I'm just trying to think what the implications are of the word 'profession'. The connotations are of being part of a club and earning the right to be in it, and one of the good things about this is suddenly you can do it. And 'profession' doesn't seem quite the word. [. . .]
>
> So, 'job'. But a special, lovely job. The best job.

While the term 'job' may suggest labour with less expertise than that defined as a 'profession', it is here understood in a different manner,

for many interviewees were adamant about their knowledge and skills which had been garnered through experience and work. For this reason, Bill Dare (2005) rejected the words 'job', 'career' and 'profession' and insisted instead on the word 'vocation'. Henry Normal (2006) called himself and his colleagues 'craftsmen', but added that the ways in which he would define his labour responds to specific activities and needs:

> Partly we're artists, so you want the product to have an artistic merit, and certainly I think you've got to start from that basis that you want to put some beauty into the world, you want to put something of worth into the world.
>
> Then I would say, people like to think of themselves as craftsmen, so you're crafting something and you want it to be crafted to the highest degree. This doesn't apply to everybody in the industry, but it certainly applies to us.
>
> And then after that you are opportunists and if somebody says, 'Here's ten thousand pounds, do us ten minutes about Wales' we will try and do it, because we want ten thousand pounds and you know, there's bound to be something funny we can do with ten thousand pounds and ten minutes about Wales.
>
> So you start from the basis of being an opportunist to actually get the money to do it. But beyond that you then try to be artistic and you try to be a craftsman. So it's sort of balance between all of them.

Running throughout such a statement is a negotiation between the financial aspects of media production and the desire to produce programmes which have some 'worth'. Similarly, Charlie Higson (2008) noted that his career as a comedy writer was a pragmatic response to the British government's Enterprise Allowance Scheme, which allowed unemployed people to set up businesses while claiming benefits.

This shows how 'Successful organizations . . . are successful because they focus on the possibilities . . . constraints leave open for their activities and develop practices which capitalize on them' (Berkeley 2003: 114). Indeed, Normal made clear that a consistent motivation was the attempt to do new and different things with comedy, and to give skilled and upcoming creative people a place within which their 'artistry' was protected. Similar statements were made by Beryl Vertue (2005), the founder and chairman of the similarly successful Hartswood, who bemoaned programming that didn't have a 'heart'. Running throughout the interviews was a sense that creative personnel saw making 'good' programmes as more important than making

'successful' ones, even if there was a desire for these to be equated. Furthermore, as Normal's quote above shows, such desire to create 'art' was knowingly filtered through an awareness of the financial and commercial needs of broadcasting, resulting in 'opportunist' activities which helped support other creative acts. In these ways, the creative process is constructed within a generic and institutional framework, and this framework is one which encourages a sense of craftsmanship in order for individuals to feel that their labour is valued. This is unsurprising considering 'Studies among media workers generally show how creative work is experienced as intensely personal because it is often an expression of the self' (Deuze 2007: 195). In these ways, debates about genre are downplayed relative to the personal relationship an individual has with a project they're working on.

It also seemed that many individuals found problematic describing themselves as 'professionals' because they didn't feel they had the knowledge and expertise which the term connotes. That is, professions are often predicated on lengthy and standardised training procedures, resulting in qualifications which are deemed an industry standard (Roberts and Dietrich 1999). Yet no such qualifications exist for working in comedy and none are required. Instead, workers learn by 'osmosis' (Clarke-Jervoise 2005) with a sense of craft passed down through generations and among colleagues. This is highly significant for debates about genre, for osmosis can only work if there is social understanding of the conventions of cultural forms which can be 'picked up' by those who encounter it enough. This means that programme-makers 'learn' what sitcom is, how it is made and what is expected of it, and, in doing so, inevitably produce texts with marked similarities to those common in the genre. Indeed, it is the fact that the genre of sitcom is learned by osmosis rather than by education or training that means interviewees could repeatedly make light of their own expertise and acknowledge that their judgements were highly fallible. When pressed on how their creative decisions were made, all interviewees resorted to 'gut instinct', and not only insisted that the processes they employed couldn't be categorised or defined but found even the idea of doing so problematic. This helps maintain the discourse 'within the cultural industries . . . that cultural work is special and mysterious and can only be understood by special and mysterious people' (Beck 2003: 3). Such an approach neatly mirrors the idea that analysis of comedy is something which destroys its pleasures, and that responses to humour are instinctive and unconscious. Yet this was also an act which repeatedly denied the experience and expertise which all such creative personnel had clearly

amassed over time and the critical faculties they brought to bear on their own working practices. For example, Andy Hamilton (2005) dismissed as 'common sense' the advice you don't write programmes with 'eight dozen sets and 47 characters' because of the logistical and financial problems this would cause; this was despite his surprise that many aspiring writers don't realise this. Similarly, while Graham Smith (2006) acknowledged that his decisions were not made on an 'uneducated gut instinct' because he had some knowledge based on his past experiences, he still insisted that 'gut instinct' formed the core of his professional activities. While such language helps maintain the 'mystery' of comedy, it also, unhelpfully, repeatedly devalues the knowledge and expertise which clearly informed the decisions and actions carried out by all interviewees. This means that while a number of books purport to offer the skills necessary to be a successful sitcom writer (Wolff 1996; Byrne and Powell 2003; Sedita 2005; Bull 2007), the industry personnel I interviewed instead reiterated the idea that the necessary abilities were simply 'talent', often failing to acknowledge the skill and expertise they had amassed during their careers precisely because sitcom is a genre which is perceived to be 'obvious' and 'knowable'.

Of course, through use of terms such as 'artist', as well as the valorisation of the 'gut instinct', the comedy industry clearly does acknowledge the abilities of those who work within it and the value such work offers. Yet these aspects remain highly nebulous, without the certainty and support engendered by the notion of such work being part of a profession or the security which is associated with permanent employment and long-term contracts. It is perhaps for this reason that so many interviewees acknowledged the luck and fortune which had guided their career, and discussed the belief that anyone could do what they do. In doing so such workers repeatedly devalued their own skills and the worth such labour has; indeed, in defining such labour as 'art' the positive aspects of professional labour are inevitably rejected. While this may be the case for all creative labour, the fact that this work is being carried out within the socially devalued area of comedy means there is little incentive for the professionalisation of the industry. The notion that any expertise such personnel have is fleeting and unspecialised is best expressed by Sophie Clarke-Jervoise (2005):

> I'm sure I'm not alone in feeling that somebody is going to come up to me and say, 'I'm sorry, but you're the wrong Sophie, we thought you were somebody with qualifications. How the bloody-hell have you got that job?'

Sitcom and the Television Industry

The television comedy industry can be seen as a microcosm of broadcasting institutions as a whole. While this chapter has focused primarily on British television, its findings can (tentatively) be applied to American broadcasting, where the sitcom is a highly industrialised product in a predominantly commercial system (Gitlin 1994: 29, 92). The sitcom industry therefore offers a useful insight into the working practices of broadcasting as a whole; considering the strong relationship between independent production and the sitcom in Britain, it can also be seen as a useful indicator of changes within the broadcasting industry in the last two decades. People who work within the sitcom industry must constantly negotiate between their commercial and artistic needs; as Pierre Bourdieu notes, workers in the cultural industries must negotiate 'a field of positions and a field of position-takings' (1993: 34). That is, working within systems that are not of your making requires workers to adopt roles which help validate their worth to themselves while simultaneously conforming to the requirements of the institutions they encounter which are commonly generically defined.

Such analysis helps move thinking about sitcom as a genre away from focusing purely on the text, and instead acknowledges that 'cultural values inform economic [and industrial] decisions as much as they are shaped by them' (Santo 2008: 20). While the individual-ised nature of the production process was repeatedly noted, all of the interviewees *must* have some sense of what sitcom is in order to be able to work together to produce programmes. Sitcom writers, producers and directors work within an understanding of genre which, in many instances, seems so obvious as to not require explication. The limits this might place on creative labour were noted by Steven Moffat who acknowledged that, as a writer, he 'missed' (2005) some aspects of writing because sitcom foregrounded the comic impetus so completely. That said, the industrial analysis carried out here also shows that genres mutate and develop in response to, in this instance, regulatory and industrial factors. If the sitcom in Britain is now different to that which was produced twenty years ago, and this can be linked to changes in the industry which took place in the 1980s, then genre can be understood as the consequence of factors far outside of the text. The professionals who have succeeded in this context are those who have negotiated industrial, cultural *and* textual factors, producing series which are categorised as 'sitcom' within particular industrial regimes.

Tellingly, what is not covered here is discussion of those who have *not* managed this negotiation; as David Hesmondhalgh notes, current industry structures mean that 'most creative workers are either under-employed, at least in terms of the creative work they actually want to do, or underpaid' (2002: 57). It is likely that there is a pool of creative people who could make highly successful writers, producers or directors if only the system which produces sitcom was different, offering different relationships between the commercial and artistic aspects which define all cultural work. Of course, this is not to delineate 'art' and 'commerce' in a simple fashion, nor to naively suggest that 'art' is always compromised by the needs of 'commerce'; indeed, many interviewees saw the competition inherent in the broadcasting institutions as a useful spur to 'better' work. But it is to note that what ends up on the television screen is the product of a set of relationships and negotiations which exist within complex organisations, and these organisations might both help and hinder the individuals who encounter them. Genre, then, is defined by this interplay, and the sitcom can be understood as the end product of the behaviour of many individuals working in response to the needs, demands and whims of organisations and discourses which aren't necessarily of their own making but which their labour helps reproduce. Talking about genre must always take into account the industrial processes by which that genre comes into being, while simultaneously acknowledging that those industrial processes are themselves a result of assumptions about genre. Analysing the industry which produces sitcom does not, therefore, reveal the 'truth' about what sitcom is: instead, it demonstrates that the industry is one of those contexts within which a social understanding of what sitcom 'is' is played out.

4 Programmes

If a show is funny you don't mind hearing other people laugh on the
laugh track: if it's not then it irritates you.
(Gareth Carrivick 2005)

The aim of this book is to demonstrate the variety of ways in which
sitcom can be explored generically, showing how genre is a process
by which the sitcom comes into being. Definitions of sitcom, as well
as industrial understandings of the term, have already been explored;
this chapter moves on to look at a range of programmes commonly
referred to as sitcoms. In doing so, it engages in work which is perhaps
the most common in genre studies: analysis of programmes. Jason
Mittell notes how 'Most analyses of genres have analyzed texts because
they are the most imminent and material objects of media' (2004: 8),
referring to this approach as a 'textualist assumption' (2–11). Yet this
book, and other studies of genre such as those of Mittell, Jane Feuer
(1992) and Robert C. Allen (1985) have argued that programmes are
only one aspect of genre, whose meanings instead come into play via
understandings of genre which circulate within industries and audi-
ences. This chapter suggests that the element central to the ways in
which sitcoms function as programmes is the comic impetus, and it
is therefore this aspect which should be prioritised when engaging
in analysis of specific episodes and series. Foregrounding the comic
impetus helps explain why it is that certain television programmes
may be labelled 'sitcom' while others are usually not. That is, there
must be textual elements within sitcoms which encourage viewers
to understand those programmes as sitcoms and to *not* label them as
something else such as documentary, drama or news. The programme
can therefore be seen as the point of negotiation between producers
and audiences. After all, as Chapter 3 showed, one of the ways in which
industry personnel see their output as 'successful' is if it is read as
intended; that is, if it's seen to be funny. Programmes are therefore not

definitive sites of meaning, whose generic characteristics can be unarguably proven: they are instead industrial products likely to be read by audiences in particular ways because of social and cultural conventions such as genre. So even though the quote above from the sitcom director Gareth Carrivick notes that someone might read 'bad' sitcom differently to 'good' sitcom, they are still likely to generically place such a programme as sitcom. This chapter, then, examines the ways in which we can think about analysing the sitcom genre as a series of programmes and intends to offer a range of approaches for that task.

Programmes can be analysed in a variety of ways; it could involve examining how sitcoms are shot, how their stories are constructed and told, how elements such as editing, music and lighting make meaning, or how performance contributes to success. Rather than isolate each of these elements, this chapter instead prioritises sitcom's comic impetus as its most defining characteristic. If comedy is a context within which jokes are placed, then, for broadcasting, sitcom is a televisual context within which jokes are placed. Each of the elements which make up sitcom and which may be isolated by analysing programmes are therefore *less* important than the ways in which these elements interact, and their role in creating and maintaining the necessary comic impetus. This analysis therefore draws on a range of literature and theoretical approaches to humour which aim to examine both how comedy works, and what social purposes it may fulfil. This body of literature has come to be referred to as Humour Theory, and it comprises work from many seemingly unrelated disciplines, such as sociology, politics, psychology, linguistics, biology and mathematics. Humour Theory has, until very recently, not been a singular set of approaches or a defined field; instead, it is rather an accumulation of writings by a broad range of people, often discussing comedy as an aside as part of the analysis of other topics.

As will be shown, the analysis of humour has troubled thinkers since philosophy began, especially as humans have traditionally been thought of as the 'laughing animal' (Bell 2003). Nowadays, this mass of Humour Theory is usually categorised into three distinct theories and this chapter works through each of these in turn; these approaches are the Superiority Theory, the Incongruity Theory and the Relief Theory. This chapter also suggests an alternative approach, which helps bring together Humour Theory and genre analysis in order to show the ways in which Humour Theory can be usefully adapted for the specifics of television sitcom. Drawing on Humour Theory is not that common in analysis of the sitcom, and this chapter suggests that this is unfortunate, as such theory offers valuable insights

into the specifically comic aspects of the genre. It also helps place the analysis of sitcom in a broader social context, suggesting that thinking through why humanity should spend so much time and effort making itself laugh is a worthwhile pursuit. In prioritising the comic aspects of the sitcom, this chapter does not intend to suggest that this is solely what defines the genre; as Chapter 1 showed, the sitcom commonly contains non-comic moments whose poignancy is apparent. But this chapter does make the claim that making sense of sitcom texts should prioritise the workings of the genre's comedy. The programmes under analysis here, and others which can be cat-egorised as 'sitcom', are those whose comic impetus defines them; the use of Humour Theory as a starting point for the textual analysis of sitcom therefore prioritises those aspects of the genre which most actively define it.

The Superiority Theory

The Superiority Theory of humour is the oldest of the three Humour Theories, dating back at least as far as Plato, the starting point of much Western philosophy. It supposes that people laugh when they feel a kind of superiority, particularly over other people. For Plato this was a negative emotion; he sees the enjoyment associated with laughter as 'one of combined distress and pleasure' for 'a person's malice shows itself . . . in pleasure at the misfortunes of those around him' ([360 BCE] 1975: 47). This categorises laughter as an immoral act, and Aristotle similarly calls humour 'a sort of abuse' ([350 BCE] 1980: 104). This suggests that all laughter is 'at' a subject rather than 'with' one, which links to analyses of the sitcom which see the genre as repeatedly mocking minorities and social groups (Medhurst and Tuck 1982; Porter 1998).

The biggest development in the Superiority Theory since the work of antiquity is that put forward by Thomas Hobbes, who suggests that humour is the result of 'sudden glory' ([1651] 2005: 45). For Hobbes, humour is a tactic employed by those with little power, who mock others in order to assert and demonstrate their dominance. Humour is, by this account, an undesirable consequence of social distinctions and an inappropriate way to deal with such tensions. In a similar vein René Descartes argues in 'The Passions of the Soul' [1649] that:

Those who have some quite obvious defect (for example, being lame, blind in one eye, or hunch-backed) or who have received some public insult, are observed to be especially inclined to derision.

Desiring to see all others as unfortunate as themselves, they are very pleased by the evils that befall them, and hold them deserving of these evils. (1985: 393)

Here, Descartes notes the pleasures inherent in laughter, for a joke-teller can glean joy by using humour to point out that everyone else is as flawed as them. This pleasure can be related to notions of social power, and joking can be seen as a tool for marking social distinctions. While some of the language Descartes uses may be problematic for contemporary tastes, his writing, along with that by others who propose a Superiority Theory, foregrounds debates about the relationship between humour and social power centuries before these issues were raised in terms of gender, race and ethnicity. This demonstrates that concerns over what comedy *does* have existed as long as humanity has been able to make jokes.

Contemporary society rarely questions whether humour can have any valuable social role at all; indeed, 'we belong to a society in which fun has become an imperative and humour is seen as a necessary quality for being human' (Billig 2005: 13). The theorists outlined here, however, do see humour as a social phenomenon to be concerned with, promoting seriousness as the appropriate mode to adopt towards the world around them. Indeed, the very notion of 'civilisation' was one which was seen in opposition to laughter, for 'Those who carry humour to excess are thought to be vulgar buffoons' (Aristotle [*c*. 350 BCE] 1980: 104) and 'most people delight more than they should in amusement and jesting' (103). Such concerns have been repeatedly raised by laughter-haters – what George Meredith terms 'misogelasts' (1897) – and M. A. Screech notes that 'A question hovers over Christendom. Most of us enjoy laughter; but should we?' (1997: 7). Contemporary broadcasting regulations, which place limits on the kinds of topics which can be joked about within sitcom, maintain this concern (see Chapter 5); similarly, worries over the amount of entertainment in broadcasting, as opposed to the more 'edifying', 'civilising' effects of television which informs and educates, shows that while comedy is seen as valuable, it 'is seldom set on a par with tragedy as an expression of what is most profound in human nature' (Gutwirth 1993: 24).

In essence, the Superiority Theory both sees laughter as the result of superiority and adopts a superior attitude towards humour itself. While Michael Billig might bemoan that we live in 'an age when a sense of humour is regarded as being self-evidently desirable' (2005: 15), others, such as Mikhail Bakhtin ([1965] 1984), would argue that we live rigidly controlled lives in which the celebratory aspects of the

'carnivalesque' are sanctioned only as a reward for diligence and hard work. In British broadcasting weekend programming is of quite a different sort than that for weekdays, with entertainment broadcasting dominating. Similarly, for quite some time now both BBC1 and Channel 4 have seen Friday nights as the place to broadcast sitcom and comedy programmes, such as *My Family* (BBC1, 2000–), *After You've Gone* (BBC1, 2007–8), *The IT Crowd* (C4, 2006–) and *Peep Show* (C4, 2003–). The placing of sitcom on such days suggests they're a reward for the successful completion of the working week and therefore the assumption that comedy is something that should not be taken to 'excess' is enshrined within notions of public service broadcasting.

Yet this is not to suggest that the Superiority Theory can be easily transposed to contemporary broadcasting, or that its application to the genre of sitcom is straightforward. Perhaps the most striking distinction is that whereas the Theory insists that laughter is the prerogative of the powerless who use it in order to attack those superior to them (Zijderveld 1982: 27–30), contemporary sitcom is more commonly critiqued for its mocking of the vulnerable. Debates over stereotyping in sitcom consistently argue that comedy is a political form because it relies on lampooning particular social groups via assumptions about their 'inherent' characteristics (Greene 2007). This can be seen in terms of race, where the 'coon' (Bogle 1994: 7–9; King 2002: 143–57) is a recurring comedic stereotype; it can be seen in terms of gender, with such characters as the 'battleaxe' mother-in-law and the needy housewife (Andrews 1998; Porter 1998); it can be seen in terms of nationality, with stingy Scots, lecherous Italians and rule-obsessed Germans (Davies 1990, 2002). Indeed, the Alternative Comedy movement which occurred in Britain in the 1980s was one which saw such stereotyping as problematic and attempted to eradicate it in series including *The Young Ones* (BBC2, 1982–4), *Saturday Live* (C4, 1985–7) and *Friday Night Live* (C4, 1988) (Wilmut and Rosengard 1989; Macdonald 2002). Running throughout the academic analysis of sitcom is an assumption that the genre problematically upholds power structures within society and is a useful tool for normalising the demonisation of certain social groups. It is therefore very definitely not the tool of the downtrodden, and sitcom humour may instead be one of the most powerful ways in which unequal social distinctions remain upheld (Mills 2008a).

Indeed, the Superiority Theory is complicated by the workings of the broadcasting system, and needs some development in order to make sense of how joking in sitcom works. For a start, the Theory – along with the other two major theories covered here – existed prior

to broadcasting and it's therefore an analysis of social humour. The theory explores the ways in which individuals tell jokes within society, and these usually take place in communicative relationships quite different to those for broadcasting. The social force which the Superiority Theory suggests derogatory humour may have only really works if the joke teller and the joke butt are in the same place, with the laughter of those who hear the joke giving support to the teller and causing embarrassment to the butt. In this instance the teller of the joke is clear, as is the butt, and those who laugh are likely to have a clear notion not only of what they are laughing at but also the consequences of such a reaction. In broadcasting, however, things are not quite as straightforward. It is difficult to discern who the teller of a joke in a sitcom is; is it the writer, or the performer, or the programme-maker, or the broadcaster? In legal and regulatory terms the broadcaster is held responsible, yet it is the writers and actors who are commonly and more visibly associated with programmes.

For example, this complexity has forever dogged programmes such as *Till Death Us Do Part* (BBC1, 1965–75) and *In Sickness and in Health* (BBC1, 1985–92), where both the writer (Johnny Speight) and lead performer (Warren Mitchell) were variously criticised *and* applauded for the content of the programme's humour (Taylor 1994: 254; Malik 2002: 93). Because the programme's main character – Alf Garnett – was a racist bigot, the views he espoused could be read either as being supported or critiqued by the programme (Husband 1988). For example, in many episodes audience laughter follows Alf's use of terms such as 'coon', but it is difficult to ascertain whether that laughter is revelling in the surprise of the word, mocking Alf for his inappropriate use of the word, or taking pleasure in the use of derogatory terms to describe social groups. Tellingly, in some episodes Alf is aware of the inappropriacy of his language. So, in the episode 'The Blood Donor' Alf whispers to his son-in-law Mike his concern that blood donated by black people may be given to white people because he is aware that it is an inappropriate way to talk; in doing so, the programme may be seen as making clear that such views are socially unacceptable, rendering Alf laughable because his opinions are out of date. However, the programme still consistently offers Alf as the key voice within the series, and there's a way in which viewers must at least find him a character they want to spend some time with in order to decide to tune in. Alf certainly invokes superiority when comparing himself to other social groups, but this is not the same as saying the programme invites audiences to adopt such a position. This means a variety of audience positions are available here, Yet all of these can

still be read in terms of Superiority: to laugh *with* Alf is to enjoy jokes which position him and the viewers as superior to those he castigates; to laugh *at* Alf is to find your own views more civilised and informed than those he espouses. This shows that while the Superiority Theory is useful for examining how the comedy in sitcom works, it is less valuable for the discussion of comedy's social role and the consequences sitcom might have.

Also central to the Superiority Theory is laughter; indeed, it might be seen as a theory of laughter rather than a theory of humour. The sound of laughter is seen as important because it is an aural sign of assent: to make the noise of laughter is to support the content of a joke. Plenty of research shows that laughter functions as an aural marker indicating agreement between participants more than it does as an indicator of joke appreciation (Provine 2000 offers a thorough summary). This means that it is precisely the *noise* of laughter which matters, for it communicates an agreement to be part of a group. Such aural markers remain a central part of the sitcom in terms of the laugh track. While it's already been noted that there's a recent trend towards moving away from the laugh track in sitcom, it can still be seen as one of the genre's most distinctive markers. In terms of the Superiority Theory, the laugh track is of significant ideological import for it represents social agreement on appropriate comic targets. Laugh tracks are made up of large groups of people laughing, even though the sound of a single laugher would be just as effective in signalling comic intent. The mass of people to be heard laughing on a sitcom laugh track doesn't just suggest that something is funny; it suggests something is obviously, clearly, unarguably, unproblematically funny, and that such responses are collectively defined and experienced. Laugh tracks don't include the responses of those who *didn't* find a joke funny or who were offended or upset by it. For Superiority Theorists the collective, baying nature of group laughter is indicative of the unthinking and uncivilised nature of humour, and it shows how laughter works as 'derision at other people' (Morreall 1983: 8) and therefore has a 'disciplinary' (Billig 2005: 39) aspect.

Yet there is another, final difficulty in equating the Superiority Theory with contemporary television sitcom. As has been shown, Aristotle and others believed that humour was the recourse of the powerless, who use it in order to drag those above them down to their level. Considering the comedy departments in British broadcasting are repeatedly criticised for being unrepresentative of the nation in terms of class (Hewison 1983), gender (Gray 1994: 80–111; Porter 1998) and race (Littlewood and Pickering 1998; Gibson 2008a), while

American sitcoms such as *The Simpsons* are awash with those who studied at Harvard (Brook 2004: 193), it's hard to see the creators of such humour as those in need of jokes to assert their social power. At the same time, however, it has been noted that certain underprivileged and marginalised groups are represented in comedy and entertainment more than in other social realms. For example, Hollywood and the entertainment industries in America are bound up with the history of Jewish immigration precisely because that community was unable to find work elsewhere due to anti-Semitism (Gabler 1989; Carr 2001; Weinstein 2006). Similarly, while African-Americans were notable by their absence from much of early American broadcasting, black characters did appear in comedy series such as *Mama* (CBS, 1949–56) and *Amos 'n' Andy* (CBS, 1951–3) (Cripps 2003; Lipsitz 2003). That is, representations of marginalised groups are often common within comedy programming quite some time before their appearance in other genres.

This can be read as a positive phenomenon at one level, yet the complexities of broadcasting again make this a difficult position to adopt. Because of the laugh track audiences are positioned as distinct from the characters on display and the jokes only make 'sense' if they are seen as a comic butt. If the Superiority Theory is valid, this suggests that mass audiences are being invited to find laughable the behaviour of marginalised groups, and are doing so through cultural texts assembled by those from privileged positions. This is, quite clearly, to give sitcom a poor bill of health, so, while the specifics of the broadcasting system do complicate the communicative strategies of humour, it seems that, were he around today, Aristotle would continue to bemoan the 'sort of abuse' ([*c*. 350 BCE] 1980: 104) caused by sitcom.

The Incongruity Theory

The second key theory of humour is the Incongruity Theory. It is usually regarded as having its origins in the work of Immanuel Kant, who argues that '*Laughter is an affection arising from the sudden transformation of a strained expectation into nothing*' ([1790] 1931: 223; italics in original). The pleasure from laughter therefore comes from the surprise of confounded expectations and laughter is the oral expression of such surprise. In sitcom, such humour can be seen in a range of programmes: *Family Guy* (Fox 1999–2002, 2005–) often incorporates brief scenes which expand on a character's dialogue and which have nothing to do with the episode's narrative, and they are funny because they are unexpected. For example, in the episode 'Holy Crap' a reference

to the Old Testament story in which 'God told Abraham to kill Isaac' cuts to a brief scene in which President Lincoln (Abraham) shoots the bartender from *The Love Boat* (ABC, 1977–86) (Isaac); this scene has no narrative purpose, and its incongruous rendering of the Bible story demonstrates its comic intent. Similarly, parodies such as *Police Squad!* (ABC, 1982) work by setting up linguistic or narrative expectations and then undermining them, which means they create an incongruity between the expectations for a police series and what actually plays out within each episode. For example, after the opening titles a voice over announces the name of that episode, yet this contradicts the caption which similarly names the episode. The conventions of television are similarly parodied, as characters commonly walk around the walls of the set rather than through the doors within the set, incongruously breaking the 'rules' of the majority of broadcasting. In parodying police series, *Police Squad!* relies on audiences knowing the conventions of that genre, and so it is these expectations which the jokes incongruously undercut.

Also adopting an Incongruity approach, Arthur Schopenhauer argues that:

> The cause of laughter in every case is simply the sudden perception of the incongruity between a concept and the real objects which have been thought through it in some relation, and laughter itself is just the expression of this incongruity. ([1819] 1970: 76)

Here humour is seen to arise from the disparity between the ways in which things are expected to be and how they actually are. This theory clearly positions humour as a cognitive rather than emotional phenomenon, while acknowledging the physical process which is its outcome. It also makes clear how important expectations and norms are to humour, for unless a viewer understands the way things are 'meant to be', incongruity will be unnoticeable and laughter will not occur. This has interesting implications for the analysis of genre, whose characteristics are themselves related to expectations. As Chapter 2 argued, any genre, including the sitcom, can only be understood as such if expectations are associated with it; we expect to be informed by the news as much as we expect to be made to laugh by the sitcom. The Incongruity Theory therefore suggests that sitcom both relies upon and undermines expectations; we can only find sitcom funny if it surprises us, but we can only have a category called 'sitcom' if expectations are conformed to. Using the Incongruity Theory to examine sitcom can therefore be a useful way to analyse the 'repetition and difference' (Neale 1980: 48) seen as vital to the workings of all genres.

Just like the Superiority Theory, the origins of the Incongruity Theory lie before the development of broadcasting; this means that the theory's applicability to television sitcom needs to be demonstrated. That said, the majority of contemporary thinkers examining comedy employ some kind of Incongruity Theory. For example, the linguistic approaches to humour proposed by Victor Raskin (1985) and Graeme Ritchie (2004) examine in detail how verbal jokes are constructed around linguistic incongruities such as puns and wordplay. Interestingly, most industry books which claim to help aspiring comedians develop their skills also adopt Incongruity Theories even if they're not aware of it. For example, Jurgen Wolff advises sitcom writers to give characters 'complications' and 'obstacles' (1996: 17) which place them in situations which are incongruous relative to their norms, expectations, or zones of comfort. John Wright encourages 'messing around with meaning' (2006: 97–195) to encourage 'states of tension' (103) in his workbook for actors exploring physical comedy. William F. Fry's analysis of his interview with the comedy writer Arnie Rosen suggests that what turns the chaos of incongruities that define 'play' into 'humour' is a 'structure' (Fry and Allen 1998: 164) which organises those incongruities into recognisable forms which audiences feel comfortable finding funny. This shows that while Incongruity is a recognisable process for producing humour, within broadcasting it is forever at the mercy of the specifics and conventions of comedy genres; utter incongruity is likely to be seen as incomprehensible, threatening and scary, and therefore not funny.

Yet flaws in the Incongruity Theory have been mooted, with many offering refinements which help to make the theory more useful for the analysis of broadcast comedy. Most apparent is the lack of limits which Kant and Schopenhauer place on the kinds of incongruity which are funny; that is, they suggest that all incongruities are funny, whereas it is more likely that it is certain kinds of incongruity, presented in certain ways, which result in laughter. Jerry Palmer therefore argues for a 'logic of the absurd' (1987), suggesting that incongruities must in some way be resolvable or have a rationale to them. Pure unnarrativised incongruity can lead to confusion and incomprehension, and was a tactic often employed by Surrealist artists. John Morreall notes how incongruities can cause 'distress' (1983: 19), giving the example of finding a cobra in your fridge as an incongruity unlikely to result in pleasurable laughter associated with comedy. Indeed, horror clearly works from a notion of incongruity too, with the surprise element in the shocking moments of such films similar to the 'sudden' shifts in perception noted by Kant and Schopenhauer. The question arises, then, as to why and how certain

kinds of incongruity are perceived as funny, and how sitcom attempts to ensure those incongruities are read in this way.

The genre of sitcom can therefore be seen as an organising tool which encourages audiences to read incongruities in particular ways. Those aspects of traditional sitcom which most clearly define the genre, such as the laugh track, can be seen as signals which make clear to audiences the ways in which they are encouraged to respond to the incongruities within any text. This is important because it's not only comedy which employs incongruities; the shocks of horror cinema also rely on incongruity, and any narrative with a 'twist in the tale' necessarily works by undermining audience expectations. The generic characteristics of comedy therefore work to ensure that its incongruities are read as 'funny' rather than 'surprising', 'shocking' or 'confusing'. The fact that generic markers such as the laugh track are lacking from other genres which also employ incongruities – such as horror – helps ensure that even if audiences find a scary moment in a horror film funny, they realise that it was not (necessarily) intended this way. William Paul (1994) shows how horror and comedy are closely linked, and therefore distinguishing between 'torture-porn' horror (Edelstein 2006) and 'gross-out' comedy (King 2002: 63), both of which rely on the shock of bodily functions for their appeal, becomes a matter of generic cues encouraging specific audience responses towards the incongruities they present.

This placing of incongruity within the conventions of genre can be seen in those programmes examined in Chapter 2 which draw on multiple genres or are difficult to categorise. For example, *The Osbournes* (MTV, 2002–5) has been categorised as a 'reality TV sitcom' (Bignell 2005: 162) and its comic moments often result from incongruities which can easily be related to Kant and Schopenhauer's theses. Ozzy Osbourne is a ripe comic figure because his shambling movements and slurred speech are incongruous relative to both his rock star image and his attempts to be a good father doling out advice to his children. Yet, in Palmer's terms, there is a clear logic to this absurdity, as Ozzy's behaviour results from years of the rock star life and the physical abuses this has placed on him. In taking someone like Ozzy and allowing us to see the mundanity of his everyday life, the programme places a logical incongruity at its very core, which it repeatedly mines for comic effect. The programme makes this comic intent clear through its editing and sound effects, employing musical stings at sudden moments of incongruity in the same manner as other American reality programmes, such as *The Simple Life* (Fox/E!, 2003–7). Ozzy's shambling attempts to be helpful to his children are often followed by stings of music, as

the programme cuts to those around him reacting in an astonished manner to his inadequacy: this mirrors the stings and reaction shots which commonly follow Paris Hilton's naivety about work and Nicole Richie's inappropriate questions about families' private lives in *The Simple Life*. Therefore *The Osbournes* makes clear that its incongruities should be read as 'funny', categorising it as a 'sitcom' in the process; to mark those incongruities as 'serious' would instead have made the programme a documentary, which shows how closely linked a range of television genres are.

Central to all versions of the Incongruity Theory is the notion of surprise, that is jokes must suddenly be 'got' rather than slowly revealed. After all, a joke that has to be explained is not funny. This aspect of humour can be seen in sitcom, and texts work in order to ensure that surprise is maintained. The editing style in sitcom is one which places great emphasis on the 'reveal', which is the moment when the incongruity is made most apparent. For example, in the *One Foot in the Grave* (BBC1, 1990–2000) episode 'The Trial', the lead character Victor Meldrew is on the telephone berating the staff at a garden centre about the delivery of a yucca plant. The joke rests on a linguistic incongruity; Victor asked the staff to put the plant 'in the downstairs toilet' and it turns out they've actually planted it *in* the bowl. The incongruity has a logic because of the double meaning of the phrase 'in the toilet', where 'toilet' can mean both the apparatus and the room which houses the apparatus. Added to this is a visual incongruity, as we see the toilet bowl with the plant neatly potted in it. The joke gets a big laugh from the audience, but the success of it rests on the 'reveal' being managed correctly. As Victor berates the staff on the phone the audience has no idea of the specifics of the problem. He walks from the living room to the bathroom as he explains his complaint, shouting, 'He's only gone and planted it in the bowl' at exactly the same time as his movement towards the bathroom means that the audience sees for the first time the plant in the toilet. It's important that both of these things occur simultaneously in order for the surprise to work: if the audience heard the details of the complaint before seeing what has happened the visual incongruity would carry far less comic weight; similarly, if the plant is seen before Victor explains what has happened, the absurdity would have no logic, and so would instead become a narrative enigma rather than an explicable incongruity. The timing means that the viewer's understanding of what is going on is suddenly shifted in both linguistic and visual terms simultaneously, and the laugh track signals the immense pleasure in the studio audience. *One Foot in the Grave*'s success repeatedly rests on its ability to manage these complexities and

to deliver jokes 'well'; that is to deliver logical incongruities whose suddenness is part of the their pleasure. Employing the Incongruity Theory allows for the analysis of such moments to be carried out, and it therefore encourages close readings of texts as a method for studying the genre.

The fact that the Incongruity Theory demonstrates that humour rests on diversions from social norms means it is of great use in the debate about the social value of comedy and sitcom. That is, the theory suggests that comedy only makes sense to viewers who understand and accept what is 'normal', for without such norms any incongruity is not sufficiently marked. This is useful fodder for those who argue that sitcom repeatedly mocks the deviant and is therefore a conservative form. Yet, in presenting incongruities and deviancies as pleasurable, the Incongruity Theory also suggests that comedy can demonstrate the tenuous and artificial nature of social norms, undermining their supposed transparency and obviousness. The joke from *One Foot in the Grave* cited above can be read as demonstrating the slippery and fragile nature of language, and how easily social interaction can fall apart; on the other hand, it can be seen as merely finding such idiocy laughable, suggesting that what is appropriate behaviour is obvious. Definitively demonstrating that comedy works one way or the other is likely to be an impossible task, and depends upon the reading strategies of individuals. However, what the Incongruity Theory does suggest is that comedy has a *relationship* to social norms and can therefore be a useful way into thinking about them. It's certainly the case that comedy from different times, or different cultures is often difficult to understand or find funny (Bell 2007a, 2007b), and this shows how humour requires audiences to have an understanding of the social norms which render certain activities or moments incongruous in order for comedy to work.

The question remains why such incongruity should be pleasurable. After all, it is perhaps odd that demonstrating the artificial nature of the society you live in counts as entertainment, with viewers in their millions flocking to such programmes as relaxation after a day's work. Perhaps this can best be thought about in terms of play theory, which examines the roles such behaviour fulfils in social development (Huizinga 1970; Kane 2004) and sees play as a vital counter to the responsibilities and stresses many face for much of their lives. Furthermore, incongruity might be pleasurable precisely because it is a respite from the mundanities and certainties of everyday life, offering audiences visions of other ways in which the world might be or can be understood. Indeed, in other media the powerful incongruities of

humour have been seen as vital to the inquisitive and anti-establish-
ment nature of art forms such as modern painting (Klein 2007). By
this account, the sitcom is therefore a powerful tool for the analysis
of the norms of society, for it repeatedly refuses to conform to such
conventions and offers representations quite at odds with what is
normal, acceptable and conventional; of course, it is precisely for these
reasons that the sitcom might also be seen as offensive, out of control
and troublesome.

The Relief Theory

The Relief Theory argues that comedy and laughter fulfil a vital role
within the individual's psyche in allowing repressed thoughts and ideas
to be expressed in a manner less problematic than might otherwise
occur. While traces of the theory are found in the work of Herbert
Spencer (1911) and William Hazlitt (1841), it is given its most sig-
nificant version by Sigmund Freud. For Freud, the preponderance of
jokes on matters such as sex, death and violence are a consequence of
the ways in which 'civilised' societies place significant barriers on dis-
cussion of these topics, even though they are ones central to the ways
in which life is lived. Such 'internal inhibition or suppression' ([1905]
1997: 184) leads to a range of psychoses which can result in problems
for the individual who must battle between the 'natural' urges of the id
which are in conflict with the civilising examples stored in the super-
ego. By this account, humour has evolved into a valuable tool for
'serving the purpose of exposure' (140), for it allows people to say rude,
offensive and violent things in a manner which renders their force
powerless while simultaneously allowing their expression. For Freud,
then, comedy is necessarily '*un*socialised behaviour that bursts through
the restraints of normally acceptable conduct' (King 2002: 92).

 The ways in which comedy is talked about in public service broad-
casting offers a similar argument. Regulations have repeatedly allowed
for comedy to deal with topics – such as sex, bad language and violence
– in a manner unacceptable for other kinds of broadcasting, suggest-
ing that the mode should be allowed to have limits different to those
for more serious forms (see Chapter 5). Similarly, changes in comic
content in broadcasting have often been seen to indicate social changes
in acceptability, with humour on particular topics moving in and out of
favour. What's noticeable is how often comedy writers and producers
note that comedy should break down taboos, insisting it has a right
to speak in ways which would be censured in other kinds of broad-
casting (Fry and Allen 1998). In the last decade or so this has often

been described as 'anti-PC' humour, with creators precisely defining their jokes as ones which refuse to conform to prescribed ideas of acceptability. So jokes about wheelchair-users in *The Office* (BBC2/1, 2001–3) and Down's Syndrome in *Summer Heights High* (ABC, 2007) can be read as criticising the characters' inability to conform to social expectations; on the other hand, the Relief Theory would argue that their existence at all is testament to the idea that many people feel socially proscribed in discussing disability and these comedies allow such repression to be 'laughed away'. Certainly the pleasures in such series are not solely those of laughing at the social inadequacies of the characters; Andy Medhurst, for example, recounts what he calls his 'seaside incident' (2007: 20–5) in which he laughed at a racist and sexist joke which he knew he should find 'wrong' because it was performed so well and was so unexpected.

The argument that humour pushes against social conventions supports the idea that comedy is distinctly human, for it is only human societies which develop notions of decorum and appropriacy which limit social behaviour. Yet there is a problem with this, as recent research has argued that a sense of humour can be found in a number of species such as chimpanzees and other primates (Provine 2000: 75–97), even though there are methodological problems in humans defining behaviour in other species as 'comedy'. That said, what is noticeable about these species is that they are ones with highly developed social structures in which the survival of the individual is dependent on the success of the group. What this suggests is that forms of behaviour which may or may not equate to the human idea of 'comedy' seem to correlate with social species, which adds credence to the argument that humour is dependent on social interaction. Again, the fact that public service broadcasting sees comedy as a necessary part of its remit suggests that humour is viewed as vital for social cohesion.

The relationship between social taboos and comedy can be examined through the comparison of different nations and cultures. As plenty of anthropologists have shown, different societies have wildly different conventions placed upon issues such as death and sex, and these indicate how those cultures express or repress those topics. So A. R. Radcliffe-Brown (1952) writes on Amerindian tribes (what might now be more often called Native Americans or First Nations communities) whose rituals concerning death seem quite odd and disrespectful by many Western 'civilised' standards. These involve the deceased's best friend lying in the grave and holding up the funeral until someone pays them money to let the ceremony proceed, as well as making sexual advances towards the deceased's widow. Such

behaviour is not only seen as unacceptable in 'developed' cultures, it is likely to be illegal, showing how cultures regulate against certain forms of behaviour. It is therefore noticeable how Western cultures have sublimated debates about death into comedy, where, according to Freud, relief from repressions about it are released through laughter; this can be seen in series such as *My Mother the Car* (NBC, 1965–6), *In Loving Memory* (ITV, 1979–86), *One Foot in the Grave*, *Waiting for God* (BBC1, 1990–4), *My Dead Dad* (C4, 1992), *So Haunt Me* (BBC1, 1992–4), *The League of Gentlemen* (BBC2, 1999–2002), *Six Feet Under* (HBO, 2001–5) and Kenny's repeated demises in *South Park* (Comedy Central, 1997–).

Relief Theory humour can also be seen in 'adult animation' (Donnelly 2001). Series such as *The Simpsons* (Fox, 1989–), *The Ren and Stimpy Show* (Nickelodeon, 1991–6), *Beavis and Butt-head* (MTV, 1993–7), *South Park* (Comedy Central, 1997–) and *Family Guy* revitalised primetime animation throughout the 1990s and brought cartoons to an adult audience in a manner unseen since *The Flintstones* (ABC, 1960–6). What is noticeable about many of these series is their interest in 'gross-out' (King 2002: 63) and obscene humour, with frequent acts of violence and scatology in their jokes. In such humour, the body is a recurring site of comedy, and many have pointed out the relationships between humour and the abject (Allen 2007; Johnson-Woods 2007: 89–103; Legman [1968] 2006; Limon 2000). Furthermore, obscene language is often employed in these series, and the feature film *South Park: Bigger, Longer and Uncut* (Trey Parker, 1999) examined the ways in which 'civilised' societies respond to the use of offensive language. It did so by showing how adults' concern over children repeating swearing in popular culture eventually led to global war, suggesting that such reactions are simplistic and exaggerated. What's significant about many of these texts is the wider societal response to them; they have repeatedly been criticised for what is perceived to be their attack on civilised values and the supposed detrimental effects they have on society. *South Park*, for example, has been accused of 'warping fragile little minds' (Johnson-Woods 2007: 75) while Bart Simpson 'found himself at the centre of the maelstrom of controversy stirred up' (Turner 2005: 131) when *The Simpsons* first aired in America because he was seen as condoning anti-authoritarian behaviour. While sitcom and comedy have always been subject to such criticisms, the consistency and volume of concerns related to these series suggests that they were seen to be doing something above and beyond the acceptable limits of comedy. Some of these concerns clearly related to the effects it was presumed such series were having on children, as not only is

animation associated with younger audiences in Western societies, but many of the series had children and teenagers as their main focus of identification. T-shirts bearing Bart Simpson were banned from some schools in America (Glynn 1996) as his counter-culture and anti-authority stance was seen to be validated by the programme.

These events raise a number of questions concerning the Relief Theory. The first concerns why it is that the topics which cause such outrage occur so frequently in animated sitcom; this is not to deny their existence in live-action series, but it is to note that 'obscene' material has become a defining aspect of adult animation. That question, though, might be more usefully answered if it is turned around; if the Relief Theory offers a useful account for the social worth of humour, the question is not why adult animation uses such jokes so frequently, but why live-action sitcom *doesn't* use such humour as much as it might. As noted above, all three Humour Theories are analyses of social humour, not broadcast humour, and Freud argues comedy relies on the 'relation' ([1905] 1997: 143) between joke-tellers and audiences. The movement to *broad*casting, however, seriously problematises this relationship and makes it less knowable. By this argument comedy is being muted in its role as a release from social repression by the regulations and precautions deemed necessary by the broadcasting system. The fact that the majority of adult animation programmes are made for, and broadcast on, niche channels shows how content is a response to assumptions about particular audiences. It perhaps also says something about the values placed on animation, whose absurdities are seen to be of less import than live-action comedy; in societies which fetishise realism as a representational strategy (Cook 1982: 13), animation will always be seen to be at one remove from live-action media.

It is also significant that Western culture associates animation with younger audiences. Sociological studies (Aronfreed 1968; Eaude 2006; Handel 2006) show how children have to learn taboos and social restrictions on behaviour, and infants rarely have the concerns or repressions about bodily functions that adults have. Similarly, jokes which most obviously equate to the ideas of the Relief Theory – such as finding piss, shit, farts, semen, sex and death funny – are often categorised as 'uncivilised'; many critics have defined 'wit' as the highest form of humour, for its wordplay and cleverness not only displays a traditional form of 'intelligence', but it is also humour which resolutely avoids the 'base' concerns of obscene joking. In these ways, such humour is defined as 'childish' at the same time as the child is encouraged to move beyond finding such things funny in order to demonstrate their movement into adulthood. For example, Rebecca Farley (2003) notes how

The Simpsons and other animations are often explored in terms of their 'double-coding', that is the assumption that certain jokes (the violence and pranks) are enjoyed by children, while others (the wordplay and the social criticism) are enjoyed by adults. Farley critiques this, arguing that adults are just as capable of enjoying violence, and the distinction that is made is therefore an attempt to distinguish between forms of humour which, as the programme shows, can happily exist side by side. Indeed, the Relief Theory would argue that society's desire to categorise such jokes as childish shows precisely how repressed we are about these topics, which in turn demonstrates the need for our acceptance of them. As it is, broadcasting strictures allow such humour only in certain places; in Freud's terms, this increases repression and may be responsible for a number of social ills.

This means that, unlike the other two approaches, the Relief Theory sees humour as a positive thing; more than that, it sees it as essential. So, while many argue that humour has a detrimental effect on society (Billig 2005: 10–33), and others argue that television sitcom acts as nothing more than a palliative reward which upholds power structures by keeping the masses entertained (Grote 1983; Postman 1986), the Relief Theory suggests that contemporary societies require humour in order to deal with the restrictions placed upon everyday behaviour. This means television sitcom is a vital force in keeping cultures ticking over; indeed, it means that the genre is more necessary to societal happiness than a whole range of other, supposedly more important, forms of programming.

A Cue Theory

As has been noted, all of the three main Humour Theories were developed prior to broadcasting and mass communications, and so their applicability to something like sitcom has to be demonstrated. They are theories of humour whose primary focus is the joke; they might analyse different aspects of the joke or see different consequences arising from their existence, but they remain tools primarily useful for exploring individual comic moments. Sitcom, however, is made up of many comic moments, alongside a whole host of other narrative and aesthetic factors, which means to analyse the joke alone is to ignore the variety of tools the genre employs. It is the notion of the 'comic impetus' which helps bring the theories and the genre together, for sitcom can be seen as a text whose every facet is intended to ensure the pleasures of the comedy are successfully achieved. Placing jokes in sitcom requires narrative justification, and plenty of writers have noted

that they removed good jokes from scripts because they undermine the 'real world' (Kerr 1984: 75) of narrative and/or character. Comic impetus also requires sitcom to validate the humorous intention of texts; it must not only signal that this is *intended* to be funny, but offer a discourse within which finding such acts funny is acceptable. Here, then, I am offering what I'm calling a 'cue theory', which attempts to develop the analyses of comedy found in the three Humour Theories with genre analysis and the specifics of sitcom. This theory argues that the ways in which jokes work in sitcom is less important than the ways in which the genre signals its intention to be funny, creating a space within which audiences are primed to laugh. As Chapter 2 argued that defining the sitcom as a genre requires a negotiation between producers, text and audience, a cue theory is useful because it foregrounds the characteristics of the genre which most simply aid that negotiation.

This is useful in terms of genre theory because such approaches suggest that the conventions of genres assist readers in aligning texts with pre-existing ones, helping them respond to programmes in particular ways (Jancovich 2000). Promotional material and opening titles for sitcoms signal comic intentions before the narrative of the programme is encountered. So trailers will edit together a number of comic moments, usually ignoring other narrative moments; for example, before it was broadcast previews of *Friends* focused on the comic possibilities of the characters and played down the highly important Ross/Rachel romance. In later series, this aspect *was* trailed, but this did not undermine the generic specificity of the programme because this had already been demonstrated in previous series. Sitcom titles and opening sequences purposefully mark series as not-news, or not-documentary, or not-serious, as much as they mark them as comic. This distinction is reiterated throughout programmes, with a performance and shooting style which has traditionally distinguished comedy from other, more serious forms. Perhaps the most obvious cue of sitcom's comic intentions is the laugh track, which not only signals specific comic moments but also repeatedly reminds the viewer of the comic intent of the episode. That genre markers should be so distinct and apparent raises interesting questions about the need for different kinds of programmes to be so clearly distinguished; such markers could be seen as necessary considering the mass of media texts available to many viewers, or might instead be representative of the ideological 'constraints' (Potter 2008: 198–200) placed upon a whole range of programming. That is, the conventions of genre could be argued to be so ingrained and so necessary to textual understanding that they become boundaries within which programmes must work.

By this account, genre is seen as a restrictive set of conventions which limit the possibilities of programming.

It should be noted that most Humour Theories acknowledge the need for comedy to signal its aims through cues, even if an agreed term for this has yet to be settled upon. So John Allen Paulos states that jokes are 'usually indicated by some kind of metacue' (1980: 52); Gary Fine notes the 'meta-communicative components of humorous interaction' (1984: 84); Paul E. McGhee refers to 'lay signals' (1979: 47) and 'play signals' (71); Susan Purdie notes 'external labels' (1993: 78); Jerry Palmer discusses 'para-linguistic markers' (1987: 23); Umberto Eco explores comedy's 'frames' (1984); Michael Mulkay refers to 'Humorous cues' (1988: 52); Stokoe lists sitcom's 'devices' (2008). Such analyses foreground the ways in which comedy signals that it is to be read as comedy; this is a considerable shift from the three traditional Humour Theories which instead foreground the textual elements of specific jokes and comic moments. As has been noted, the kinds of jokes which the three major theories explore can be found in a range of genres, for humour is present in drama, documentary and news programmes, and is not limited only to comedy programming. What makes the sitcom a genre, then, is not its comedy; it is those cues which signal it as a sitcom and which, in this case, encourage programmes to be read as comedic. A cue theory therefore allows for comic failure, for a viewer can still generically place a sitcom even if they find the jokes within it unfunny. It is therefore unsurprising that when those cues associated with sitcom are aligned with other genres – as in the case of *The Osbournes* outlined above – that the resulting programmes are generically defined in multiple ways by different readers.

Using a cue theory to examine sitcom is therefore helpful because it allows for comic failure and offence. Humour Theory conventionally only analyses that which is agreed to be funny; not only does it often ignore the range of ways in which comedy might be responded to, it also sidelines texts which are intended to be funny but which fail to raise a laugh. So, while comedy might be thought of as that which is funny, a cue theory suggests that comedy's primary marker is the *intention* to be funny, for we know that something is a comedy even if it doesn't make us laugh at all. There are plenty of sitcoms that I find tiresome, repetitive, unfunny and boring; but I still know they're sitcoms. Indeed, this disparity is vital for comic offence to occur. That is, you can only be offended by a joke if you perceive it to be a joke, albeit one that you don't find funny. This means you need to understand the cues which signal the text's comic intention while simultaneously finding such

humour inappropriate; to not accept the cue is to render the moment serious, or, worse, incomprehensible.

Don Handelman and Bruce Kapferer helpfully note that there are two ways in which cues may be offered. The first is 'category-routinised joking' (1972: 484), in which the relationship between the joke-teller and the audience is already firmly established as a comic one. When sitting down to watch an episode of *Everybody Loves Raymond* (CBS, 1996–2005), for example, the audience brings a wealth of expectations from their previous encounters with the programme, which may also be inflected through their understanding of its star (Ray Romano) or how the programme is scheduled relative to other comedy programmes. The star system means that 'category-routinised joking' is apparent for new sitcoms too, as performers like Bill Cosby or Ronnie Barker bring their comic heritage to series audiences are new to.

The second form of metacues is that of 'setting-specific joking' (Handelman and Kepferer 1972: 484), which is where there is no pre-defined relationship between the joker and the audience prior to the joke instance. This means that an obvious, unambiguous, deliberately noticeable metacue has to be supplied with every moment that is intended as humour and the relationship between the joker and the audience has to be constantly negotiated and confirmed. This would explain why sitcom doesn't look like any other kind of television; the opening titles, the shooting style and the laugh track are 'setting-specific' cues which signal to audiences the comic impetus of the programme. As noted in Chapter 2, scheduling and channel associations similarly work as cues, helping audiences 'find' comedy easily. As Chapter 6 shows, much contemporary sitcom has abandoned many of the conventions commonly associated with sitcom, such as the laugh track, theatrical performances and the 'three-headed monster' shooting style. All of these conventions are setting-specific aspects which help audiences read a text as comic whenever they encounter it, and therefore negate the need for viewers to have seen a programme before in order to read it as funny. The 'comedy vérité' (Mills 2004) mock-documentary sitcom such as *The Office, Marion and Geoff* (BBC2, 2000–3) and *Summer Heights High*, however, instead reduces such setting-specific aspects, and draws on category-routinised humour in which the humour of the programme is more obviously something understood by audiences through their previous encounters with it. There is little in either of these programmes which explicitly and conventionally says, 'this is sitcom'. These series, therefore, have the possibility of 'fooling' audiences into thinking they're 'real' documentaries, precisely because they use the setting-specific characteristics, such as

their aesthetics and subject matter, of that genre instead. The ways in which individual viewers negotiate their understanding of programmes which less explicitly state their generic allegiances has yet to be explored in detail; this would seem to be a vital move, as examining at what point a viewer new to *The Office*, for example, realises that the series is not a 'real' documentary but a comedy programme instead would help pin-point how audiences use textual markers to categorise particular texts.

The comic impetus of the sitcom is therefore made up of instances of both category-routinised and setting-specific joking. Indeed, the use of both kinds of jokes is necessary because of the serial nature of television. Category-routinised joking offers pleasure to viewers who have seen episodes of a series before as they draw on an understanding of the characters and the kinds of humour which we can expect from them and the programme: setting-specific joking, on the other hand, helps reiterate the comic impetus of an episode as well as offering a 'way in' for viewers new to the programme. The pleasure in catch-phrases is one which only makes sense in category-routinised terms, for audiences must be aware that a particular character repeatedly makes such a statement in order to find it funny. In catchphrase-heavy programmes such as the Second World War resistance sitcom *'Allo 'Allo!* (BBC1, 1982–92), the actors commonly leave elongated pauses before uttering their catchphrases ('Listen very carefully, I will say this only once'; 'Good moaning'; 'You stupid woman!'; 'It is I, Leclerc'), cueing audiences into the upcoming comic moment. Setting-specific joking, on the other hand, helps ensure that each comic moment is signalled as funny, and is more apparent in new series which must appropriately align themselves with the conventions of sitcom. This is achieved through marketing, opening titles, scheduling, the use of performers associated with comedy and the shooting style associated with sitcom. Genre is often thought of as dealing in 'repetition and difference' (Neale 1980: 48): for the sitcom this can easily be equated with the two forms of joking Handelman and Kapferer describe.

Robert Hodge and Gunther Kress place such cues within a wider social sphere, arguing that they result from what they call the 'logo-nomic system' within which all forms of communication must be situated:

A logonomic system is a set of rules prescribing the conditions for production and reception of meanings, which specify who can claim to initiate (produce, communicate) or know (receive, understand) meanings about what topics under what circumstances and with what modalities (how, when, why). (1988: 4)

This helpfully acknowledges that cues work within social conventions, and can therefore be explored as indicative of cultural norms. For Hodge and Kress, 'when a logonomic system allows a statement offensive to women to be read as "a joke", this signifies a particular structure of gender relations' (ibid.: 5); this can be extended to apply to all identity categories. For example, sitcom has been routinely criticised for its portrayal of homosexuality, employing camp stereotypes whose effeminacy is funny because it fails to conform to the logonomic system which requires men to behave in particular ways. For Kathleen Battles and Wendy Hilton-Morrow, the portrayal of Jack in *Will and Grace* is nothing more than 'the stereotype of the flamboyant gay man' (2002: 91) who is found funny because of his verbal and physical excess. Such excesses can be seen to be comic cues, highlighting particular comic moments as well as demonstrating the comic impetus of the entire programme. While *Will and Grace* refers to Jack's homosexuality, Battles and Hilton-Morrow argue that understanding such behaviour as 'funny' can only occur if a logonomic system which defines such behaviour as 'abnormal' exists; would Jack still be funny – or funny in quite the same way – if homosexuality was culturally seen as 'normal' as heterosexuality? That Jack's excesses can be used for comic effect demonstrates the logonomic system which defines heterosexuality as a norm. This means that cues can themselves be read as indicative of social conventions, for, in order to work, they must draw on expectations which exist for the genre of sitcom as well as wider, social ones. Saying that the sitcom is a genre defined by its comic impetus and that impetus is one which must be communicated by cues is not to say that such processes exist *outside* of social conventions: instead, they can be read as indicative of those conventions. Therefore examining such cues can be a useful way to delineate the social and cultural ways in which genres function.

To summarise, examining the ways in which sitcoms communicate to viewers that they have a comic impetus is a fruitful way to explore the specifics of sitcom as a genre. Furthermore, such an approach helps develop those Humour Theories which, in their focus on the joke, have limited, albeit highly useful, applications to a narrative, serial genre such as the sitcom. Chapter 5 examines audience responses to sitcom and explores why it is that sometimes sitcom causes offence. While the analysis of comic offence has commonly explored the specific working of the particular joke in question, a cue theory might helpfully note that the problem may instead lie with the ways in which a specific programme was cued. The cue, therefore, becomes the defining aspect of comic communication, even if it must also be acknowledged that

cues are not capable of rendering everything funny; audiences will not find a new sitcom hilarious simply because the laugh track cues them into doing so. That said, while a cue theory might be of limited use in examining how jokes work, it offers a vital step forward in the analysis of sitcom as a genre, which relies on expectations and conventions for its generic specificity.

Reading the Sitcom

Now that a range of approaches appropriate to the analysis of sitcom programmes has been outlined, how can we think about sitcom as a genre? That this chapter is divided into four key sections is intended in no way to suggest that there is nothing to be gained from drawing on all of these approaches. Indeed, the fact that each of them examines different parts of comedy shows that a fuller understanding of sitcom as a genre is likely to arise from using them in conjunction. The Superiority Theory outlines the relationship between the joke teller, the audience and the butt; the Incongruity Theory examines the content and structure of jokes; the Relief Theory explores the need for comedy in the individual and within society; the Cue Theory examines programmes' textual elements and their relationship to the society within which they function.

So how can these theories be used to examine a programme? Let's take *Only Fools and Horses* (BBC1, 1981–2002) as an example, precisely because it is a highly successful, long-running programme which, as Chapter 1 showed, has been routinely ignored by academic analysis. Applying the Superiority Theory would require exploring the ways in which the programme invites us to find funny the failed plans of the leading character and the general gormlessness of his brother Rodney; indeed, the fact the programme makes a catchphrase out of Del Boy calling his brother 'plonker' shows how humour can be used within the programme to assert superiority. A Superiority Theorist might assert that, in inviting us to find the failures of such working-class characters funny, the programme upholds class distinctions and renders unfair social divisions merely laughable. Such a reading would conform to the concerns of Aristotle and Plato that comedy functions as a negative social phenomenon. Using the Incongruity Theory, on the other hand, would result in quite a different reading. This would examine the working of individual jokes, finding that the iconic moment in the series where Del Boy falls through a work surface in a bar is funny because of the incongruity between the behaviour he is attempting to exhibit and what happens to him. The Incongruity Theory could

be used to examine every joke in the series to show how these rely on social norms; Del Boy's mangling of the English language is funny, therefore, because such malapropisms are incongruous relative to accepted ways of speaking. And the Relief Theory would result in yet another reading. This would foreground the ways in which the programme serves to express concerns over social divisions, with our laughter the result of a valuable release of tension. Here seeing Del Boy call Rodney a 'plonker' is seen to be funny because it oversteps the boundaries of 'appropriate behaviour', and so we find funny the expression of such indecorum. Finally, a Cue Theory would examine the generic conventions of the series, such as the laugh track, the shooting style and the performance style. So, while later series of *Only Fools and Horse* had episodes centred on tragic narratives such as the death of Uncle Albert and Rodney's partner's miscarriage, a Cue Theory would note that such elements remain surrounded by sitcom's traditional conventions and this the programme never truly wavers from its status as a sitcom.

The fact that sitcoms can be explored in this variety of ways shows that the genre is a complex one. Moreover, these theories repeatedly place understanding of comedy within a social context, and this shows how genre is a 'cultural category' (Mittell 2004: 1–28) always open to negotiation, development and rejection. The fact that there are different kinds of sitcom and there is difficulty in defining what sitcom *is* shows how the genre functions as a negotiation between producers, industry, audiences and social norms and conventions. In the end, though, it is viewers who respond to programmes in particular ways and it is therefore *people* who make decisions about cultural categories and television genres. It is hence fruitful to move on to discussing audiences in the next chapter.

5 Audiences

Here's the big difficulty with television comedy; it's the only bit of television that tells the audience what they'll feel before it starts. (Jon Plowman 2005)

The notion that sitcom's aim is to make people laugh seems so obvious as to not warrant evidence or investigation. Television comedy is repeatedly judged on its funniness, and this is an approach adopted by audiences, critics and the creative industries. The aim here is not to suggest otherwise; while academic approaches to sitcom are many and employ a range of methods with various aims, the genre is defined by its 'comic impetus', which has a clear relationship to audience responses to it. What shall be examined here is the effect such a generic characteristic has. While all media texts have some kind of aim, and somehow take into account the audience for whom they are made, this has a particular inflection for the sitcom because of the 'form of pragmatism' (Curtis 1982: 4) which defines its success. This not only affects industrial decisions and textual practices, it also, significantly, cues audiences into a particular kind of response, with viewers criticising programmes that fail to deliver. As Plowman notes above, the expectations audiences bring to sitcom are clear and defined, and these require a response which is as much emotional as it is anything else.

It's worth thinking about what is meant by the word 'feel' here. Clearly a whole range of programmes invite emotional responses: game shows such as *Deal or No Deal* (Endemol, 2000–) invite empathy with the contestants as they risk large sums of money on the opening of a box; reality programmes such as *The X-Factor* (ITV, 2004–) encourage viewers to both laugh at the awful audition, and cry at those brilliant singers for whom progressing through the competition is a lifetime's ambition; depending on the subject matter, television drama may intend to make its viewers cry, laugh, get angry, be outraged, be scared or a combination of any of these. What is noticeable in each of

these examples is that the emotional aspects of the programme are in addition to what the series is ostensibly 'about'; *Deal or No Deal* can be enjoyed as a game of luck and gambling without the emotional investment in the contestant, just as *The X-Factor* can be viewed as a talent show whose emotional aspects are additions rather than the main attraction. Indeed, the fact that such programming invites emotional responses has been seen as evidence of the 'tabloidization' (Glynn 2000; Sparks and Tulloch 2000) of television. Tellingly, analysis of all forms of culture remains wary of emotions, despite much valuable work on soap operas which found a key element of their generic pleasure is their 'emotional realism' (Ang 1985: 45).

Sitcom, on the other hand, places such 'feelings' at its core. While critics and audiences might be impressed by a sitcom's narrative, performances or aesthetics, these are minor concerns in the context of its success in making you laugh or not. The debate about whether laughter is an emotion or not is both long-standing and ongoing. So Glenn E. Weisfeld (2006: 18–19) notes research that finds brain activity when laughing has many similarities to that which accompanies other emotions; Phillip J. Glenn (2003) sees laughter as strengthening emotional bonds due to humour's social nature; and Robert Sharpe (1975) gives seven reasons as to why amusement is an emotion, including laughter's relationship to pleasure. On the other hand, Robert Provine (2000: 170) notes the difficulty in distinguishing the physical and emotional aspects of humour and laughter, as well as problems in analysing the relationships between the two. That said, the notion that laughter is a feeling is a lot less contentious, and the fact that it is a physical response to an event shows how a cognitive response is expressed as a bodily one. To note that sitcom and television comedy are predicated on their ability to make the audience laugh is not to denigrate or ignore the other pleasures audiences might get from the genre, nor how important other factors are to a generic understanding of comedic forms in broadcasting. But it is to note that this is a genre which foregrounds one of its aims in a highly visible way, and encourages audiences to respond to it as clearly and unambiguously as possible. To find a sitcom unfunny is to unarguably define it as bad sitcom, no matter what else the programme in question might be doing; I've yet to find a single person who has continued watching a sitcom they found unfunny because it offered them some other kind of pleasure which made up for the lack of humour.

It is for this reason that the audience becomes a textual element in the sitcom. Sitcoms cannot unarguably prove that a programme is funny; in their shooting style and adoption of expected characteristics they

can signal an *intention* to be funny, but the hoped-for audience reaction cannot be guaranteed. However, what a sitcom *can* tell you is that other people found it funny, and this can function as a guarantor of a programme's comic success. This is why the key generic characteristic of the sitcom is the laugh track, which has been associated with it since its inception. The laugh track is the aural embodiment of the audience, captured electronically and transmitted alongside the programme in order to show that real people found the events on-screen funny. Many of my interviewees (see Chapter 3) were extremely keen to stress that the laughter heard on transmitted sitcoms was that of audience members at the recording and was not added afterwards in order to boost a programme's perceived funniness. It was clear for such industry personnel that employing laughter captured at the time of recording was a sign of 'authenticity' and that using canned laughter was tantamount to acknowledging that a programme had failed. The sitcom is, therefore, a recording of a series of comic fictional events accompanied by the responses of those who witnessed them; in using the latter to signal the success of the former the sitcom is a genre which acknowledges that audience pleasure is the aim of its comic impetus, without whom making funny fiction becomes a rather pointless project.

Of course, this is not to suggest that the only way in which audiences are acknowledged in sitcom is through their laughter. Sitcom audiences make other sounds too. In *Friends* (NBC, 1994–2004), for example, the audience is often heard to be responding in a range of ways to a series of events and it's clear that these run across many emotions. The whooping and cheering which accompanies Rachel's first kiss with Ross, for example, is clearly not a laughter response, but one of surprise, of elation and of release after two series of their failure to become a couple. Similar surprise noises are heard when we first see Chandler and Monica get together. That audiences should react in this way – and that the programme should see such reactions as worthy of inclusion in the final broadcast – places response, and in particular emotional response, at the heart of the genre. Other fictional genres rarely employ an audience in this way; while soap operas are defined by their emotional engagement and its clear audiences at home enjoy the 'guilty pleasures' (Brunsdon 2000: 131) such programming offers, they do not have 'crying tracks' in the way in which sitcoms have 'laugh tracks'. In that sense, the laugh track is quite at odds with the realist tendency of the majority of broadcast fiction; that it is such a central and consistent characteristic of the sitcom is testament to the notion that genre expectations become normalised and help create future expectations for genre series.

The Laugh Track

The existence of the laugh track has been seen as evidence of the hegemonic ways in which television comedy works. The sounds heard on the laugh track are a public response to comic events, capturing the responses of a crowd rather than that of specific individuals. So even though an individual laugh might occasionally be heard on a laugh track, someone with too distinctive a guffaw is likely to be edited out of the final broadcast. Similarly, someone laughing in the 'wrong' place would be removed, which suggests there is a collectively agreed notion of when it is appropriate and inappropriate to laugh. And alternative responses are not allowed; if an audience member finds a joke unfunny and tuts in disgust or is offended by a joke and makes their revulsion clear, this too is unlikely to make it into the final edit. In these ways, the laugh track presents the audience as a mass, whose responses are unambiguous and who signal a collective understanding of what is and isn't funny. This contradicts the idea that a sense of humour is central to an idea of 'personhood' (Wickberg 1998: 5) based on 'individualism' (14), for the collective nature of broadcasting is incapable of expressing the range of ways in which it is possible to respond to comedy. And Ien Ang notes that the term 'the audience' is nothing other than a 'taxonomic collective' (1991: 33) which is meaningless for the majority of individuals watching television, and is instead an industry and policy term which helps such institutions 'conquer the audience' (35). While this is an aspect of all broadcasting, it perhaps gets its most obvious example in the laugh track, which not only ignores alternative readings of a comedy text, but also suggests there is a pleasure to be had in going along with the rest of the crowd.

For Barry Curtis, 'In sitcoms the position proposed for the audience is one from which the operations of the narrative and the "points" of the jokes make sense' (1982: 9). This sense is one which works from agreed notions of what can be made funny and an awareness of the generic conventions which signal it as such. Andy Medhurst and Lucy Tuck see the characteristics of sitcom, especially those which signal its theatrical and music-hall past, as evidence of the 'collective experience' (1982: 45) of comedy, and note that this necessarily encourages conservatism in comedy required to make sense to the majority. Indeed, this has been at the core of critiques of sitcom and all popular culture, for the desire to reach the mass inevitably sidelines those needs and ideologies of minorities and excluded groups. While programming on niche channels might offer a respite from this, it's clear that the unambiguity necessary to comic success encourages joking which

discourages the possibility of viewers reading programmes in a variety of ways.

Yet I want to argue that the inclusion of the audience in the sitcom text offers a notion of the collective consciousness against which the individual can define their own response. That is, the notion that media may contain hegemonic messages which are normalised to the extent that they deny alternative ideologies is central to critiques of media power, especially in terms of debates about media 'effects' (Winn 1985; Postman 1986; Barker and Petley 2001). What is telling is that the majority of broadcasting occupies a position of authority in which the audience is assumed rather than invited into the pro- gramme; newscasters talk directly to the audience, looking out of the screen at the viewers at home, yet the reactions of the audience are never incorporated into the text. It seems to me that in such pro- gramming the unambiguous response to the meaning of the text is predicated on the exclusion of the audience, for individual viewers are given no sense of how actual audience members are reacting. I cannot be outraged at what others think about news events because television news doesn't tell me what those viewers are thinking or how they're responding. By including its audience in the text, sitcom at least makes explicit the audience position being offered to me and, in doing so, encourages me to notice when I'm responding differently. After all, viewers only spot laugh tracks when they accompany programmes they don't find funny, that is when the audience position offered by the programme is one that viewers cannot align themselves with. While I'm not trying to argue that the inclusion of the assumed response in the sitcom makes it an unambiguous text which offers the viewer a complex range of responses; I am arguing that in making explicit the position that the viewer is offered, it makes more possible the adop- tion of alternative readings, even though the consequences of these might be localised and, in political terms, minute. In offering a mass response the laugh track offers the individual the possibility of defin- ing themselves in response to that mass; other programming, which disavows the audience response which it encourages, fails to offer the individual the same collective response against which he or she might measure themselves.

Of course, one of the most defining aspects of recent sitcom is the abandonment of the laugh track. A range of series such as *The Office* (BBC2/1, 2001–3), *Flight of the Conchords* (HBO, 2007–), *We Can Be Heroes: Finding the Australian of the Year* (ABC, 2005) and *Little Mosque on the Prairie* (CBC, 2007–) do not employ a laugh track and therefore distinguish themselves from the characteristics of traditional sitcom.

Sports Night (ABC, 1998–2000) is perhaps emblematic of this development, as its first series had a laugh track while its second didn't; it is also, tellingly, a programme which is generically difficult to place as either a sitcom or a comedy-drama. Stephen Peacock argues that the 'stripped down' (2006: 116) nature of a non-laugh track sitcom such as *Marion and Geoff* (BBC2, 2000–3) means the programme has a 'lack of definition' (ibid.: 120), suggesting that the range of ways in which it can be responded to are more various than for 'traditional' sitcom. In another way, Tara Brabazon argues that the mock-documentary format of *The Office* allows the programme to engage with the 'postmodern, post-colonial, post-industrial' (2005: 101) nature of the contemporary workplace through lingering shots of office technology and characters engaging in mundane work activities, which would be far less likely to appear in a sitcom with a laugh track. But I would want to make a clear distinction between a textual element which represents audience response and actual audience responses from viewers. The abandonment of the laugh track is here seen as a signifier of 'quality' (Geraghty 2003) and sitcom writers like Susan Nickson are aware that not using audience laughter 'leads to more critical acclaim' (Nickson 2005). We cannot see the movement towards sitcoms without laugh tracks as evidence of audience empowerment because the fact that a programme doesn't incorporate its audience into the text in no way shows that it doesn't offer a single position from which the comedy can be best understood. The lack of research into sitcom audiences means we have no evidence that viewers read programmes with and without laugh tracks differently; indeed, as will be shown below, audience research finds that individual viewers respond to different kinds of sitcom in remarkably similar ways.

The notion that sitcoms can exist with and without laugh tracks is perhaps best demonstrated by *M*A*S*H* (CBS, 1972–83). This programme was shot without a studio audience but, when broadcast in America, had canned laughter added for fear that audiences might find the jokes difficult to spot and to salve concerns about humour within a wartime setting (Lewisohn 2003: 501). When shown in Britain, however, the laugh track was omitted, resulting in a series with a noticeably different tone. *M*A*S*H* therefore shows that even though laugh tracks are understood to be a key characteristic of the genre, they are distinct enough from the programme's diegesis that their removal doesn't make the series difficult to situate within genre. Indeed, the fact that academic and critical responses to *M*A*S*H* are broadly similar in both countries suggests that the laugh track is of minimal importance in the success and meaning of the sitcom. Reading laugh

tracks as emblematic of audience responses to broadcast comedy is, therefore, highly problematic. This means that studies which see the laugh track as evidence of the socially cohesive nature of sitcom might too easily confuse a textual element with the feelings and readings of millions of individual viewers at home whose responses we know extremely little about.

Researching Sitcom Audiences

Indeed, studies of sitcom audience responses are few and far between, despite many laudable attempts. Charlotte Brunsdon and David Morley's (1978) work on *Nationwide* is the most cited study of the domestic role of television and offered a watershed in the use of ethnography to place the consumption of television into everyday life. Certain genres have been analysed in depth using these methods; the soap opera has been explored by Ien Ang (1985) and Dorothy Hobson (1982), while factual and reality television audiences have been examined by Annette Hill (2007). Considering sitcom's relationship with its audience and the large viewing figures such programming often garners, it might seem odd that sitcom audiences have not been examined in this way in a sustained manner, but perhaps this is a consequence of the assumption that the extra-diegetic audience reaction on the laugh track can be straightforwardly read as emblematic of audience reactions at home, even though it's safe to assume that many viewers are likely to respond to jokes in quite different ways in the domestic context.

This is not to say no work has been done, though. Perhaps the most in-depth is Sut Jhally and Justin Lewis's (1992) account of a series of interviews with viewers of *The Cosby Show* (NBC, 1984–92), which engages with debates about that programme's representation of race. This study offers a useful development for discussions of the ways in which race and class are often confused, and how white assumptions are deployed as markers of normalcy by viewers (Dyer 1997). Jhally and Lewis define such audience responses as 'enlightened racism', in which viewers deny the ethnic aspects of the *The Cosby Show* in order to demonstrate that race 'doesn't matter'; however, they can only do so if the programme erases any notion of African American culture from its content, resulting in a programme that is 'white' in all but name. It's noticeable that this study engages with the nature of humour and comedy very little and 'reads' sitcom in a manner congruous with that which would be employed for any other kind of genre. This is not to plead a special case for comedy programming, nor to suggest that the

comic elements of some kinds of programming excuse questionable aspects of it; however, it is to suggest that comic expectations are part of the reading strategies viewers bring to such series and this comic impetus must be taken into account when examining what audiences do with sitcom.

Smaller pieces of research than this do exist and offer useful inroads into the examination of sitcom audiences. For example, Aniko Bodroghkozy (1995) finds that black and white audiences made very different readings of the programme *Julia* (NBC, 1970–3) through her analysis of the letters and phone calls the broadcaster received about it. These different readings were found to correlate with viewers' race and ethnicity, showing how these are important markers of understanding comedy. Considering many smaller American networks such as HBO have gone out of their way to reach audiences not catered for by 'mainstream' programming (Leverette et al. 2008) the relationship between race and humour seems one ripe for further analysis. This is also noted by Marie Gillespie (1995) in her analysis of teenagers in Asian communities in South East London, for whom a whole range of programming, including comedy, become significant generational markers. And Alexander Doty (1993) has explored the ways in which gay, lesbian and queer communities offer 'alternative' readings of sitcoms such as *Bewitched* (ABC, 1964–72) and *I Dream of Jeannie* (NBC, 1965–70), taking particular pleasure in their campness.

Despite these sterling pieces of research, though, it's quite clear that the vast majority of sitcom consumption goes unexamined. This may be because work on television audiences remains limited for all genres: it may be because getting audiences to explain how and why something is funny is difficult as it transgresses the notion that a sense of humour is unarguable. Some studies have instead drawn on examining laughter as a quantitative method for exploring audience reactions to comedy, by measuring the length, volume and type of laughter comic moments elicit in viewers (Chapman and Foot 1976; Provine 2000: 23–53).

The problem with such studies is that – like the laugh track – they position the comic response as a group event, with little space for alternative readings or individual responses. While this may be useful for debates about the hegemonic nature of broadcasting, it does little for discussion of the personal and particular ways in which individual audience members respond to, and use, comedy. Furthermore, it offers few insights into the ways in which different kinds of audiences might read sitcoms, especially in terms of those programmes broadcast in

many countries across the world. While America remains the world-leader in sitcom export, to read this as evidence of straightforward cultural imperialism or globalisation ignores the variety of ways in which viewers in different countries make sense of such programming (Gray 2007). A wealth of research shows that viewers make sense of imported programming through a filter which acknowledges their country of origin; for example, Ien Ang's (1985) seminal work on *Dallas* (CBS, 1978–91) shows that American television is read in terms of assumptions about that country's ideologies of democracy and capitalism, and viewers insist on seeing differences between such tropes and those of their own nation. Of course, what this does is reiterate the link between television and nation, with audiences defining their own sense of national identity at least partly through its differences to those espoused in imports. For sitcom this has a particular inflection considering the relationship between sense of humour and national identity (Davies 1990, 2002).

I was able to examine the ways in which audiences make links between television comedy and national identity via research and teaching carried out in the United States. In 2002 I spent a term teaching a range of media units at Central Missouri State University (now the University of Central Missouri) and did the same at Indiana University, Kokomo in 2005. Central to that teaching was introducing students to a range of British comedy programming they hadn't experienced before, and inviting them to discuss what they thought of it, with particular reference to its relationship to their assumptions about British comedy and culture more generally. This wasn't 'formal' research in which specific research questions were formulated and repeatable studies were carried out within controlled conditions: it was instead material gathered as part of teaching, which the students involved then used throughout the rest of the course. This material is, of course, in no way representative of wider audiences and the classroom setting within which it was constructed would no doubt have influenced the kinds of answers that were given. However, the material is valuable because it gives an initial insight into the ways in which specific audience members respond to, think about and categorise the sitcom, placing such responses within an everyday context similar to that within which television is commonly consumed.

In Missouri this exploration began with asking a class of twelve students to compile a list of British sitcoms they knew or had heard of, whether they had seen them or not. This was intended to glean their notion of British comedy before I introduced them to any new material. The list came out as:

1. *The Day Today* (BBC2, 1994)
2. *Austin Powers*
3. *Absolutely Fabulous* (BBC2/1, 1992–6, 2001–4)
4. *Whose Line is it Anyway?* (C4, 1988–98)
5. *Monty Python* [sic] (BBC1, 1969–74)
6. *Mr Bean* (ITV, 1990–6)
7. *The Benny Hill Show* (ITV, 1969–89)
8. *Fawlty Towers* (BBC2, 1975–9)
9. *Red Dwarf* (BBC2, 1988–99)
10. *Keeping Up Appearances* (BBC1, 1990–5)
11. *Are You Being Served?* (BBC1, 1972–85)
12. *Coupling* (BBC2/3, 2000–4)
13. *Steptoe and Son* (BBC1, 1962–74)
14. *Till Death Us Do Part* (BBC1, 1965–75)
15. *Last of the Summer Wine* (BBC1, 1973–)
16. *Blackadder* [sic] (BBC1, 1983–9)
17. *Father Ted* (C4, 1995–8)
18. *The Young Ones* (BBC2, 1982–4)

This is quite a diverse range of programmes which span many decades of British broadcasting. Yet not everyone in the class had heard of all of these series, and a number (*The Day Today, Coupling, Father Ted*) were known to only one student who was very keen on comedy and often purchased DVDs and videos from overseas in order to see programmes that weren't broadcast in America. The programmes which were familiar to everyone were *Monty Python's Flying Circus*, *Benny Hill* and *Mr Bean*, who are the triumvirate which, in my years of teaching international students about comedy, are the names which virtually everyone from every country can be assumed to know. These programmes were defined by many of the American students as particularly British for reasons that will be discussed below; most notably, the notion that they were British was predicated on the idea that their content and style was of a sort impossible to find in American programming. Considering these three series are a good few decades old, the fact that they are constantly referred to as the epitome of British comedy might suggest worrying things about the impact of contemporary UK television comedy overseas.

The most unexpected entry on the list is probably Austin Powers, the character played by Mike Myers in the films *Austin Powers: International Man of Mystery* (Jay Roach, 1997), *Austin Powers: The Spy Who Shagged Me* (Jay Roach, 1999) and *Austin Powers in Goldmember* (Jay Roach, 2002). All of these films were made with American and

German money, and Myers is Canadian. While the films parody
Englishness in their spoofing of James Bond films and a range of
aspects of British culture, it is highly unlikely that British viewers
would define them as 'British' in any sense. Indeed, the students who
drew up the list spent some time discussing whether Powers should
be considered British at all, but eventually conceded that, due to the
content and setting of the humour, he should. While this debate is not
one of sitcom, the terms within which it was placed connect to those
discussed below related to notions of British humour. In that sense,
the students defined Austin Powers as a 'British comedy' because of
its content, ignoring aspects of production or finance. This shows that
they had a clear sense of what British comedy was and suggests that
the tropes of such humour can be invoked by performers and writers
of any nationality.

A similar activity was carried out at Indiana University, but here
a group of twenty students were invited to make general comments
about British comedy and to reflect on what made particular pro-
grammes different from the norms for American programming.
The following consists of a selection of the material gathered, in the
students' own words:

1. *Monty Python* → outrageous, excessive violence, not realistic
2. British people are more outspoken → sex and nudity,
 immorality
3. *Keeping Up Appearances* → 'very British', about being proper,
 high society
4. irony → saying the opposite
5. dry → not loud, subtle, no definite punchline, jokes are
 inferred
6. open to sensitive subjects → sex, homosexuality, cross-
 dressing
7. *The Office* → understated, subtle
8. lack of seriousness
9. immorality
10. language differences
11. in-your-face

This is an extremely complex list which contains many contradictions;
can British comedy be both 'subtle' and 'in-your-face', and how do we
reconcile it being both about 'high society' and 'immorality'? What's
clear is that there are a range of aspects of British comedy which is
seen to define it rather than there being one overriding characteristic.
Furthermore, in defining British comedy using these terms, these

participants were clearly making statements about what they would *not* expect in homegrown comedy; this is therefore a list of what does *not* constitute American comedy as much as it's one which is seen to define the humour of the UK.

The contradiction mentioned above can, perhaps, be reconciled. The notion that British comedy is about class as well as being open to 'outrageous' subjects unavailable to American sitcom suggests that, as others have argued (Littlewood and Pickering 1998; Wagg 1998), comedy is, in Britain, a useful tool for the expression of ideas and opinions which are regulated via the class system and a sense of decorum. This clearly connects to Sigmund Freud's ([1905] 1997) Relief Theory of comedy discussed in Chapter 4, in which humour allows the release of 'nervous energy' built up by the repressive nature of contemporary societies. For these participants, the 'excessive' nature of much British comedy is precisely a consequence of social controls which dominate life in the UK, and American comedy's lack of such content is indicative of the 'freer' life on offer to a nation with a much less rigid class system. Of course, this is not to suggest that the class system in either country is noticeably different, nor is it to suggest that any of the students involved in this task saw comedic differences as evidence of clear social disparities, but it is to note that British comedy was seen as interested in expressing a notion of social class rigidity which was not seen as a characteristic of American popular culture. So, while these differences help define British comedy, there is no evidence that they unproblematically 'reflect' the societies that produce them; quite the opposite – they can be seen as national comedic conventions which respond to generic expectations of those nations.

Assumptions about differences in comedic performance can be seen in the comments about British humour being 'dry', 'understated' and 'subtle'. For many participants the ways in which British humour signalled itself as funny were often difficult to spot; this was apparent both for individual comic moments and for episodes as a whole. For example, many students found *The Office* difficult to interpret, and when I screened an episode of it to a group who had never seen it before, I had to spend considerable time afterwards convincing them it was 'a sitcom'. This is not to suggest that they were fooled into thinking it was a real documentary for they were quickly aware that it was a piece of fiction, but for many it was a struggle to place the programme within any genre, and the programme failed to contain enough conventional sitcom characteristics for it to be read as one simply enough. This research was carried out before the format of *The Office* was sold to the American network NBC, who started producing their own

version of the series in 2005. Jeffrey Griffin notes that this remake had to be 'Americanized' in order to overcome a possible 'cultural disconnection' (2008: 162) because of the 'Britishness' of the original series. What the research here suggests is that this disconnection is as much generic as cultural; for the participants the 'British-ness' of the programme was not a problem, but the genre of it was. This shows how generic expectations are culturally structured, for these viewers insisted it was their ignorance of some aspects of British comedy genres which resulted in their confusion over *The Office* rather than that programme's failure to conform to internationally agreed ideas of what sitcom is, how it looks and how it tells its jokes.

This failure to recognise the comic impetus of *The Office* demonstrates how important a Cue Theory suggested in Chapter 4 is to the understanding of comedy. These viewers weren't rejecting the jokes as unfunny or offensive; they were simply not equipped to work out where the jokes were. Indeed, many of the students requested that we watch parts of the episode again and I point out exactly where something funny happened. On doing this, the students asked how I knew a small piece of dialogue or a minor piece of performance was funny, especially as these moments invariably didn't conform to the conventions of traditional sitcom. The fact that I couldn't really explain this showed how normalised comic reaction is. Of course, making a comic reading of *The Office* is at least partly dependent on an awareness of the docusoap and popular factual television boom which characterised British television in the 1990s (Winston 2000: 54–9), and whose visual characteristics the programme aped and pastiched for its comedy. That American television didn't have such a boom means that the visual style being mocked was not apparent to American viewers. That said, many of the American participants in the discussion of *The Office* remained emotionally detached from the programme's humour once I'd attempted to point out where the jokes were. That is, even though they could now see what was funny they remained unmoved by it all, which gives credence to the notion that comic reaction is something which must remain straightforward and a joke isn't funny if it has to be explained.

Other comments made by the students show an assumption that comedic content is broader in British comedy than in its American counterpart, and this was seen as indicative of a 'homogenized' American culture in which broadcasters avoid controversial content for fear of upsetting audiences and advertisers. Indeed, many of the participants had never come across television without adverts before and were startled (in both positive and negative ways) by the idea that television was paid for through a licence fee in the UK. Throughout

the discussion there was an assumption that television in Britain is 'better' than that in America, which is quite the opposite of responses, in my experience, when such comparisons are requested of British students. Perhaps most telling was a number of responses to *The Office* in which the students maligned themselves for not being able to access the humour in it that I (and, by extension, the UK) could see in it. While I assumed not finding the programme funny would lead to them to the legitimate conclusion that it wasn't a very good sitcom, many of my participants instead assumed it *was* a good sitcom, not least because it was British. They insisted that they were 'not clever enough to get it', which makes clear links to notions of cultural capital and their perceived lack of interpretative expertise. For these students *The Office* was representative of forms of culture which they felt they had no access to and which their broadcasting system neither offered nor had given them the tools to make sense of. In this way, not laughing at jokes which others find funny resulted in a feeling of exclusion, even though the programme doesn't contain a laugh track and therefore doesn't signal the audience who might be laughing at it. While this could be read positively as demonstrating the cultural specificity of television programming, these students clearly made a distinction between the American series on offer to them and the 'good sitcom' made by British television which they felt excluded from and which they saw as missing from the broadcasting fare which makes up the majority of American television.

Of course, there are difficulties in extrapolating wider readings from these localised studies and the participants might disagree with some of the readings I've offered of their responses. Differences in regional senses of humour in America (Romero et al. 2007) also make it hard to see such readings as indicative of national responses to comedy. However, what they do show is that responses to television sitcom are localised and specific, and offer a way into bigger debates about the relationship of media and individuals, and the nature of genre and national broadcasting industries. These participants were 'active assimilators' (Rixon 2006: 24), keen to respond to the movement of television texts from other cultures into theirs. Considering the complex and thoughtful ways these participants responded here, as well as the fact that this is a genre which makes such a display of its relationship with its audience, the sitcom remains alarmingly under-explored in terms of studies of its viewers and consumers. It seems that the sitcom audience remains a textual component, gathered into studios in order to verbally define a text as comedic, and once this has been achieved, individual responses to such series become assumed.

Regulating Sitcom Audiences

The ways in which genres bring together large numbers of viewers show how the audience is an industrial construct. Indeed, genre only works if audiences are treated as a mass, for 'Genre is what we collectively believe it to be' (Tudor 1970: 38). For the sitcom, this construct is incorporated into the text via the laugh track. Yet the mass nature of audiences can also be shown through examination of the ways in which broadcasting in general, and sitcoms in particular, are regulated. Such regulations are usually structured around national boundaries, for despite changes in technology which allow many viewers to gain access to television which is not broadcast in their location via traditional broadcasting technologies, television is still thought of in national terms. Examining regulation is a useful way of exploring the ways in which audiences are perceived by regulators, who must, by necessity, make generalised decisions which attempt to aggregate the millions of people they speak for. This chapter therefore draws on adjudications and reports produced by the Office of Communications (Ofcom) in the UK, the Australian Communications and Media Authority (ACMA) and the Federal Communications Commission (FCC) in America to examine how regulators make sense of the mass of citizens they are required to represent.

The problems of regulating comedic content on television arise from the consequences of national broadcasting. That is, sitcom content is a response to broadcasters' needs to create programmes that offer comedic pleasure to large groups of people rather than individuals. While niche broadcasting mitigates against a truly mass audience, the numbers of viewers watching such programmes is still markedly larger than comedy audiences outside broadcasting. It has been noted that the success of comedy relies on the relationship between joke-teller, joke audience and butt, and, in social humour, this can often be quite easily defined and negotiated. For broadcast comedy, however, this relationship becomes a problematic one. For a start, who is the joke-teller: the writer, the performer, the director, the broadcaster, or someone else? The ability to pinpoint who a joke 'belongs' to is vital in comic communication and offers someone offended or upset by a joke a target for response. So comedy often relies on 'permitted disrespect' (Radcliffe-Brown 1952: 90–1) whose permission is granted because of the possibility of reply. Yet outlining who is responsible for a joke deemed unacceptable by many is problematic. Within British law the broadcaster is responsible, even though the institution with this responsibility may have had little to do with the actual creative

process which led to such humour. The notion that a broadcaster is responsible for a joke is a significant step away from the traditional communicative model for humour and means that institutions such as the BBC must adopt general strategies towards comedy which help define its role and purpose in comedy and ensure texts don't damage the reputation and role of it as a public service broadcaster.

Defining who the audience for humour is also alters the relationship within the comic exchange because broadcasters are incapable of knowing who will hear or see a joke they broadcast. While trailers, scheduling and channel associations all serve to create expectations for programming, these cannot be guaranteed; indeed, the ethos of many public service broadcasters encourages audiences to encounter types of broadcasting they may not have come across before, with this notion of broadening people's horizons a justification for television being a public good. Comedy, like all programming then, must also take into account a hypothetical audience who may or may not watch a programme, but who are deemed to have a right not to be offended or disgusted if they stumble across a programme they might not normally watch. Programmes are therefore made for a mass larger than the mass that consumes them. While stand-up comedians can quickly judge the mood of the audience and alter their routine in response to them, for the sitcom such judgements have to be made during the production process and cannot be altered during a broadcast. This means that the production of television sitcom works from an assumed audience, whose tastes, values and expectations are predicated on previous examples of similar broadcasting; in that sense, genre is a useful tool for constructing audience expectations but, in doing so, it places limits on the kinds of material the majority of sitcom can offer.

In addition, broadcasting regulations help define the ways in which broadcasters define their viewers. As Sonia Livingstone et al. (2007) note, the emergence of Ofcom in Britain in 2003 brought public and commercial broadcasting under the same aegis for the first time, and therefore construed a single notion of the audience which must be applied to all broadcasters. One of the key developments here was the definition of the viewer as a 'citizen-consumer', which abandons other possible terms such as 'customers', 'users', 'publics' (Nolan 2006) and 'audiences'. This concept draws on public sphere (Habermas [1962] 1989) notions of viewers and sees television and media as a part of engaged citizenship (Jones 2006): at the same time, it sees this as compatible with audiences as consumers, able and willing to pay for media products and defining citizenship as an activity which can be expressed through consumption. Johannes Bardoel and Leen d'Haenens place

this in a European perspective, and note that, despite increased competition and the expansion of media technologies, the European public service broadcasting system remains remarkably stable and 'a model for the rest of the world' (2008: 352). In America the FCC defines television as 'a unique market where a public good is provided by privately-owned, profit-driven firms' (Brown and Cavazos 2003: 4), showing how even within a system often purported to be resolutely commercial the social value of broadcasting is apparent. Broadcasting models differ globally, but a notion of the public which arises from such public service ideals underpins them all: that is that broadcast media are too powerful for them not to be regulated and this regulation is best structured along national lines. Furthermore, such regulation clearly assumes that television can have some kind of social effect, even if the degree and extent to which this occurs is hotly debated and has been since the advent of mass media. The state and its regulators therefore see their role as one of protection, rightly limiting the public's access to possible texts for a whole set of reasons: national security, public safety, offence, and so on.

This results in legislation and codes of practice which construct a version of comedy which is deemed to be acceptable by the public at large. While this is the case for all broadcasting, it's noticeable that the vast majority of legislators find in comedy a set of expectations and communicative techniques that require special legislation. For example, Ofcom adopts the Programme Code which its predecessor, the Independent Television Commission (ITC) published, whose aim is to outline 'the editorial standards which audiences are entitled to expect from . . . television services in the UK' (ITC 2002: 2). In protecting children from the potentially damaging effects of television, the Code defines acceptable and unacceptable portrayals. In its sections on violence and sex it notes that comedy can work by slightly different rules than those for serious fiction:

> While it is accepted that stylised violence can be entertaining and often humorous in comedy and in animation, more serious representation, for example, in children's drama, should always be editorially justified and should ensure that the consequences of violence are treated appropriately. (5)

> Much great fiction and drama have been concerned with love and passion which can shock and disturb. Popular entertainment and comedy have always relied to some extent on sexual innuendo and suggestive behaviour but gratuitous offence should be avoided. (9)

While neither of these edicts makes clear what 'gratuitous offence' and 'appropriate' treatment are, they acknowledge that comedy's boundaries are somewhat different to those for other kinds of programming. Regulators such as Ofcom base their Codes on audience research, and this advice is therefore seen to reflect the consensus of the British population. In Australia, similar edicts apply. The publicly-funded Australian Broadcasting Corporation's (ABC) Code of Practice (2007) rules against language or images which 'convey prejudice' or 'reinforce stereotypes', but adds the caveat that this does not prevent content 'presented in the legitimate context of a humorous, satirical or dramatic work' (4). Australian commercial television, on the other hand, is regulated by the government agency, the ACMA, which defines programme acceptability by schedule, which works from the assumption that the kinds of audience watching a programme is correlated to when it is on. The ACMA restricts violence within programming likely to be seen by children, stating that such programmes,

> must include no material which involves . . . punches, blows or other physical or psychological violence against people or animals (other than in sequences that clearly depict comedy or slapstick behaviour). (2004: 29)

The insistence that comedy must 'clearly depict' its intent is a statement of genre, and assumes that genres can be easily signalled by broadcasters and understood by audiences. Running throughout all of this legislation is a certain freedom available to comedy which is not apparent for other types of programming; whether this is evidence of television comedy's 'carnivalesque' (Bakhtin [1965] 1984) nature, or its role as 'only entertainment' (Dyer 1992) is debatable.

The problems involved in ensuring comedy audiences respond to texts in the desired manner are shown by complaints broadcasters and regulators receive in response to perceived unacceptable programming. These complaints are investigated by the regulators who require statements from the broadcasters and come to decisions related to their Broadcasting Codes. For sitcom, these decisions often take into account the comic impetus of such programming. For example, in 2007 the ACMA received a complaint about *According to Jim* (ABC, 2001–), which is broadcast in Australia on Channel Seven (often known as the Seven Network). The complainant stated that 'the storyline contained inappropriate visual and verbal sexual references' (ACMA 2007: 2) such as 'sexual role play fantasies, partner swaps, and, sex toys' (3). The episode had been broadcast at 3 p.m. and was rated PG, which the ACMA notes means 'presentations of adult

themes or concepts . . . must be mild in impact and remain suitable for children to watch with supervision' (2) and 'Visual depiction or verbal reference to sexual behaviour must be restrained, mild in impact and justified by the story line or program context' (3). Channel Seven justified the broadcast as the 'references to sex, although relatively frequent . . . are generally portrayed through innuendo, suggestion or implication and therefore beyond the comprehension of children viewers' (4). The ACMA disagreed, and found that 'while younger children may not understand the references in these scenes, older children may do so', and that the frequency of the depictions 'were not restrained, and that their impact exceeded mild' (5). The complaint was therefore upheld.

Such a ruling works from assumptions about the abilities and knowledges of children of various ages and the cumulative impact of frequent depictions of sexual behaviour. Of generic importance is that the ACMA, in its final ruling, notes that the sexual material 'is presented within the context of a scripted comedy which mitigates the impact of the material to some extent' (5) showing how such decisions respond to assumptions about types of programming. The ruling does not go on to say how the comedic nature of the text mitigates against its content or to what extent; the assumption is simply that presentations of unacceptable material are in some way excused or made less threatening when comedy is included to soften the blow. In this instance the humour was not powerful enough and Channel Seven were still censured for the broadcast, but it's worth noting the small amount of extra freedom sitcom is perceived to have and therefore the assumptions this makes about the expectations audiences bring to comedic texts.

This notion of generic context is complicated further in a similar adjudication made by Ofcom concerning the family sitcom *The War at Home* (Fox, 2005–7) which is broadcast in the UK on Channel 4 and E4. As Ofcom notes:

> In this episode, the entire family, including the grandmother, became involved in different ways with the use of marijuana. A viewer complained that the programme normalised drugs and did not show the negative implications associated with the use of marijuana. (2007a: 10)

The episode was shown on Channel 4 at 8 p.m., and the broadcaster notes that its content 'led to discussions at senior level within the channel' which concluded that this was an acceptable pre-watershed broadcast as 'this slot was usually reserved for material aimed at older members of the family' (ibid). However, the broadcaster also notes

that this is a programme also shown at the earlier time of 7.30 p.m. on the youth channel E4, and had decided that its content made it unsuitable for this slot; this can be read as a statement concerning channel as much as it can timeslot. This adjudication was eventually resolved, with Channel 4 agreeing that the broadcast had been inappropriate, and making assurances that the episode would not be broadcast pre-watershed again. In its decision, though, Ofcom makes a statement about imported American programming:

> Ofcom recognises that this is an American sitcom, reflecting cultural values which may differ to those in the United Kingdom. It is not unusual for American sitcoms to take a comedic approach to the theme of drug use and UK viewers are familiar with this. Given the American context of the programme, it is conceivable that younger viewers would distance themselves from the scenes, interpreting them as fictional and removed from reality. The American context of this programme could, therefore, potentially provide editorial justification for the content of the episode. (Ofcom 2007a: 10–11)

This means that while Channel 4 admitted its mistake and Ofcom, in the end, censured the broadcaster for showing programming with explicit drug use before the watershed, the regulator decided to include this paragraph acknowledging cultural differences and audiences' awareness of them. The assumption that younger viewers would 'distance' themselves from the content purely because the programme was American suggests that the viewers whom society most worries about have a strong generic and cultural awareness which means they can define programming as unrelated to their everyday lives from an early age. This also shows how genre is inflected through cultural and national differences, which, in turn, defines possibilities for programming. What this suggests is it is possible for an American sitcom to portray drug use on British television before the watershed if done in an (undefined) suitable manner: at the same time, it suggests that a British sitcom could *not* offer such as depiction. The generic boundaries are here defined by nation; more than that, they are defined by the nation of production and not the nation of broadcast. This suggests countries all over the world could possibly have different responses to this sitcom episode, all of which negotiate the specificities of that country and expectations for imported American programming. In that sense, imports might be 'mere interlopers' (Rixon 2003: 49) read by audiences as different to home-grown programming, but they appear to be ones which, in some cases, have more freedom than indigenous programming.

International differences and similarities in regulating and pro-
tecting television audiences can be seen in the various ways in which
regulators and broadcasters responded to *Popetown* (BBC3, unbroad-
cast). Commissioned by the BBC, this is an animated series set in a
fictional version of the Vatican City, focusing on Father Nicholas's
efforts to keep an infantile Pope on a pogo stick out of trouble. In
finding humour in sexually deviant priests and the corrupt nature of
the Catholic Church, the programme inevitably caused controversy
and many groups campaigned for its removal before it was broadcast.
In Britain the programme was never shown, after 'executives decided
it was not funny enough to justify the potential offence it could
cause to Christians' (Armitage 2006: 6); this was despite an invest-
ment of £2.4 million into the series (New Zealand Herald 2005: 8).
The programme was broadcast on New Zealand's C4 in 2005, MTV
Germany in 2006 and on MTV Baltics in Lithuania in 2007, with
showings on other MTV networks across South America and Eastern
Europe. In New Zealand the Catholic Church lodged a complaint
with the Broadcasting Standards Authority, calling the programme 'a
calculated and deliberate insult to Catholic belief and culture' (quoted
in Saunders 2005: 9); however, this was rejected by the Authority,
who argued that 'the right to satirise, dramatise and laugh at institu-
tions was the "very essence" of free speech' (Dominion Post 2006:
2). The Church responded by calling for a boycott of CanWest, the
conglomerate that owns C4 (Globe and Mail 2005: 6). In Germany,
a 'Stop *Popetown*' campaign was launched, with Catholics calling the
series 'an outrageous provocation' (quoted in Van Gelder 2006: 2).
The programme was broadcast in Lithuania after a ban proposed by
the Lithuanian Bishops' Conference was rejected by the courts (Van
Gelder 2007: 2).

In all, *Popetown* remains one of the most controversial television
comedies ever made and follows in the wake of campaigns concerning
religion and comedy all over the globe. Perhaps the most significant
of these globally were the protests following cartoons of Mohammed
published in the Danish newspaper *Jyllands-Posten* in September 2005,
which occurred on a global scale and resulted in Danish embassies in
Syria, Lebanon and Iran being set on fire (Lewis *et al.* 2008). In Britain,
Jerry Springer – the Opera (BBC2, 2005) remains the most complained
about programme in the history of British broadcasting, with 60,000
e-mail complaints and protests outside the BBC (Mills 2005: 101).
This was a televised version of a stage play that had run in London
since 2003, and depicted Jerry Springer refereeing an edition of his
show in which God and the Devil were the main participants. While

neither of these is a sitcom, they show the extent to which significant sections of the public respond when comedy and religion are brought together. Significantly, the ensuing offence does not rest on the existence of the text, but is a consequence of the dissemination of them in a mass medium. The Mohammed cartoons and *Jerry Springer – the Opera* had been in circulation for some time before the outrage caused by their publication in mass media, and while the BBC decided not to show *Popetown* it has since been released on DVD by its production company. Protests against the existence of such material pale into insignificance in comparison to protests responding to their broadcast. As broadcasters and mass media work by bringing together disparate groups and defining them as an 'audience' they necessarily imply that their content is acceptable to, and representative of, the norms and appropriacies of the mass. That offensive material receives protests only once it enters this mass arena shows that the problematic nature of much television comedy is less to do with its comedic content and more to do with it being on *television*.

The Pleasures of Sitcom

Comedies have no purpose other than their 'primordial fixation upon pleasure' (Herbert 1984: 402), so it's worth thinking about the ways in which audiences get pleasure from sitcoms. As has been shown above in the analysis of complaints about sitcoms, the genre is, like all television, capable of also engendering *dis*pleasure, and nation-states inaugurate legislators in order to come to decisions about what a society can reasonably expect from broadcast comedy. Such displeasure works from assumptions viewers bring to programmes, which are the result of generic and broadcasting factors. It's reasonable, therefore, that assumptions of pleasure work in the same way, and broadcasters make clear attempts to define programmes as comically pleasurable prior to them being consumed by audiences. For example, BBC2 has been scheduling comedy programmes (sitcoms, sketch shows, panel shows) on Thursday nights since 2007 under the banner 'Thursdays are funny' which has its own logo and idents. This has included the sitcoms *Saxondale* (2006–), *Lab Rats* (2008–) and *The Cup* (2008). Prior to this BBC2 had defined Mondays as funny, with line-ups that included *'Orrible* (2001) and *Dossa and Joe* (2002). In America, NBC maintained its 'Must-See' line-up on Thursdays for over twenty years (Martin 2003); while this constituted a schedule of dramas and sitcoms, it's most often associated with comedy programming such as *Cheers* (1982–93), *The Cosby Show* (1984–92), *Frasier* (1993–2004) and

Friends (1994–2004). In 2006 NBC rebranded its Thursday nights as 'Comedy Night Done Right', putting together a schedule of single-camera sitcoms that included *Scrubs* (2001–), *My Name is Earl* (2005–), *The Office* (2005–) and *30 Rock* (2006–). In this way, broadcasters place comedy within a particular zone, suggesting that the expectations for the genre transcend individual programmes and can be assumed to be similar for all series defined as 'funny'. This process also marks comedy out as something 'other' than serious fare, ensuring that the delineation between the two is as clear and unambiguous as possible. Giving comedy its own idents and zone suggests that this is not 'normal' programming, and its difference from what can 'normally' be expected from television is apparent. While this undermines the public service broadcasting notion that there is a value in audiences accidentally coming across programmes they might not actively seek out, it also places comedy as a discrete and cordoned-off segment within the context of the rest of television.

This situates comedy as something which audiences might actively seek out, suggesting that viewers will tune into a comedy 'zone' desiring to be made to laugh rather than necessarily because of the appeal of a particular programme or performer. Indeed, the reasons why people should be interested in laughing are complicated and hotly debated. Such analysis often draws from anthropology, which has examined the evolutionary purpose of humour and laughter. William F. Fry (1977: 23) argues that laughter must have some kind of social function for the stresses it places upon the body are so extreme that it's likely humanity would not have evolved the process if it did not have a purpose. That social purpose has been thought about in a variety of ways, often focusing on the liberating (Lipman 1991) and subversive (Jenkins 1994) nature of comedy. The key analysis in this respect is Mikhail Bakhtin's theory of the carnivalesque ([1965] 1984), which argues that comic behaviour fulfils a communal function of bringing people together to ridicule and mock institutions, such as the church and governments, which constrain and control everyday behaviour.

Analysis of the sitcom has often been engaged in debates concerning to what extent television comedy fulfils the anarchic social roles it is seen to have traditionally had, with textual analysis standing in for the actual responses and readings of real audiences. Indeed, debates about appropriate comic content which have plagued broadcasting ever since it began struggle with the problems of aggregating millions of comic responses into national broadcasting structures. In terms of academic analysis, it's probably more telling that the research which has examined the ways in which actual audiences make sense of comedy

is extremely rare; indeed, the banishment of certain kinds of comic content from broadcasting because of its reactionary and offensive nature is an act which in no way took into account actual audiences' responses to such humour. It is stating the obvious to make a call for more audience research for all forms of media and culture; for a genre such as the sitcom which actively incorporates the audience into its texts it's even more of an oversight that such audiences are absent from debates about comic appropriacy. This means that academic and policy understandings of the comic responses of millions of individuals have been guilty of neglecting the specificities of such responses in a manner which mirrors the sitcom laugh track's homogenous nature. This is a shame, as examining what audiences *do* with sitcom would broaden the ways in which the genre can be understood and explored. So while the audience remains a central and verifiable aspect of sitcom's textual elements, what actual people do with the genre, and what they laugh at, are confused by, are offended by, and are oblivious to, remains a mystery indicative of the 'textualist assumption' (Mittell 2004: 2–11) of much genre studies.

6 The Future

Vaudeville died, didn't it? Music hall died. And I think we have to be aware of the possibility that sitcom has died.
(Bill Dare 2005)

The future of the sitcom may be bleak: received wisdom is that it is a 'dead' genre. For example, in 2006 Channel 4 broadcast *Who Killed the Sitcom?*, an analysis of the genre which gave it a pretty sick bill of health and saw it as a victim of changes in broadcasting, technology and audiences. After all, the recent history of international broadcasting is usually written in terms of the rise of reality television and factual entertainment programming, for such series are cheaper to produce than scripted material, are highly flexible and can run for long periods thus ensuring audience familiarity. Alongside this has been the development of 'quality' television drama, whose high production costs are offset by overseas sales and revenues available from DVD box sets. Academic work has responded to these shifts, and a wealth of books has recently been produced covering 'quality' drama (Jancovich and Lyons 2003; Hammond and Mazdon 2005; McCabe and Akass 2007; Nelson 2007) and reality television (Bignell 2005; Hill 2007; Holmes and Jermyn 2004); the sitcom, on the other hand, remains a relatively unexamined form. Considering *Who Killed the Sitcom?* was presented by David Liddiment, a respected director and producer of sitcoms such as *Surgical Spirit* (ITV, 1989–95) and *Up the Garden Path* (ITV, 1990–3), the pronouncement that the sitcom is dead can be seen as a fairly incisive indictment from someone inside the industry.

It's worth thinking about what is meant by the term 'dead', for it can be interpreted in a variety of ways. Firstly, it can be dead in terms of industrial production; that is, the high costs and risks associated with sitcom have reduced the amount of money broadcasters are willing to invest in such programming, and so sitcom is 'dead' simply because there's a lot less of it about. It's certainly the case that in Britain ITV,

which has a long heritage of high-rating sitcoms, spent much of the beginning of the twenty-first century with no slots available in its primetime schedule for sitcoms. The genre can also be thought of as 'dead' because it fails to garner the audiences it once did. So, while all programming in Britain has seen its ratings decline because of increased competition, this is most noticeable for sitcom and the days when the most-watched programme in a week could be a sitcom seem a long time ago. In fact, in the 1990s programmes such as *One Foot in the Grave* (BBC1, 1990–2000) and *Only Fools and Horses* (BBC1, 1981–2003) regularly topped the charts, while others such as *The Royle Family* (BBC2/1, 1998–2000, 2006, 2008), *Men Behaving Badly* (ITV/BBC1, 1992–8) and *Absolutely Fabulous* (BBC2/1, 1992–6, 2001–4) were hitting the ten million mark. The loss of audiences for sitcom is a significant shift for a genre that not only usually defines itself as 'popular' but also draws on the communal nature of broadcasting for much of its potency.

A final way in which the genre can be thought of as 'dead' is in terms of its creativity. As has been noted, sitcom has often been thought of as responding to, and defining, the eras which produce it, and the kinds of things which can and cannot be joked about are a significant social barometer. *M*A*S*H*'s relationship to the Vietnam war is as telling as *Whatever Happened to the Likely Lads?*'s comic exploration of significant changes in the class system in Britain in the 1970s; similarly, *Men Behaving Badly*'s 'new lad-ism' could be seen to define gender politics in Britain in the 1990s, just as *Murphy Brown* (CBS, 1988–98) had done in America. While sitcom inevitably draws on the era of its production for some of its meaning, it's argued that it's harder to see contemporary programmes as being solely and definitively about now; *Two and a Half Men* adopts the 'incomplete family' structure that can be traced back via *My Two Dads* (NBC, 1987–90) and *Diff'rent Strokes* (ABC, 1978–86) to programmes such as *Julia* (NBC, 1968–71), just as *The Office*'s examination of the workplace has precursors in *The Rag Trade* (BBC, 1961–3), *The Dustbinmen* (ITV, 1968–70) and *Drop the Dead Donkey* (C4, 1990–98). So, while the 1970s can be seen as a time in sitcom's history where it outraged audiences in many countries due to head-on examination of social changes, and the 1980s Alternative Comedy boom ushered in a raft of new comedians and altered the kinds of jokes which could and couldn't be told, it's hard to see how sitcom since the dawn of the new millennium could similarly be categorised as defining the age.

To think about the future of sitcom is, then, to have a rather bleak outlook. Certainly those within the industry felt that things were never as hard as they are now, and many of them expressed defeat in the face

of the success of reality programming and the need for broadcasters to garner substantial audiences quickly, arguing that sitcom needs time to be nurtured in order to be successful. For example, Jeff Zucker, the CEO and President of NBC Universal, insists that:

> Gone forever . . . are the *All in the Family*s, the *Friends*, the *Mary Tyler Moore*s, those great, fit-for-every-demo sitcoms that sucked up huge audiences and delivered vast swaths of advertising-friendly viewers. 'It was a lot simpler back then,' Zucker laments, 'when there were three networks and you could run your programs once and repeat them twice and that's all you had to worry about.' (Greenfeld 2008: 87)

In order to cut costs NBC has decided that it will now commission only five pilot episodes of programmes a year, when it has traditionally commissioned about twenty; while Zucker hopes that this will encourage the broadcasters to 'have the courage of [their] convictions' (Greenfeld 2008: 130), suggesting a more fruitful relationship between programme-makers and the networks, commissioning fewer pilots clearly has implications for the amount of money in the broadcasting industry making its way into comedy. Nick Lacey notes that genres are 'cyclical'; while it's desirable to the see the current state of the sitcom as representative of all genres' tendencies to go through 'rise and decline', the fact that he also sees some genres having a limited '"life"' cycle' (2000: 225) could be seen as sounding the death knell for the television sitcom: the outlook is pretty bleak.

However, as many interviewees noted, the death of the sitcom has been heralded many times before. As Jon Plowman eloquently put it, 'I think that the death of the sitcom is much predicted and much talked about and probably bollocks' (2005). Similarly, Sioned Wiliam (2005) had a newspaper article from 1967 about the death of the sitcom. Indeed, the television industry repeatedly offers predictions of doom and gloom, at least partly because all industries must maintain a facade of difficulties in order to avoid further regulation and taxation being imposed upon them. Perhaps what is most significant about this recurring pessimism is that the decline of the sitcom can only be a recurring topic if it's assumed that the genre *matters*; the fact that so many executives and creatives, as well as audiences and reviewers, bemoan the lack of high-rating, era-defining sitcom shows that there's a hunger for the genre to occupy precisely this position, and to give audiences a form of entertainment and pleasure that it cannot find anywhere else. None of the people I interviewed suggested they were going to give up writing comedy or fighting the protracted battles to get it made; furthermore,

broadcasters all over the globe continue their search for the sitcom that will reach big audiences, garner critical acclaim and offer impressive returns on their investment. For Charlie Higson, 'people always need different kinds of comedy' (2008); the death of the sitcom would herald the death of a certain kind of communal conversation, and it's hard to see any society willingly allowing that to happen.

Current Trends

Before offering predictions for the future of sitcom, the current state of play for the genre needs to be outlined, summarising the ways in which the genre has developed in the last decade. Genre theory has consistently noted the ways in which programming types develop and how newer forms respond to the expectations instituted by previous programming. However, sitcom has often been defined as 'remarkably stable' (Hartley 2001: 65), and the genre has been seen as less experimental – particularly in terms of its aesthetics – than other kinds of programming. And it's certainly the case that the 'traditional' sitcom exists and continues to flourish. *My Family* (BBC1, 2000–) and *After You've Gone* (BBC1, 2007–8) are the most-watched comedy programmes on British television, just as *Two and a Half Men* gets the highest ratings of any sitcom in America. Each of these shows conforms to the generic characteristics the sitcom developed in its early stages, and each is shot using the 'three-headed monster' model in front of a live studio audience. In constructing their narratives around the family, they also employ the 'traditional' domestic settings which have been crucial throughout the sitcom's existence. It's noticeable that none of these programmes is critically lauded, and none of them has been explored by academics either. As the writer Steven Moffat noted, 'audience sitcom is currently the uncoolest thing in the world' (2005). In some way these are 'invisible' programmes, whose reach, success and popularity seems to occur quite out of kilter to the ways in which television is talked about within academic and critical circles. However, it must be borne in mind that while these programmes continue to define mass, mainstream sitcom, there are fewer such series being so successful than would have been the case decades ago. That 'traditional' sitcom can exist in a space where it is rarely talked about and examined shows how there is an assumption that the more 'interesting' comedy is happening elsewhere, and I want to suggest that there are two other kinds of sitcom currently being broadcast, both of which define themselves in terms of their look and aesthetics.

The first is sitcom which has the realist/naturalist look of drama and/

or documentary, and is programming which therefore places itself in relationship to forms and aesthetics normally distinct from comedy. Such programming resolutely rejects the theatrical nature of sitcom, abandoning the laugh track and offering a visual style which positions the viewer as an observer of everyday behaviour. There are two ways in which this is carried out. The first is through the adoption of documentary aesthetics, in series such as *The Office, Marion and Geoff* (BBC2, 2000–3) and *Summer Heights High* (ABC, 2007); each of these programmes is a mock-documentary and the characters speak directly to the camera in the manner of such factual programming. These series can be seen as a response to the growth in popular factual programming in global broadcasting in the 1990s and the British series recreate the characters and visual style of the 'docusoap boom' on British television in that decade. Elsewhere I've categorised these programmes as 'comedy vérité' (Mills 2004; see also Dunleavy 2008), arguing that they function as powerful critiques of the ways in which factual programming presents itself as 'authentic' to its viewers, examining the performative nature of these who take part in them. In contrast to the 'traditional' sitcoms outlined above, those series *have* garnered critical and academic attention, with *The Office* in particular becoming a global format which has won awards all over the world.

The second realist/naturalist form of sitcom is that which looks like drama and so draws on the conventions of, in Britain in particular, the soap opera and social realism which has always been a part of broadcasting conventions. While their aesthetic may be quite similar to those of 'comedy vérité', they are not mock-documentaries. So, while *The Royle Family* can be seen to grow out of representations of the working-class North which are central to British culture, its characters do not break out of the fourth wall and talk to the audience as they would in a docusoap. Similarly, even though *Gavin and Stacey* draws on the clash of families drawn together by marriage which has been the staple of sitcoms such as *Soap* (ABC, 1977–81), *Mixed Blessings* (ITV, 1978–80) and *Just Good Friends* (BBC1, 1983–6), it is not shot like a traditional sitcom. There is no laugh track, and the programme employs a larger amount of location filming than the usually studio-bound sitcom. These programmes find humour in observed behaviour rather than jokes, and we're meant to find funny things like Stacey's mom's recurring interest in offering people omelettes, a detail which neither the performance nor the editing signals and which only becomes funny through repetition. In a sense, such programming doesn't need to be filmed in this way; while the 'comedy vérité' programmes necessarily adopt the aesthetics of the form they're mocking, the realist approach

could be seen as nothing more than a way to distinguish a programme from the connotations of 'traditional' sitcom. Other programmes adopting such a style includes *The Smoking Room* (BBC3, 2004–5), *Early Doors* (BBC2, 2003–4), *Pulling* (BBC3, 2007–9), *Rob Brydon's Annually Retentive* (BBC3, 2006–) and *Nighty Night* (BBC3, 2004–5).

In addition to the traditional sitcom and the realist/naturalist sitcom, there is a third current trend which draws on recent developments in television's use of the image. Karen Lury suggests that the television image can both dramatise and demonstrate; the former acknowledges its 'artifice' (2005: 18) and is commonplace in non-factual programming such as drama and quiz and game shows, while the latter, common in documentary and news, instead has 'a claim to reality' (18). Yet Lury is keen to note that the distinctions between such images do not neatly correlate to the differences between fictional and factual programming and, through an analysis of *CSI: Crime Scene Investigation* (CBS, 2000–) she shows how contemporary television 'commonly blurs the distinction between images as evidence and as illustration' (44). This means that '*CSI* is a programme that is entirely self-conscious about its use and manipulation of the television image' (56), resulting in a programme whose 'look' is vital to its meaning and central to the pleasures it offers. The idea that the 'look' of television might be one of the pleasures that the medium offers is often seen as a recent development, which takes into account newer technologies such as widescreen and plasma television sets and high-definition broadcasting: authors such as Jonathon Bignell, however, question the notion that television has hitherto adopted a 'zero-degree style' (2007: 159).

That said, it is perhaps convincing that there is a strand of contemporary sitcom which makes an explicit display of its use of the image, and this foregrounding of the look of such programming marks it as different from traditional sitcom. An example of this kind of programming is *Arrested Development* (Fox, 2003–6), whose setting is the traditional comedy premise of the chaotic and dysfunctional family which has recurred in programmes such as *Soap* (ABC, 1977–81), *No Place Like Home* (BBC1, 1983–7), *Bread* (BBC1, 1986–91) and *My Family* (BBC1, 2000–). Yet the ways in which *Arrested Development* tells its jokes to the audience is quite different to the techniques of traditional sitcom. In its abandonment of the laughter track and single-camera shooting, it has something in common with the aesthetics of the naturalist/realist sitcom, and can be seen as a development which is similarly motivated by a desire to distinguish itself from traditional sitcom. Yet such sitcom uses an extra set of techniques to signal its comic impetus, and these mark it as distinct from other kinds of sitcom.

Many of the jokes in *Arrested Development* can be understood through application of the Incongruity Theory outlined in Chapter 4, for much of the humour relies on the incongruity between the characters' actions and words. This is often achieved through flashbacks and flashforwards, so that immediately after a character says something, the audience are shown them, at a different time and place, doing something quite other. The notion that comedy characters are self-deluding and untruthful runs through much sitcom, but the editing together of actions from different times and places in the programme's diegesis is quite at odds with traditional sitcom's linear narrative structures. Sometimes, *Arrested Development* also contradicts its characters' statements through voiceovers or captions, resulting in a text which uses a wide-range of communicative techniques in order to construct its comedy. In that sense, the programme gets comic mileage out of the distinctions between images which 'dramatise' and images which 'demonstrate', drawing on the conventions of such images in order to set up contradictions whose consequences are humour. A series such as *Arrested Development* therefore appears textually rich, and its mixture of rapid edits, voiceovers, captions and action can be seen as a visual aesthetic which distinguishes it quite noticeably from either the realist/naturalist form or the traditional form of the sitcom.

There are a number of American series which work in this way, such as *30 Rock* (NBC, 2006–), *My Name is Earl* (NBC, 2005–), *Scrubs* (NBC, 2001–) and *Everybody Hates Chris* (UPN/CW, 2005–). There's clearly a way in which, through their glossy production values and appearance of complexity, they attempt to categorise themselves as akin to 'quality' television drama such as *24* (Fox, 2001–), *Lost* (ABC, 2004–), and the *CSI* franchise. So, Jon Silberg (2008) notes that the cinematographer on *30 Rock*, Vanja Černjul, had spent his career working on drama and independent cinema before being employed on that sitcom. Similarly, James Hawkinson, the director of photography on the first series of *Arrested Development*, developed a shooting style for that programme which specifically aimed to 'hide the sitcom's artifice', making it 'closer aesthetically to a reality show' (2004: 108). This involved rejecting the tradition of shooting from the fourth wall, and using zooms and out-of-focus shots which are quite at odds with the organised, clear shooting style of the majority of sitcom. Indeed, Hawkinson argues that 'the cameraman thus became a character in the narrative' (107) for the camera movements and zooms 'tell' the jokes in *Arrested Development* in a manner quite rare in other comedy programming.

Yet there's much in these programmes which can also be related to the traditional ways in which the comic impetus of the sitcom is

upheld. For a start, the reaction shot, which has been the mainstay of the sitcom since the 1950s, remains a necessary and powerful tool in all of these series; the only difference is that the single-camera production technique used in a programme such as *Everybody Hates Chris* means that such reaction shots are often framed slightly differently to traditional sitcom, and often employ a wobbly camera. Indeed, *30 Rock* has moved from being shot on single camera to having two cameras covering the action, with each performing very similar roles to those used in traditional sitcom, allowing narrative space in which comedy performances are best captured (Silberg 2008: 67). Similarly, *Arrested Development* quickly moved back 'into more traditional coverage' in its shooting style after problems arose in making the jokes 'work' in the editing suite, and the programme employs 'high-key lighting . . . in common with traditional sitcoms' (Hawkinson 2004: 108). As both of these programmes, show, then, the gloss of 'quality' television appears to be compatible with sitcom, yet in order for such series to signal their comic impetus they have found that adopting a shooting style which draws on the one traditional for the genre is necessary.

Perhaps, then, more significant in these programmes is that while the abandonment of the laugh track is a clear indicator of a desire to be read as 'quality', the sound of the audience laughing has been a useful generic signifier for decades and not employing it risks confusing audiences as to the intentions of the programme. In all of these series, then, incidental music not only signals the programme's comic intent, but also highlights the punchlines of particular jokes. *Scrubs*, for example, very often ends comic scenes on a close-up of one of the characters' faces, usually reacting in a theatrical manner to some absurdity; the end of the scene, and the comic response the audience is invited to have, is signalled through a short sting of music, often a few beats of a drum or a quick chord of a guitar, which continues into the opening action of the next scene. While a different noise, the sound is situated in exactly the same place as the roar of the crowd on a traditional sitcom's laughter track and offers it the punctuation of laughter in precisely the same way. Jonathan Gray calls this interplay between different representational modes, '*Scrubs*' magic realism' (2008a: 33). So while these programmes certainly have an appearance which marks them as distinct from other forms of sitcom, the techniques and rhythms required for the successful telling of a joke on television remain intact. They can therefore be seen as indicative of 'television's performance of distinction' (Polan 2007: 261) by which some series attempt to *appear* unlike traditional sitcom because of the cultural worth associated with such 'quality'.

Such programming exists on British television too; *Spaced* (C4, 1999–2001), *Green Wing* (C4, 2004–7) and *Peep Show* (C4, 2003–) are all examples, as is *Roman's Empire* (BBC2, 2007), which was seen by many critics as a reworking of *Arrested Development. Spaced* adopts what has been termed a 'cinematic' style, which describes 'an enhanced visual means of story-telling in place of the dialogue-led television play with its theatrical, rather than filmic, heritage' (Nelson 2007: 11). *Spaced* foregrounds this relationship with cinema through repeated references to cult films such as *The Thing* (John Carpenter, 1982), *The Shining* (Stanley Kubrick, 1980) and *Invasion of the Bodysnatchers* (Philip Kaufman, 1978). The hospital-set *Green Wing*, on the other hand, adopts an initially confusing visual style, with sequences sped up and slowed-down seemingly at random. Sometimes these effects help shorten comically dead moments, such as when shots of characters moving around the hospital are sped up: sometimes they help punctuate a comic moment, such as when slowed-down moments draw out the comic moment, mirroring the pauses in action that accompany the audience laughter in traditional sitcom. *Peep Show*, meanwhile, relies on the comic conceit that we get to hear what the characters are thinking as well as what they are saying, and the distinction between the two offers a humorous incongruity and shows the ways in which individuals mask their true responses in order to remain socially acceptable (Mills 2008a). While not a voiceover in the same manner as that employed in *Scrubs* or *My Name is Earl*, the narrator still helps position the audience in a place where the narrative and events make sense, and has a God-like authority which we are invited to believe.

It's important to consider why some sitcom has adopted these narrative techniques, especially as, as has been noted, in many cases they are a visual style that is in addition to, rather than a replacement for, the comic techniques of traditional sitcom. It's telling that all of the British examples come from Channel 4, which states in its Annual Report that 'comedy is a rich source of innovation, and innovation is Channel 4's life blood' (2007: 13). Indeed, for some of the interviewees I spoke to, *Green Wing* could be seen as an experiment in commissioning extravagance, for the programme had a production schedule and cost far in excess of that typical for sitcom and approaching that for high-budget drama (Greig 2008). Similarly, *Arrested Development* was made by Fox which, although often demonised as the product of Rupert Murdoch, has a heritage of experimenting with highly influential comedy, such as *Married . . . with Children* (1987–97), *The Simpsons* (1989–) and *Family Guy* (1999–2002, 2005–). Fox has also attempted to reach audiences underserved by the major networks in America, and Kristal Brent Zook

(1999) shows how its early programming was clearly aimed at African-American audiences. HBO has made similar inroads into comedy, and with programmes such as *The Larry Sanders Show* (1992–8) and *Flight of the Conchords* (HBO, 2007–) has repeatedly adopted a visual style which is distinctly not traditional (Feuer 2007). And in Britain, BBC3's remit to reach out to younger audiences not served by the rest of the Corporation's output has resulted in programmes such as *Ideal* (2005–), *Nighty Night* and *The Mighty Boosh* (2004–).

Such experimentation can be seen to equate with notions of 'art' cinema which valorises texts that allow for ambiguity and confused character motivation, in conjunction with a foregrounding of visual style (Bordwell 1979). Christine Geraghty notes that 'Most textual analysis of television pays attention to narrative . . . but devotes less space to other elements such as the audio and visual organization' (2003: 33); however, analysis of the sitcom *has* often explored how the genre 'looks'. That said, recent work on 'quality' television has often focused on the visual and aural nature of newer forms of programming, such as Peter Kaye's examination of the 'musical innovation' (2007: 222) in series such as *thirtysomething* (ABC, 1987–91) and *Studio 60 on the Sunset Strip* (NBC, 2006–7). Furthermore, 'quality' television makes links with 'art' cinema through the concept of authorship, and Janet McCabe and Kim Akass note that 'Reliance on an authorial vision driving the project finds HBO placing a high premium on the kind of authorship more commonly associated with traditional art forms carrying high cultural kudos' (2008: 87). Central to this notion is that 'quality' television is therefore a product whose high cultural standing rests only partly on textual content; its categorisation is also dependent on industrial and promotional aspects which help place a programme within a particular category regardless of its content.

For Pierre Bourdieu, the distinctions made between different cultural forms have significant social consequences, for they help construct 'a social hierarchy of the consumers' (1979: 1). That is, demonstrating knowledge of particular kinds of culture helps individuals gain access to certain social groups, and such social categorisations are related to inequalities in social power. Ideas of niche marketing in contemporary broadcasting help foster such distinctions, as 'quality' television remains associated with particular broadcasters such as HBO. The similarities between some forms of contemporary sitcom and David Bordwell's analysis of 'art' cinema shows how such programming offers itself up to be understood as something quite other than 'mainstream' programming; in doing so, it also signals its distinction from, and disdain for, the mass. In a broadcasting context in which '*niche* is

the new normal' (Harris 2008: 93, italics in original), the movement away from mass, public service broadcasting is one in which popular forms such as the sitcom become valuable tools in demonstrating cultural capital. The abandonment of the 'traditional' sitcom, along with its contemporary association with lower 'quality' than that of newer forms, is therefore a highly ideological move in which the sitcom becomes embroiled in ongoing tussles over cultural distinctions. I'd want to suggest, then, that these newer forms of sitcom can be understood as 'comedies of distinction'; that is, that these are sitcoms which offer audiences the pleasures of *not* being traditional, and engage in industrial and textual work in order to distinguish themselves from traditional sitcom as much as possible. It's hard to argue that newer forms of sitcom are *funnier* than traditional ones; the fact that certain audiences might find them so can then instead be understood as indicative of categorised responses and preferences which are likely to correlate with social distinctions. It's therefore perhaps highly problematic that the academic community seems much more comfortable writing about such 'comedies of distinction' rather than 'traditional sitcom', and does so using criteria which foregrounds those aspects of such programming which most actively distinguish them. In finding sitcom a worthwhile text for analysis primarily within the context of 'quality television', such academic 'communities of taste' (Bennett 2006: 194) demonstrate their own cultural distinctions.

This means that a programme such as *Two Pints of Lager and a Packet of Crisps* (BBC2/BBC Choice/BBC3, 2001–) remains untouched by academic interest. Indeed, *Two Pints . . .* offers an interesting case study for the analysis of the disparity between success and critical appreciation. Currently one of the longest-running sitcoms on British television, it has given a space for a wealth of new writers to see their work on screen, and its collaborative writing process gives untested talent a supportive space in which to experiment. In addition, the programme receives noticeably higher ratings than most of the output on BBC3, and this remains true when the series is repeated. Yet the fact that it is shot in the traditional manner means that it is not one of the 'new comedies' with high amounts of cultural capital (Bennett 2006: 193). Indeed, the fact that the programme is popular may be something which counts against it, for Bourdieu notes that cultural goods lose their 'distinctive value as the number of consumers inclined and able to appropriate them grows. Popularization devalues' (1993b: 114). The writer Paul Mayhew-Archer proposed a similar argument, stating that 'there's a lot of snobbishness about popular culture' (2005) precisely because it is popular. Similarly, Richard Dyer explores how historically

'entertainment' 'became identified with what was not art, not serious, not refined' (2002: 6), and it's certainly the case that 'entertainment' has always been the most difficult to justify of the 'inform, educate, entertain' triptych which has commonly defined British public service broadcasting. When thinking about the 'death' of sitcom, the key question should be why it is that traditional sitcom has lost much of the social position it once had, to the point where some creatives working in broadcasting refuse to be associated with it. As Sioned Wiliam (2005) notes, 'It's very difficult for actors to be in comedies now. It's very difficult to get companies to want to make them, because they're fed up of being crucified for daring to try and make a sitcom.'

As 'quality television' has developed, the cultural legitimacy associated with it has rested on programming signalling as clearly as possible that it is different from what preceded it; analysing the content of broadcasting, however, shows that what television is *about* has changed very little, and structuralists would argue that it is nigh on impossible for storytellers to tell new kinds of stories if they want their programmes to remain intelligible. The only option available to creatives desiring cultural legitimacy, therefore, is to alter television aesthetics, and this has been achieved through visual styles often read as 'better, more sophisticated, and more artistic than the usual network fare' (Thompson 1996: 13). For these reasons, traditional sitcom has become the scapegoat of a cultural hierarchy that necessitates certain texts to be defined as less worthy: the naturalist/realist mode and the comedy of distinction mode can, then, be read as the sitcom repositioning itself in order to protect its future by denying its links to the past.

That some forms of sitcom should see themselves as distinct as possible from 'traditional' comedy programming is seen in *Extras* (BBC2, 2005–7). In that programme, Ricky Gervais plays Andy Millman who, over the programme's two series, moves from being a desperate extra playing background parts in a range of films and television programmes to the writer and star of a successful sitcom, 'When the Whistle Blows'. In this sitcom-within-a-sitcom, Millman plays Ray Stokes, the manager of a factory in Wigan who repeatedly rebukes his staff with the catchphrase, 'Are you having a laugh?'. 'When the Whistle Blows' is as 'traditional' as it can be; we hear the live studio audience laughing, as the characters wear ridiculous costumes, engage in absurd misunderstandings and the whole is performed in an excessively theatrical style, replete with comedy accents and facial gurning. *Extras* deals with Millman's responses to his programme's success and his difficulty in squaring the programme's high profile with the lack

of credibility it gives him. Throughout the series, 'When the Whistle Blows' is presented as outdated, embarrassing and low quality and, in the final episode of *Extras*, Millman becomes a contestant on *Celebrity Big Brother* which results in him delivering an outburst bemoaning the atrocious and uninventive state of British television as a whole. *Extras* is thus an impassioned and angry piece of television in which the overlap of Gervais and Millman is apparent; the programme seems to state that sitcom is an either/or choice, for enjoying the 'quality' comedy programming which is associated with Gervais is incompatible with finding pleasure in a traditional programme such as 'When the Whistle Blows'. It calls for a future which abandons the past, which might seem a bit unfair to those millions who enjoy *My Family*.

Of course, there are problems in categorising sitcom in this way, not least because, as Chapter 2 showed, there are problems in all generic categories. It would be possible to argue, for example, that *Peep Show* is better placed in the realist/naturalist category than as a comedy of distinction, for its gloomy colours and downplayed performances suggest a kind of naturalism. While such debates could rage endlessly, the most significant point is that a range of programming is keen to insist that it is *not* traditional sitcom, desperate to avoid the old-fashioned, non-quality associations that kind of television appears to have. As has been noted, the cultural capital associated with certain kinds of comedy far outreach those of others for certain demographics and such audiences are ones broadcasters are often keen to attract. Traditional sitcom is under attack from another angle too, though: new technologies.

New Technology

Much has been said about the possibility for new technologies to offer alternative ways of delivering media content, and the challenge this poses for traditional broadcasters. The ability for television programmes and clips to be distributed via the Internet not only makes it hard for broadcasters and programme-makers to control rights to programmes; it also allows comedy writers and performers to distribute their work without recourse to networks and broadcasters. The challenges which this poses traditional broadcasters are many, especially as younger viewers spend less time watching television 'because they are dividing their time between an expanding range of media consumption opportunities (for example, using social networking sites, downloading music or video clips and playing video games)' (Ofcom 2008a: 152). Capturing the 16–24 age bracket has resulted in a number of British television channels rebranding themselves and comedy has

been a key aspect of that development; thus in 2007 UKTV Gold2 became Dave, while in 2008 BBC3 relaunched as a 'pan-media operation' (147) which aims to offer viewers a variety of ways to access its programmes and invite audiences to be a part of the channel's creative process. Thus viewers can upload homemade continuity links to the channel's website, which are then used to introduce programmes. Similarly, entertainment programming such as *Upstaged* (2008) and *The Wall* (2008–) use lots of user-generated content, with viewers at home shooting material that is then incorporated into the broadcast. Perhaps most tellingly, all of BBC3's content is now simultaneously broadcast on the Internet and television and, in some cases, previews are available on the website prior to their being broadcast (170). As the BBC has noted, this has meant that BBC3 has increased its reach among the 16–34 age group and this has been fostered by material available online (BBC 2008a: 9).

The 16–34 age group is seen as significant for public service broadcasting in Britain because unless such viewers develop a relationship with television at a young age, they are unlikely to use such services and therefore maintain support for the licence fee when older. This is of concern at a time when support for the licence fee among the British population has dropped below 50 per cent (Gibson 2008b). There is some evidence within this research that while the majority of the British population support the kinds of programming the BBC makes, it is the institution itself which is seen as suspect, and it therefore may be seen as emblematic of large corporations whose power stifles the voices of others. BBC3's attempt to involve audiences in programme-making, then, could be a shrewd move in which the simple act of inviting viewers to introduce the programmes they like is seen as a way of connecting the institution to the public it serves.

For the sitcom, BBC3 is a significant development, for the channel clearly equates the ability to attract 'younger', 'harder-to-reach sections of the audience' with comedy (BBC 2008b: 19). It defines itself as 'the UK's leading digital channel for new comedy ideas and talent' (ibid.); indeed, it signals its priority in terms of the BBC's institution-wide commitment to 'stimulating creativity and cultural excellence' solely through comedy and entertainment. This has resulted in series such as *The Mighty Boosh*, *Pulling*, *Gavin and Stacey* (2007–), *How Not to Live Your Life* (2008–), *Clone* (2008–) and *Trexx and Flipside* (2008–). The BBC has also announced that the sitcom *Fresh!* will be delivered via its online section 'BBC Switch', the first time that comedy has been commissioned by the Corporation specifically for broadcast on the web. 'BBC Switch' is the Corporation's new 'teen offering' (BBC

2008c: 33) and is a range of programming, covering music, drama and factual, which is broadcast on television, radio and online. Its intention is to attract teenagers through content which can be accessed via a range of media, in response to the perceived collapse of the boundaries between various media. That comedy should be at the heart of such an initiative shows an assumption about the kinds of programming enjoyed by younger viewers; it all suggests that comedy is seen as a mode that can work well across a range of media.

The BBC has also made much of its content available online, through its highly successful iPlayer service. Indeed, this is now commonplace among British broadcasters, with Channel 4's '4oD' service, and ITV's 'Catch Up'. The BBC now also has its own channel on YouTube (http://www.youtube.com/BBC), which is a significant step for a broadcaster that has always valued its ability to control the broadcasting infrastructure through which its content is delivered. Indeed, YouTube represents a significant development for the ways in which texts can be distributed, and many of its clips are comedic. The Internet has allowed performers unable (or unwilling) to produce material within the traditional broadcasting system to distribute their work, though, as many have noted, it's important not to overstate the challenge this poses the networks.

Online sitcoms include programmes such as *Daisy Power* (http://www.daisypower.com/, 2008–), which is created, written by, and stars the actress and model Ashlie Rhey. Rhey plays the titular Daisy, who dreams of communicating with her guardian angel, much to the chagrin of her down-to-earth friend Mary. In *Mr Deity* (http://www.mrdeity.com/, 2006–) God looks down on his creation and discusses it with his assistant, Larry; like *Daisy Power* the production crew and the cast are the same people. *The Junkies* (http://www.notbbc.co.uk/junkies/, 2000) was a sitcom pilot which, in the promotional material on its website, makes much of the fact that whereas traditional comedy costs around £200,000 to make, it was produced for only £3,500. Indeed, it was made by established comedy professionals; the writers Jane Bussman and David Quantick have worked on series such as *Brass Eye* (C4, 1997, 2001) and *South Park* (Comedy Central, 1997–) while the performers Sally Phillips, Peter Baynham and Peter Serafinowicz are faces recognisable from programmes such as *Smack the Pony* (C4, 1999–2003), *The Saturday Night Armistice* (BBC2, 1995–9) and *The Peter Serafinowicz Show* (BBC2, 2007–). That *The Junkies* is distributed via a website called 'Not BBC' shows how it attempts to distinguish itself from the connotations of that broadcaster, and the claims about the cost appear to define the programme as something quick and

cheap, quite at odds with the lengthy commissioning processes and restrictive professionalism of conventional broadcasters.

Such online fare raises many questions concerning the generic conventions for the sitcom. The episodes for many of these series are only a few minutes long rather than the half-hour format standard for sitcom. While they are structured around regular characters and settings, they could be thought of as akin to recurring sequences in sketch shows such as *The Fast Show* (BBC2, 1994–2000) and *Little Britain* (BBC3/1, 2003–6). Furthermore, while these programmes take advantage of the new possibilities for distributing sitcom, they employ extremely traditional techniques in their making. *Daisy Power*, for example, has the aesthetics of traditional sitcom, including a laugh track, and its ditzy, glamorous female lead can be traced back to series such as *I Love Lucy* (CBS, 1951–7). The Internet offers an interesting development for genre, especially as production is less likely to be tied to institutional structures which place programming within generic categories. Yet, so far, much programming made for the Internet looks extremely traditional; in fact, it looks far more traditional than that being made by traditional broadcasters. Perhaps this is a result of Internet broadcasting's lack of promotional material; that is, while traditional broadcasters can use promotional material to generically place a programme before audiences have even seen it, it's likely that many viewers stumble across comedy on the Internet and so clear cues are necessary in order for the comic impetus to be apparent. What this suggests is that while the Internet offers a significant development in the distribution of programming, at the present it appears to do less so for programming content.

This can be demonstrated through analysis of sitcoms broadcast by traditional networks that have attempted to respond to the possibilities of new technology. An example of this is *iCarly* (Nickelodeon, 2007–), a sitcom about Carly Shay who has her own web show. *iCarly* is, in many senses, a traditional sitcom, in terms of its look and narrative structures. In each episode, Carly is presented with a problem that she then tries to solve; the interactive hook, though, is that the resolution to the narrative relies on Carly giving the viewers some kind of task, which involves them making and uploading videos. Sometimes these videos are incorporated into the programme and sometimes they become part of the programme's website. The programme has been highly successful, with viewing figures of around 4 million, and it is the 'highest rated non-sports program on cable'; in addition the website 'generated 270,000 unique visitors and 1.1 million streams on the week of the premiere' (Thompson 2008). In constructing narratives

which rest on television and the Internet, *iCarly* is a 'convergence comedy' (ibid.) which successfully marries the interactive with the professionally produced. Yet it is telling to note the traditional manner in which the sitcom is made and looks, and how this is quite at odds with the comedy of distinction which abandons traditional aesthetics. Thompson goes on to argue that 'the broadcast networks seem to have passed the sitcom mantel to cable channels that don't seem to fear that young viewers are averse to multicamera sitcom' (ibid.), which suggests a link between audience demographics and a willingness to enjoy different kinds of sitcom. This implies an interesting paradox: while the fact that sitcom could be seen to have 'grown up' because in abandoning its traditional aesthetics it has made itself attractive to older and more educated audiences, it has done so at the same time as younger audiences have found pleasure in the traditional formats because they mesh so easily with newer technologies and invite audience participation. For audiences raised on the vérité and rough-and-ready aesthetic of reality television and YouTube clips, perhaps the aesthetics of traditional sitcom don't have the 'cheap' connotations which older audiences might apply to it (Hill 2007: 66–7). This suggests that there is a split in the ways in which audiences respond to the look of sitcom, and it is *iCarly*'s traditional mode which connotes innovation, with the rough aesthetic a signal of authenticity.

A perhaps more surprising development is the 'satcom'; the situation comedy delivered by satellite navigation systems in cars. Pidd (2008) reports on *230 Miles of Love*, a comedy narrative which drivers can download from a website and install in their car's satnav, and which constructs a comic narrative out of the 230-mile long M6, which joins Rugby and Carlisle. Sketches and jokes are site-specific, reacting to, and making jokes about, landmarks that are visible and, in one particular case, mocking you if you decide to take the toll-free but always jammed route on the road. *230 Miles of Love* is the first in a series of six comedies which the production company, Moving Audio, calls 'The Moving Comedies'. These are comedies which are 'all linked by various themes of transport, movement and presented in a variety of new and innovative media' (http://movingaudio.wordpress.com/projects/). The final of these is planned to be the first comedy which is part of the search for extra-terrestrial intelligence, and is to be broadcast into space in the hope that the first aspect of human culture any alien might encounter is comedic.

Of course, comedy in the car is nothing new; BBC Radio 4 produces sitcoms and sketch shows which can be listened to while mobile, and BBC7 has been successful in unearthing the BBC's back catalogue and

making a wealth of previously unavailable material accessible to new audiences. Clearly the satnav system offers many opportunities for such narrative fiction for drivers and, in being able to respond to your specific geographical location, offers a more personalised experience than radio comedy. Still, it's telling that the first use of this system employs comedy. The narrative bits which make up much comedy are perfect for quick responses to locations which drivers are passing at speed, and also allow users to dip in and out of the material in a manner which would be more difficult for lengthier and more serious texts. Perhaps what's more significant is that this represents a telling development of the domestic context which has always motivated the sitcom. As outlined in Chapter 1, the sitcom quickly focused on domestic humour in order to reflect the circumstances of those consuming it; this satcom, in making jokes about a driver's location, does the same for the sphere of the motorist. In this sense, the personal experience of the listener/viewer remains at the heart of comedy, and sitcom maintains its role as a commentator on the ways in which people go about their lives.

New technologies, then, offer many challenges and possibilities for the television sitcom. Indeed, Leena Saarinen argues that because comedy is a 'rule-based genre' (2007: 143), it is highly suited to experimentation with new technologies because its impetus and output can be clearly measured. Similarly, those rules offer a defined framework around which new technologies can be applied. Saarinen goes so far as to suggest that a 'comedy machine' might effectively produce humorous texts if a suitable comic formula can be fed into it; that said, attempts to do this have so far produced little other than simplistic puns. In terms of genre, comedy mixes well with new technologies because the codes and conventions of the sitcom are assumed to be transparent and clear for the majority of audiences. In bringing audiences to new technologies producers have repeatedly fallen back on traditional formats in order to ensure audience intelligibility, which is quite at odds with many predictions which suggested that the Internet and home-produced media would offer challenges to traditional forms. In addition, the sheer mass of comedy material on the Internet means that consumers gravitate towards material that can be clearly understood, which is likely to be that which accommodates traditional genres and production practices. And television has quickly absorbed the material which home video in particular has offered; series such as *You've Been Framed!* (ITV, 1990–) and *America's Funniest Home Videos* (ABC, 1989–) repackage the possibilities of new technology as conventional television. So, while all broadcasters have called for '360° commissioning' (Parker 2007) in which ideas can be translated

into a range of formats and media, this appears to have done little to the generic possibilities and conventions of broadcasting. This may be a consequence of the generically defined commissioning process; perhaps, though, in an era of technological change, both audiences and producers require some stability, particularly in entertainment genres such as sitcom whose 'undeniable pleasures' rest on the 'familiar' (Curtis 1982: 11).

Back to Basics

As has been shown, in the last decade or so the sitcom has developed a range of style and methods of delivery, and these amount to significant developments for the ways in which narrative comedy might work on television. The sitcom has responded to developments in quality television in ways which have altered its aesthetics and performance style, and it's clear that, for both the television industry and its audiences, the notion that traditional sitcom may not have the cachet it once did is apparent. Yet I want to end this book by arguing that the more genres develop, the more they stay the same. While it's clear that a broader range of sitcom is available now then ever before, this is not to suggest that these have replaced the traditional format completely. Indeed, as has been shown, all of these comedies of distinction maintain significant links with narrative and aesthetic conventions developed in the early days of the genre, even if they go out of their way to suggest that they don't. More than this, the highest-rated sitcoms across the world remain those from the traditional format; comedies of distinction are, on the whole, precisely niche products whose distinction rests partly on their perceived minority status. Perhaps more significant than this is the desire among the industry for the next traditional sitcom: this is partly an economic decision, and partly because it's felt that such sitcom can offer pleasures unavailable to the newer forms of sitcom.

In Britain, therefore, there has been a steady stream of programming written by newer comedians and writers with the explicit intention of recreating the traditional format, and the promotional material accompanying them repeatedly makes clear how such writers and performers felt that the pleasures associated with such series was missing from some forms of comedy. Thus Ben Elton's *The Thin Blue Line* (BBC1, 1995–6) was 'Elton attempting to create a series with the comedic style of *Dad's Army*, a show he greatly admires' (Lewishon 2003: 760); Victoria Wood's *dinnerladies* (BBC1, 1998–2000) has a 'downmarket premise and broad humour' (830) which responded to Wood's concerns that the naturalism had made traditional sitcom look

'quite contrived' (quoted in Dowell 2008: 6); Chris Addison notes his
Lab Rats (BBC2, 2008–) works from an assumption that jokes are the
'cornerstone of comedy' even if such gags are 'unfashionable' (quoted
in Hall 2008: 14); Graham Linehan states his writing on both *Father
Ted* (C4, 1995–8) and *The IT Crowd* (C4, 2006–) are an attempt to
refute the wealth of 'charmless' comedy currently available (quoted in
Akbar 2008: 4); and Lee Mack's *Not Going Out* (BBC1, 2006–8) reflects
the fact that he loves 'old-fashioned, studio-based sitcoms such as
Porridge, *Rising Damp* and *Fawlty Towers*' (quoted in Mardles 2007: 6).

The return to traditional sitcom is one espoused by many in the
media industries in Britain and, for the BBC, the mass audience a
successful programme can garner is precisely the kind of thing a
public service broadcaster should be aiming for. Lucy Lumsden, BBC
Controller of Comedy Commissioning, has stated that her primary
aim is to develop such long-running, high-profile family sitcoms and
sees *After You've Gone* and *The Green, Green Grass* (BBC1, 2005–) as
the first steps along this road (Dowell 2008: 6). It's worth nothing
how fearful many writers and performers now are about working on
mass mainstream comedy, precisely because a lack of instant success
is leaped on by voracious critics and creative personnel can be tainted
with failures for some time. For example, Sophie Clarke-Jervois (2005)
discussed Jessica Stephenson's involvement in *According to Bex* (BBC1,
2005), a sitcom shot in the traditional style with a studio audience, and
created by Fred Barron, the man responsible for *My Family*:

> Well, she was very nervous about it. And we all felt really badly for
> her. I actually think with another series, it had the potential to be
> a really great sitcom, and I certainly think some of the scripts were
> really very funny. . . . But I did feel badly for her because I think she
> was really nervous about doing a BBC1 sitcom and, god, she won't
> want to do another one. She just had a lot of really bad press – well,
> actually, she didn't get bad press because all of the critics seemed
> to be saying, 'What on earth is Jessica Stevenson doing in this ter-
> rible sitcom?' But I think she probably got a lot of stick from her
> contemporaries for doing it.

This is an interesting response, and shows how the impetus for tradi-
tional comedy has been lost for some of those performers and writers
who might be seen to naturally gravitate towards mass audience
acceptance via the mainstream sitcom.

A sitcom is a high creative risk, and the BBC's proliferation of
channels has meant that it now offers places where those risks can be
taken in less visible spaces. In that sense, for a programme to make

it to primetime BBC1 it must have earned its spurs elsewhere. The notion of the family audience had been declared dead many years ago, but the demographics of drama and entertainment series such as *The X-Factor* (ITV1, 2004–), *Strictly Come Dancing* (BBC1, 2004–) and the reimagined *Doctor Who* (BBC1, 2005–) show that television can remain a place where families come together to be entertained. Furthermore, there are those writers and performers, such as those outlined above, who desire to occupy that mainstream role within the entertainment industry and see a value in its existence. This is a significant rejection of the comedy of distinction, and places pleasure over cultural capital. It remains to be seen whether the traditional sitcom will ever reoccupy the significant cultural position it once did, or whether it will now forever seem 'old-fashioned' in comparison to other types of comedy. Yet the evidence of series such as *iCarly* suggests that there will be a resurgence of traditional sitcom in response to the rough and ready appearance of homemade media, so even though those traditions arose out of the genre's theatrical heritage, they now serve perfectly the needs of new media. The 'remarkable stability' of sitcom is, then, a set of generic characteristics which have responded endlessly to social and technological changes, suggesting a remarkable fluidity and adaptability in the ways in which narrative comedy is made for television.

Indeed, the sitcom has been remarkably effective at responding to local needs in a time of perceived global media and transnational formatting. Thus Dana Heller outlines how Russian 'sitkoms' such as *Druzhnaia Semeika* (RTR, 2002–) and *Strawberry Café* (RTR, 1997–8), while clearly importing many of the tropes and conventions of Anglo-American sitcom, worked to 'appeal directly to Russian viewers' indigenous sensibilities and pride in national as well as regional cultural identity' (2003: 60). Similarly, both Sue Turnbull (2008) and Wendy Davis (2008) see *Kath and Kim* (ABC/Seven Network, 2002–) as arising out of its specifically Australian industrial and cultural context, especially in terms of its notion of suburbia. Bart Beaty and Rebecca Sullivan show how *Corner Gas* (CTV, 2004–) 'succeeds in fulfilling nationalist tropes of distinct Canadian stories, but it creates a sense of concordance with the audience that these tropes are tired, paternalistic, and sometimes even downright insulting' (2006: 81). And Alexander Dhoest (2006) outlines comedy programming on Flemish television, showing how sitcoms such as *Het Eiland* [*The Island*] (ÉÉN, 2004–5) draw both on 'traditional' forms of sitcom which have a long national heritage, as well as other trends – such as the mock-documentary – which have informed sitcom in

many ways all over the globe. The concern about the death of the sitcom is, therefore, a peculiarly Anglo-American phenomenon, and these countries can only be concerned about such a lack because they have a history of large numbers of popular and critically acclaimed comedy programming. That is, the sitcom remains a vital global television force; it may just be that, at the time of writing, the interesting things going on in the genre are occurring outside of the UK and the USA.

This book began discussing why it is that sitcom may be thought of as 'small-time'. This local inflection which means many more countries are now producing their own versions of sitcom suggests that there is another way we can think of sitcom's small-time-ness – that it has become a text produced in multiple forms the world over rather than the preserve of the two English-speaking countries which have historically been its major producers. There is much to be applauded in the sitcom's ability to respond to much more small-scale, local concerns, drawing on differing ideas of national senses of humour and offering comic moments which draw on audience specificity. This suggests that the sitcom is a genre whose flexibility makes it ideal for programme-makers the world over to draw on, making links between the comic impetus of the genre and the specificities of particular locations, nations, communities and audiences. The genre is therefore indicative of the 'cultural hybridity and cultural mixing' (Flew 2007: 163) at the heart of contemporary global media.

This book also began with reference to E. B. White's statement that 'Analyzing humor is like dissecting a frog. Few people are interested and the frog dies of it' (quoted in Gale 1996: *xi*). The range of approaches to genre adopted in this book hopefully demonstrate that the frog is not dead; indeed, not only is the frog very much alive, but it turns out that it is a far more fascinating beast than was at first thought. Exploring sitcom in terms of the industry that produces it, the programmes which constitute it, and the audiences which consume it show that genre is a tool capable of exploring media in a variety of ways, and that the sitcom is a 'cultural category' (Mittell 2004: 1–29) whose meanings accumulate across production, text and consumption. And just as genre is useful for examining the sitcom, so sitcom is useful for examining genre. While the range of texts analysed here shows how sitcom has multiple meanings across the globe and at different points in history, the genre remains, on the whole, broadly recognisable. In that way, the sitcom shows how genre as a process *works*. While this chapter began by noting that the health of the sitcom, like that of White's frog, has recently been called into question, it is hoped

that this book as a whole has instead demonstrated the vitality of the genre, and its centrality to television as a whole. The sitcom is likely to remain a potent force within television for as long as communities want to come together to enjoy laughter. That is, it's going to be around for quite some time.

Appendix

This book incorporates primary material consisting of a number of interviews conducted by the author with members of the British terrestrial television comedy industry. This research was funded by an Arts and Humanities Research Council Grant (Ref: APN19118) and took place in 2005–6. The aim of the interviews was to gain an insight into the working processes of those within the industry and, perhaps more importantly, to capture the ways in which such personnel *talk* about the work that they do. A full list of the interviewees, with a brief biography of their working career, is provided below.

The interviews were informal in nature and of various lengths, ranging from thirty minutes to four hours. Some took place in workplaces while others were in bars, coffee-shops or the interviewee's home. While I had key questions in mind before each interview, conversations were allowed to develop to take into account interviewees' responses. Holliday notes the difficulties in carrying out such qualitative research, and warns that 'Researchers must be wary of reducing reality to the "culture" they themselves construct' (2007: 41). Certainly, others carrying out this research might well have asked different questions, and would no doubt have drawn different conclusions from the data. Their presentation in this book, therefore, is *not* intended to offer a definitive account of the industry or those who work within it. They are, instead, an account of a 'small culture' (40) whose relevance to this book's focus on genre demonstrates the ways in which cultural categories and creative labour are linked. Indeed, by selecting interviewees who work in comedy, the participants were first and foremost being defined by this research via a generic category. For a more in-depth account of the process of carrying out these interviews and a discussion of the ethical considerations applicable to their use, see Mills (2008b).

I would like to thank all of those who participated in these interviews for their time and generosity, and their willingness to engage wholeheartedly in the project.

Gareth Carrivick is a comedy and sitcom director who has worked on series such as *The Vicar of Dibley* (BBC1, 1994–2007), *Keeping Mum* (BBC1, 1997–8), *Two Pints of Lager and a Packet of Crisps* (BBC2/BBC Choice/BBC3, 2001–) and *Little Britain* (BBC3/1, 2003–6). He was interviewed at BAFTA Headquarters, London, on 19 October 2005.

Boyd Clack is a comedy writer and actor who has worked on series such as *The Celluloid World of Dezmond Rezillo* (BBC Wales, 1994–7), *Satellite City* (BBC Wales, 1996–9) and *High Hopes* (BBC Wales, 2000–). He was interviewed in Cardiff on 28 May 2007.

Sophie Clarke-Jervoise was, at the time of the interview, Head of Comedy at the BBC. At the time of writing she is a Senior Executive at the independent production company Tiger Aspect. She was interviewed at BBC Television Centre, London, on 14 June 2005.

Bill Dare is a comedy and sitcom writer, producer and director who has worked on series including *Spitting Image* (ITV, 1984–96), *Mr Charity* (BBC2, 2001) and *Dead Ringers* (BBC Radio 4 2000–7; BBC2 2002–7). He was interviewed at the Groucho Club, London, on 19 July 2005.

Brian Dooley wrote the sitcom *The Smoking Room* (BBC3, 2004–5) and has written sketches for *Monkey Dust* (BBC3, 2003–5) and *The Sketch Show* (ITV, 2001–3). He was interviewed at his home in London on 8 August 2005.

Andy Hamilton is a sitcom and comedy writer, producer, director and actor. He has worked on series such as *Not the Nine O'Clock News* (BBC2, 1979–82), *Drop the Dead Donkey* (C4, 1990–8), *Bedtime* (BBC1, 2001–3) and *Outnumbered* (BBC1, 2007–). He was interviewed at the London offices of the independent production company Tiger Aspect on 1 November 2005.

Charlie Higson is a comedy writer, actor and producer. He has worked on programmes such as *Saturday Live* (C4, 1985–7), *The Fast Show* (BBC2, 1994–2000), *Randall and Hopkirk (Deceased)* (BBC1, 2000–1) and *Swiss Toni* (BBC3, 2003–4). He was interviewed in Norwich on 30 May 2008.

Guy Jenkin is a comedy writer, director and producer. He has written programmes such as *Not the Nine O'Clock News* (BBC2, 1979–82),

Drop the Dead Donkey (C4, 1990–8), *Lord of Misrule* (BBC1, 1996) and *Outnumbered* (BBC1, 2007–). He was interviewed at the London offices of the independent production company Tiger Aspect on 18 October 2005.

Stephen McCrum has produced sitcoms such as *Keeping Mum* (BBC1, 1997–8), *Two Pints of Lager and a Packet of Crisps* (BBC2/BBC Choice/BBC3, 2001–), *The Crouches* (BBC1, 2003–5) and *Grownups* (BBC3, 2006–). He was interviewed at BBC Television Centre, London, on 28 June 2005.

Paul Mayhew-Archer is a comedy writer and script editor. He has worked on series including *The Vicar of Dibley* (BBC1, 1994–2007), *My Hero* (BBC1, 2000–6), *Office Gossip* (BBC1, 2001) and *Two Pints of Lager and a Packet of Crisps* (BBC2/BBC Choice/BBC3, 2001–). He was interviewed at his Oxfordshire home on 22 July 2005.

Steven Moffat is the writer of *Press Gang* (ITV, 1989–93), *Joking Apart* (BBC2, 1993–5), *Chalk* (BBC1, 1997) and *Coupling* (BBC2/3, 2000–4). He was interviewed in his London home on 2 November 2005.

Susan Nickson is the writer of *Two Pints of Lager and a Packet of Crisps* (BBC2/BBC Choice/BBC3, 2001–), and *Grownups* (BBC3, 2006–). She was interviewed in a London pub on 26 July 2005.

Henry Normal co-founded the independent production company Baby Cow in 1999. Before that, he was a stand-up comedian, poet and writer, contributing to series such as *Packet of Three* (C4, 1991–2), *The Fast Show* (BBC2, 1994–2000) and *The Mrs Merton Show* (BBC2/1, 1995–8). He was interviewed at Baby Cow's London offices on 22 March 2006.

Simon Nye is the writer of sitcoms including *Men Behaving Badly* (ITV/BBC1, 1992–9), *Is It Legal?* (ITV/C4, 1995–8), *How Do You Want Me?* (BBC2, 1998–9), *Wild West* (BBC1, 2002–4), *Hardware* (ITV, 2003) and *Carrie and Barry* (BBC1, 2004–5). He was interviewed in his London home on 20 May 2005.

Jon Plowman was, at the time of the interview, Head of Comedy at the BBC. At the time of writing he is an independent comedy producer. He was interviewed at BBC Television Centre, London, on 8 June 2005.

Graham Smith was, at the time of the interview, Controller of Comedy at Five and Paramount Comedy Channel. At the time of writing he is an independent comedy producer. He was interviewed at Five's London offices on 13 January 2006.

Beryl Vertue OBE is the Chairman of the independent production company Hartswood Productions and has produced series such as *Men Behaving Badly* (ITV/BBC1, 1992–9) and *Coupling* (BBC2/3, 2000–4). She was interviewed in her London home on 21 June 2005.

Sioned Wiliam was, at the time of the interview, Controller of Comedy at ITV. She was interviewed at ITV's London headquarters on 8 June 2005.

Bibliography

ABC (2007), *Code of Practice*, Canberra: ABC.

Achter, Paul (2008), 'Comedy in unfunny times: news parody and carnival after 9/11', *Critical Studies in Media Communication*, 25: 3, pp. 274–303.

ACMA (2004), *Commercial Television Industry Code of Practice*, Canberra: ACMA.

ACMA (2007), *ACMA Investigation Report No. 1948 – According to Jim Broadcast by Channel Seven Melbourne Pty Ltd on 29 August 2007*, Canberra: ACMA.

Akass, Kim and Janet McCabe (eds) (2004), *Reading Sex and the City*, London and New York: I. B. Tauris.

Akbar, Arifa (2008), 'Writer attacks "charmless" TV comedy', *The Independent*, 12 July, p. 4.

Alberti, John (ed.) (2003), *Leaving Springfield: The Simpsons and the Possibility of Oppositional Culture*, Detroit, MI: Wayne State University Press.

Allen, Robert C. (1985), *Speaking of Soap Operas*, Chapel Hill, NC: University of North Carolina Press.

Allen, Valerie (2007), *On Farting: Language and Laughter in the Middle Ages*, Basingstoke: Palgrave Macmillan.

Altman, Rick (1999), *Film/Genre*, London: British Film Institute.

Amin, Ash (1994), 'Post-Fordism: models, fantasies and phantoms of transition', in Ash Amin (ed.), *Post-Fordism: A Reader*, Oxford and Cambridge: Blackwell, pp. 1–39.

Anderson, Benedict (1983), *Imagined Communities: Reflections on the Origins and Spread of Nationalism*, London: Verso.

Andrews, Maggie (1998), '*Butterflies* and caustic asides: housewives, comedy and the feminist movement', in Stephen Wagg (ed.), *Because I Tell a Joke or Two: Comedy, Politics and Social Difference*, London and New York: Routledge, pp. 50–64.

Ang, Ien (1985), *Watching Dallas: Soap Opera and the Melodramatic Imagination*, trans. Della Couling, London: Methuen.

Ang, Ien (1991), *Desperately Seeking the Audience*, London and New York: Routledge.

Anstine, Diane Bruce (2001), 'How much will consumers pay? A hedonic analysis of the cable television industry', *Review of Industrial Organization*, 19: 2, pp. 129–47.

Aristotle [*c*.350 BCE] (1980), *The Nicomachean Ethics*, trans. David Ross, Oxford and New York: Oxford University Press.

Armitage, Tom (2006), 'Pogoing Pope parody is "too dumb to be banned"', *Irish Independent*, 4 May, p. 6.

Armstrong, Stephen (2008), 'Alternative Comedy: you've got to laugh', in Rosie Boycott and Meredith Etherington-Smith (eds), *25x4: Channel 4 at 25*, London: Cultureshock, pp. 71–4.

Aronfreed, Justin (1968), *Conduct and Conscience: The Socialization of Internalized Control over Behavior*, New York and London: Academic Press.

Attallah, Paul (2003), 'The unworthy discourse: situation comedy in television', in Joanne Morreale (ed.), *Critiquing the Sitcom: A Reader*, Syracuse, NY: Syracuse University Press, pp. 91–115.

Auslander, Philip (1999), *Liveness: Performance in a Mediatized Culture*, London and New York: Routledge.

Bakhtin, Mikhail ([1965] 1984), *Rabelais and his World*, trans. by Hélène Iswolsky, Bloomington and Indianapolis, IN: Indiana University Press.

BARB (2008) 'Television ownership in private domestic households, 1956–2008', *Broadcasting Audience Research Board Ltd TV Facts*, found at http://www.barb.co.uk/facts/tvOwnershipPrivate.

Bardoel, Johannes and Leen d'Haenens (2008), 'Reinventing public service broadcasting in Europe: prospects, promises and problems', *Media, Culture and Society*, 90: 3, pp. 337–55.

Barker, Martin and Julian Petley (eds) (2001), *Ill Effects: The Media/Violence Debate*, 2nd edn, London: Routledge.

Barlow, David M. and Brett Mills (2009), *Reading Media Theory: Thinkers, Approaches, Contexts*, Harlow: Pearson.

Barreca, Regina (ed.) (1992), *New Perspectives on Women and Comedy*, Philadelphia, PA: Gordon & Breach.

Barry, Peter (2002), *Beginning Theory: An Introduction to Literary and Cultural Theory*, 2nd edn, Manchester: Manchester University Press.

Bathrick, Serafina (2003), '*The Mary Tyler Moore Show*: women at home and at work', in Joanne Morreale (ed.), *Critiquing the Sitcom: A Reader*, Syracuse, NY: Syracuse University Press, pp. 155–86.

Battles, Kathleen and Wendy Hilton-Morrow (2002), 'Gay characters in conventional spaces: *Will and Grace* and the situation comedy genre', *Critical Studies in Media Communication*, 19: 1, pp. 87–105.

Baym, Geoffrey (2005), '*The Daily Show*: discursive integration and the reinvention of political journalism', *Political Communication*, 22: 3, pp. 259–76.

BBC (2004), *Building Public Value*, London: BBC.

BBC (2007), *BBC Annual Reports and Accounts 2006/2007*, London: BBC.

BBC (2008a), *BBC Annual Reports and Accounts 2007/2008, Part 1: The BBC Trust's Review and Assessment*, London: BBC.

BBC (2008b), *BBC Statements of Programme Policy 2008/2009*, London: BBC.

BBC (2008c), *BBC Annual Reports and Accounts 2007/2008, Part 1: The BBC Executive's Review and Assessment*, London: BBC.

BBC Trust (2007a), *BBC Public Service Remit: Sustaining Citizenship and Civil Society*, London: BBC.

BBC Trust (2007b), *BBC Public Service Remit: Representing the UK, its Nations, Regions and Communities*, London: BBC.

Beals, Alan R., George Spindler and Louise Spindler (1967), *Culture in Process*, New York: Holt, Rinehart & Winston.

Beattie, Keith (2004), *Documentary Screens: Non-Fiction Film and Television*, Basingstoke: Palgrave Macmillan.

Beaty, Bart and Rebecca Sullivan (2006), *Canadian Television Today*, Calgary, Alberta: University of Calgary Press.

Beck, Andrew (2003), 'Introduction: cultural work, cultural workplace – looking at the cultural industries', in Andrew Beck (ed.), *Cultural Work: Understanding the Cultural Industries*, London and New York: Routledge, pp. 1–11.

Beck, Ulrich (2000), *The Brave New World of Work*, trans. Patrick Camiller, Cambridge: Polity.

Bell, J. M. (2003), 'The laughing animal: an inquiry into the ethical and religious implications of humor', *Kinesis*, 30: 2, pp. 4–22.

Bell, Nancy D. (2007a), 'How native and non-native English speakers adapt to humor in intercultural interaction', *Humor: International Journal of Humor Research*, 20: 1, pp. 27–48.

Bell, Nancy D. (2007b), 'Humor comprehension: lessons learned from cross-cultural communication', *Humor: International Journal of Humor Research*, 20: 4, pp. 367–87.

Bennett, Tony (2005), 'The media sensorium: cultural technologies, the sense and society', in Marie Gillespie (ed.), *Media Audiences*, Maidenhead: Open University Press, pp. 51–96.

Bennett, Tony (2006), 'Distinction on the box: cultural capital and the social space of broadcasting', *Cultural Trends*, 15: 2/3, pp. 193–212.

Berkeley, Dina (2003), 'Creativity and economic transactions in television drama production', in Andrew Beck (ed.), *Cultural Work: Understanding the Cultural Industries*, London and New York: Routledge, pp. 103–20.

Bielby, William T. and Denise D. Bielby (1994), '"All hits are flukes": institutionalized decision making and the rhetoric of network prime-time program development', *American Journal of Sociology*, 99: 5, pp. 1287–313.

Bignell, Jonathan (2005), *Big Brother: Reality TV in the Twenty-First Century*, Basingstoke: Palgrave Macmillan.

Bignell, Jonathan (2007), 'Seeing and knowing: reflexivity and quality', in Janet McCabe and Kim Akass (eds), *Quality TV: Contemporary American Television and Beyond*, London and New York: I. B. Tauris, pp. 158–70.

Billig, Michael (1995), *Banal Nationalism*, London: Sage.

Billig, Michael (2005), *Laughter and Ridicule: Towards a Social Critique of Humour*, London, Thousand Oaks, CA and New Delhi: Sage.

Biressi, Anita and Heather Nunn (eds) (2008), *The Tabloid Culture Reader*, Maidenhead: Open University Press.

Boddy, William (2001), 'The quiz show', in Glen Creeber (ed.), *The Television Genre Book*, London: British Film Institute, pp. 79–81.

Bodroghkozy, Aniko (1995), '"Is this what you mean by color TV?": race, gender, and contested meanings in NBC's *Julia*', in Gail Dines and Jean M. Humez (eds), *Gender, Race and Class in the Media: A Text-Reader*, Thousand Oaks, CA: Sage, pp. 413–23.

Bogle, Donald (1994), *Toms, Coons, Mulattoes, Mammies and Bucks: An Interpretive History of Blacks in American Films*, Oxford: Roundhouse.

Bonner, Frances (2003), *Ordinary Television: Analyzing Popular TV*, London, Thousand Oaks, CA and New Delhi: Sage.

Bordwell, David (1979), 'The art cinema as a mode of film practice', *Film Criticism*, 4: 1, pp. 56–64.

Bourdieu, Pierre (1979), *Distinction: A Social Critique of the Judgement of Taste*, trans. Richard Nice, London: Routledge.

Bourdieu, Pierre (1993a), *The Field of Cultural Production: Essays on Art and Literature*, Cambridge: Polity.

Bourdieu, Pierre (1993b), *Sociology in Question*, London: Sage.

Bourdon, Jérôme (2000), 'Live television is still alive: on television as an unfulfilled promise', *Media, Culture and Society*, 22: 5, pp. 531–56.

Brabazon, Tara (2005), '"What have you ever done on the telly?": *The Office*, (post) reality television and (post) work', *International Journal of Cultural Studies*, 8: 1, pp. 101–17.

Branston, Gill (2006), 'Understanding genre', in Marie Gillespie and Jason Toynbee (eds), *Analysing Media Texts*, Maidenhead: Open University Press, pp. 43–78.

Brassfield, Rebecca (2006), 'Rereading *Sex and the City*: exposing the hegemonic feminist narrative', *Journal of Popular Film and Television*, 34: 3, pp. 130–8.

Bremmer, Jan and Herman Roodenburg (eds) (1997), *A Cultural History of Humour*, Cambridge: Polity.

Brewer, Paul R. and Emily Marquardt (2007), 'Mock news and democracy: analyzing *The Daily Show*', *Atlantic Journal of Communication*, 15: 4, pp. 249–67.

Brook, Vincent (2003), *Something Ain't Kosher Here: The Rise of the 'Jewish' Sitcom*, New Brunswick, NH and London: Rutgers University Press.

Brook, Vincent (2004), 'Myth or consequences: ideological fault lines in *The Simpsons*', in John Alberti (ed.), *Leaving Springfield: The Simpsons and the Possibility of Oppositional Culture*, Detroit, MI: Wayne State University Press, pp. 172–96.

Brown, Alan (ed.) (2006), *D'oh!: the Psychology of the Simpsons*, Dallas, TX: BenBella Books.

Brown, Keith S. and Roberto J. Cavazos (2003), *Empirical Aspects of Advertiser Preferences and Program Content of Network Television*, Washington, DC: Federal Communications Commission.

Brown, Maggie (2007), *A Licence to Be Different: The Story of Channel 4*, London: British Film Institute.

Brunsdon, Charlotte (2000), *The Feminist, the Housewife and the Soap Opera*, Oxford: Oxford University Press.

Brunsdon, Charlotte and David Morley (1978), *Everyday Television: Nationwide*, London: British Film Institute.

Bull, Sheldon (2007), *Elephant Bucks: An Insider's Guide to Writing for TV Sitcoms*, Studio City, CA: Michael Wiese.

Burns, Tom (1977), *The BBC: Public Institution, Private World*, London: Macmillan.

Byrne, John and Marcus Powell (2003), *Writing Sitcoms*, London: A. & C. Black.

Cantor, J. R. (1976), 'What is funny to whom? The role of gender', *Journal of Communication*, 26: 3, pp. 164–72.

Carr, Jimmy and Lucy Greeves (2006), *Only Joking: What's so Funny About Making People Laugh?*, New York: Gotham.

Carr, Steven Alan (2001), *Hollywood and Anti-Semitism: A Cultural History up to World War 2*, Cambridge: Cambridge University Press.

Carrivick, Gareth [sitcom director] (2005), interview with author, 19 October.

Casey, Bernadette, Neil Casey, Ben Calvert, Liam French and Justin Lewis (2008), *Television Studies: The Key Concepts*, 2nd edn, London and New York: Routledge.

Castiglia, Christopher and Christopher Reed (2004), 'Ah yes, I remember it well: memory and queer culture in *Will and Grace*', *Cultural Critique*, 56: 1, pp. 158–88.

Channel 4 (2007), *Channel 4 Television Corporation: Report and Financial Statements 2007*, London: Channel 4.

Channel 4 (2008), *Channel 4 Statement of Programme Policy 2008*, London: Channel 4.

Chapman, Tony and Hugh Foot (eds) (1976), *Humour and Laughter: Theory, Research and Applications* London: John Wiley.

Cherry, Simon (2005), *ITV: The People's Channel*, Richmond: Reynolds & Hearn.

Clack, Boyd [sitcom writer and actor] (2007), interview with author, 28 May.

Clarke-Jervoise, Sophie [BBC Head of Comedy] (2005), interview with author, 14 June.

Coleman, Robin R. Means (2000), *African American Viewers and the Black Situation Comedy*, New York: Garland.

Conboy, Martin (2007), *The Language of the News*, London and New York: Routledge.

Cook, Jim (1982), 'Narrative, comedy, character and performance', in Jim Cook (ed.), *BFI Dossier 17: Television Sitcom*, London: British Film Institute, pp. 13–18.

Cook, William (1994), *Ha Bloody Ha: Comedians Talking*, London: Fourth Estate.

Cooper, Lane ([1922] 1969), *An Aristotelian Theory of Comedy: With an Adaptation of the Poetics and a Translation of the Tractatus Coislinianus*, New York: Klaus Reprint.

Cornea, Christine (2007), *Science Fiction Cinema: Between Fantasy and Reality*, Edinburgh: Edinburgh University Press.

Cottle, Simon (2003), 'The changing production ecology of natural history TV', in Simon Cottle (ed.), *Media Organization and Production*, London: Sage, pp. 170–87.

Coward, Rosalind ([1987] 2000), 'Dennis Potter and the question of the television author', in Robert Stam and Toby Miller (eds), *Film and Theory: An Anthology*, Oxford: Blackwell, pp. 7–15.

Creeber, Glen (ed.) (2008), *The Television Genre Book*, 2nd edn, London: British Film Institute.

Cripps, Thomas (2003), '*Amos 'n' Andy* and the debate over American racial integration', in Joanne Morreale (ed.), *Critiquing the Sitcom: A Reader*, Syracuse, NY: Syracuse University Press, pp. 25–40.

Critchley, Simon (2002), *On Humour*, London and New York: Routledge.

Curtis, Barry (1982), 'Aspects of sitcom', in Jim Cook (ed.), *BFI Dossier 17: Television Sitcom*, London: British Film Institute, pp. 4–12.

Daily Mirror (1999), 'Voice of the Mirror: farewell Compo', *Daily Mirror*, 13 July, p. 6.

Dalton, Mary M. (2005), '*Our Miss Brooks*: situating gender in teacher sitcoms', in Mary M. Dalton and Laura L. Linder (eds), *The Sitcom Reader: America Viewed and Skewed*, Albany, NY: State University of New York Press, pp. 99–110.

Dare, Bill [comedy writer and producer] (2005), interview with author, 19 July.

Davies, Christie (1990), *Ethnic Humor around the World: A Comparative Analysis*, Bloomington, IN: Indiana University Press.

Davies, Christie (2002), *The Mirth of Nations*, New Brunswick, NH and London: Transaction.

Davis, Wendy (2008), 'Playing the television field: *Kath and Kim* and the changing face of TV comedy', *Continuum: Journal of Media and Cultural Studies*, 22: 3, pp. 353–61.

deCordova, Richard (1990), *Picture Personalities: The Emergence of the Star System in America*, Urbana, IL: University of Illinois Press.

Descartes, René (1985), *The Philosophical Writings of Descartes, Volume 1*, trans. John Cottingham, Robert Stoothoff and Dugald Murdoch, Cambridge: Cambridge University Press.

Deuze, Mark (2007), *Media Work*, Cambridge and Malden: Polity.

Dhoest, Alexander (2006), 'From theatre play to reality comedy: a history of fictional comedy genres on Flemish television', *New Review of Film and Television Studies*, 4: 2, pp. 147–66.

Dominion Post, The (2006), 'Bishops fail in new *Popetown* protest', *The Dominion Post*, 6 May, p. 2.

Donnelly, Kevin (2001), 'Adult animation', in Glen Creeber (ed.), *The Television Genre Book*, London: British Film Institute, pp. 73–5.

Dooley, Brian [sitcom writer] (2005), interview with author, 8 August.

Doty, Alexander (1993), *Making Things Perfectly Queer: Interpreting Mass Culture*, Minneapolis, MN and London: University of Minnesota Press.

Double, Oliver, (1997), *Stand-Up! On Being a Comedian*, London: Methuen.

Dowell, Ben (2008), 'The sitcom is dead. Long live the sitcom', *The Guardian*, 18 August, Edinburgh special section, p. 6.

Dunleavy, Trisha (2008), 'Hybridity in TV sitcom: the case of comedy verité', *FlowTV*, found at http://flowtv.org/?p=2244.

Dyer, Richard (1979), *Stars*, London: British Film Institute.

Dyer, Richard (1981), 'Entertainment and utopia', in Rick Altman (ed.), *Genre: A Reader*, London: Routledge, pp. 175–96.

Dyer, Richard (1992), *Only Entertainment*, London and New York: Routledge.

Dyer, Richard (1997), *White*, London and New York: Routledge.

Dyer, Richard (2002), *Only Entertainment*, 2nd edn, London and New York: Routledge.

Easthope, Antony (2000), 'The English sense of humor', *Humor: International Journal of Humor Research*, 13: 1, pp. 59–75.

Eaude, Tony (2006), *Children's Spiritual, Moral, Social and Cultural Development: Primary and Early Years*, Exeter: Learning Matters.

Eco, Umberto (1984), 'The frames of comic "freedom"', in Thomas A. Sebeok (ed.), *Carnival!*, Berlin, New York and Amsterdam: Mouton, pp. 1–9.

Edelstein, David (2006), 'Now playing at your local multiplex: torture porn', *New York Magazine*, found at http://nymag.com/movies/features/15622/.

Farley, Rebecca (2003), 'From Fred and Wilma to Ren and Stimpy: what makes a cartoon "prime-time"', in Carol A. Stabile and Mark Harrison (eds), *Prime Time Animation: Television Animation and American Culture*, London and New York: Routledge, pp. 147–64.

Feldman, Lauren (2007), 'The news about comedy: young audiences, *The Daily Show*, and evolving notions of journalism', *Journalism*, 8: 4, pp. 406–27.

Feuer, Jane (1992), 'Genre study and television', in Robert C. Allen (ed.), *Channels of Discourse, Reassembled: Television and Contemporary Criticism*, London and New York: Routledge, pp. 138–60.

Feuer, Jane (2007), 'HBO and the concept of quality TV', in Janet McCabe and Kim Akass (eds), *Quality TV: Contemporary American Television and Beyond*, London and New York: I. B. Tauris, pp. 145–57.

Fine, Gary Alan (1984), 'Humorous interaction and the social construction of meaning', in Norman K. Denzin (ed.), *Studies in Symbolic Interaction: A Research Annual, Volume 5*, Greenwich, CT: Jai Press, pp. 83–101.

Fiske, John and John Hartley (1978), *Reading Television*, London and New York: Routledge.

Flew, Terry (2007), *Understanding Global Media*, Basingstoke: Palgrave Macmillan.

Florida, Richard (2002), *The Rise of the Creative Class*, New York: Perseus.

Fox, Julia R., Glory Koloen and Volkan Sahin (2007), 'No joke: a comparison of substance in *The Daily Show with Jon Stewart* and broadcast network television coverage of the 2004 presidential election campaign', *Journal of Broadcasting and Electronic Media*, 51: 2, pp. 213–27.

Fox, Kate (2004), *Watching the English: The Hidden Rules of English Behaviour*, London: Hodder & Stoughton.

French, Philip (2005), *Western: Aspects of a Movie Genre*, Manchester: Carcanet.

Freud, Sigmund ([1905] 1997), *Jokes and Their Relation to the Unconscious*, trans. James Strachey, London: Penguin.

Fry, William F. (1977), 'The appeasement function of mirthful laughter', in Antony Chapman and Hugh Foot (eds), *It's a Funny Thing, Humour*, Oxford: Pergamon Press, pp. 23–6.

Fry, William F. and Melanie Allen (1998), *Creating Humor: Life Studies of Comedy Writers*, New Brunswick, NH and London: Transaction.

Fuller, Linda K. (1992), *The Cosby Show: Audiences, Impact and Implications*, Westport, CT: Greenwood Press.

Gabler, Neal (1989), *An Empire of Their Own: How the Jews Invented Hollywood*, New York: Doubleday.

Gale, Steven H. (ed.) (1996), *Encyclopedia of British Humorists: Geoffrey Chaucer to John Cleese, Volume 1: A–K*, New York and London: Garland.

Gehring, Wes D. (1997), *Personality Comedians as Genre: Selected Players*, Westport, CT and London: Greenwood Press.

Geraghty, Christine (2003), 'Aesthetics and quality in popular television drama', *International Journal of Cultural Studies*, 6: 1, pp. 25–45.

Gibson, Owen (2008a), 'Comedian attacks TV chiefs over lack of ethnic diversity', *The Guardian*, 8 February, p. 4.

Gibson, Owen (2008b), 'BBC funding: the public's verdict', *The Guardian*, 18 August, Media Section, p. 1.

Gillespie, Marie (1995) *Television, Ethnicity and Cultural Change*, London and New York: Routledge.

Gitlin, Todd (1994), *Inside Prime Time*, revised edn, London: Routledge.

Glenn, Phillip J. (2003), *Laughter in Interaction*, Cambridge: Cambridge University Press.

Globe and Mail, The (2005), 'New Zealand bishops call for boycott of CanWest', *The Globe and Mail*, 16 July, Weekend Review, p. 6.

Glynn, Kevin (1996), 'Bartmania: the social reception of an unruly image', *Camera Obscura*, 38: 1, pp. 61–90.

Glynn, Kevin (2000), *Tabloid Culture: Trash Taste, Popular Power, and the Transformation of American Television*, Durham, NC and London: Duke University Press.

Goddard, Peter (1991), '*Hancock's Half-Hour*: a watershed in British television comedy', in John Corner (ed.), *Popular Television in Britain*, London: British Film Institute, pp. 75–89.

Gray, Frances (1994), *Women and Laughter*, Basingstoke: Macmillan.

Gray, Jonathan (2005), *Watching with the Simpsons: Television, Parody and Intertextuality*, London and New York: Routledge.

Gray, Jonathan (2007), 'Imagining America: *The Simpsons* go global', *Popular Communication*, 5: 2, pp. 129–48.

Gray, Jonathan (2008a), *Television Entertainment*, New York and London: Routledge.

Gray, Jonathan (2008b), 'Television pre-views and the meaning of hype', *International Journal of Cultural Studies*, 11: 1, pp. 33–49.

Greene, Doyle (2007), *Politics and the American Television Comedy: A Critical Survey from I Love Lucy to South Park*, Jefferson, NC: McFarland.

Greenfeld, Karl Taro (2008), 'Zuckervision', *Condé Nast Portfolio*, September, pp. 84–92, 130–2.

Greig, Tamsin (2008), 'The swot memoirs', in Rosie Boycott and Meredith Etherington-Smith (eds), *25x4: Channel 4 at 25*, London: Cultureshock, pp. 75–9.

Griffin, Jeffrey (2008), 'The Americanization of *The Office*: a comparison of the offbeat NBC sitcom and its British predecessor', *Journal of Popular Film and Television*, 35: 4, pp. 154–63.

Griffiths, Merris and David Machin (2003), 'Television and playground games as part of children's symbolic culture', *Social Semiotics*, 13: 2, pp. 147–60.

Grote, David (1983), *The End of Comedy: the Sit-Com and the Comedic Tradition*, Hamden, CT: Archon.

Gutwirth, Marcel (1993), *Laughing Matter: an Essay on the Comic*, Ithaca, NY and London: Cornell University Press.

Habermas, Jürgen ([1962] 1989), *The Structural Transformation of the Public Sphere: An Enquiry into a Category of Bourgeois Society*, trans. Thomas Burger and Frederick Lawrence, Cambridge: Polity.

Hall, Julian (2008), 'Chris Addison: swapping satire for sitcom', *The Independent*, 10 July, Extra, p. 14.

Hallin, Daniel C. (1997), 'Commercialism and professionalism in the American news media', in James Curran and Michael Gurevitch (eds), *Mass Media and Society*, 2nd edn, London: Arnold, pp. 243–62.

Halpern, Paul (2007), *What's Science Ever Done for Us? What the Simpsons can Teach us About Physics, Robots, Life, and the Universe*, Hoboken, NJ: John Wiley & Sons.

Hamilton, Andy [sitcom writer, producer, director and actor] (2005), interview with author, 1 November.

Hammond, Michael and Lucy Mazdon (eds) (2005), *The Contemporary Television Series*, Edinburgh: Edinburgh University Press.

Handel, Gerald (ed.) (2006), *Childhood Socialization*, New Brunswick, NH: Aldine Transaction.

Handelman, Don and Bruce Kapferer (1972), 'Forms of joking activity: a comparative approach', *American Anthropologist*, 74: 2, pp. 484–517.

Haralovich, Mary Beth (2003), 'Sitcoms and suburbs: positioning the 1950s

homemaker', in Joanne Morreale (ed.), *Critiquing the Sitcom: A Reader*, Syracuse, NY: Syracuse University Press, pp. 69–85.

Harper, Graeme (ed.) (2002), *Comedy, Fantasy and Colonialism*, London and New York: Continuum.

Harris, Mark (2008), 'Saving TV', *Condé Nast Portfolio*, September, pp. 92–4, 132–3.

Harris, Trudier (1995) 'Genre', *Journal of American Folklore*, 108: 430, pp. 509–27.

Hartley, John (2001), 'Situation comedy, part 1', in Glen Creeber (ed.), *The Television Genre Book*, London: British Film Institute, pp. 64–7.

Hartley, John (2008), 'The infotainment debate', in Glen Creeber (ed.), *The Television Genre Book*, 2nd edn, London: British Film Institute, pp. 115–17.

Harvey, Sylvia (2000), 'Channel Four television: from Annan to Grade', in Edward Buscombe (ed.), *British Television: A Reader*, Oxford: Oxford University Press, pp. 92–117.

Havens, Timothy (2006), *Global Television Marketplace*, London: British Film Institute.

Hawkinson, James (2004), 'Breaking sitcom rules on *Arrested Development*', *American Cinematographer*, February, pp. 107–8.

Hazlitt, William (1841), *Lectures on the English Comic Writers*, London: John Templeman.

Heller, Dana (2003), 'Russian sitkom adaptation', *Journal of Popular Film and Television*, 31: 2, pp. 60–72.

Herbert, Christopher (1984), 'Comedy: the world of pleasure', *Genre* 17: 4, pp. 401–16.

Hesmondhalgh, David (2002), *The Cultural Industries*, London, Thousand Oaks, CA and New Delhi: Sage.

Heuvelman, Ard, Allerd Peeters and Jan van Dijk (2005), 'Irritating, shocking, and intolerable TV programs: norms, values, and concerns of viewers in the Netherlands', *Communications*, 30: 3, pp. 325–42.

Hewison, Robert (1983), *Footlights! A Hundred Years of Cambridge Comedy*, London: Methuen.

Higson, Charlie [sitcom writer] (2008), interview with author, 30 May.

Hill, Annette (2007), *Restyling Factual TV: The Reception of News, Documentary and Reality Genres*, London and New York: Routledge.

Hillis, Ken and Michael Petit with Nathan Scott Epley (eds) (2006), *Everyday eBay: Culture, Collecting and Desire*, London and New York: Routledge.

Hobbes, Thomas ([1651] 2005), *Leviathan, Parts I and II*, Peterborough, ON, Plymouth, UK and Sydney: Broadview Press.

Hobson, Dorothy (1982), *Crossroads: The Drama of a Soap Opera*, London: Methuen.

Hobson, Dorothy (2008), *Channel 4: The Early Years and the Jeremy Isaacs Legacy*, London and New York: I. B. Tauris.

Hodge, Robert and Gunther Kress (1988), *Social Semiotics*, Ithaca, NY: Cornell University Press.

Holliday, Adrian (2007), *Doing and Writing Qualitative Research*, 2nd edn, London, Thousand Oaks, CA and New Delhi: Sage.

Holmes, Su (2008), '"A term rather too general to be helpful": struggling with genre in reality TV', in Lincoln Geraghty and Mark Jancovich (eds), *The Shifting Definitions of Genre: Essays on Labeling Films, Television Shows and Media*, Jefferson, NC: McFarland, pp. 159–80.

Holmes, Su and Deborah Jermyn (eds) (2004), *Understanding Reality Television*, London: Routledge.

Holtzman, Linda (2000), *Media Messages: What Film, Television, and Popular Music Teach Us About Race, Class, Gender and Sexual Orientation*, Armonk, NY and London: M. E. Sharpe.

Horan, Dermot (2007), 'Quality US TV: a buyer's perspective', in Janet McCabe and Kim Akass (eds), *Quality TV: Contemporary American Television and Beyond*, London and New York: I. B. Tauris, pp. 111–17.

Huizinga, Johan (1970), *Homo Ludens: A Study of the Play Element in Culture*, London: Paladin.

Husband, Charles (1988), 'Racist humour and racist ideology in British television, or, I laughed till you cried', in Chris Powell and George E. C. Paton (eds), *Humour in Society: Resistance and Control*, Basingstoke: Macmillan, pp. 149–78.

Independent Television Commission (2002), *The ITC Programme Code*, London: Independent Television Commission.

Irwin, William (ed.) (2000), *Seinfeld and Philosophy: A Book about Everything and Nothing*, Chicago, IL: Open Court.

Irwin, William, Mark T. Conrad and Aeon Skoble (eds) (2001), *The Simpsons and Philosophy: The D'oh! of Homer*, Chicago: Open State.

Jacobs, Jason (2001), 'Hospital drama', in Glen Creeber (ed.), *The Television Genre Book*, London: British Film Institute, pp. 23–6.

Jancovich, Mark (2000), 'A real shocker: authenticity, genre and the struggle for distinction', *Continuum: Journal of Media and Cultural Studies*, 14: 1, pp. 23–35.

Jancovich, Mark and James Lyons (eds) (2003), *Quality Popular Television: Cult TV, the Industry and Fans*, London: British Film Institute.

Janko, Richard (1984), *Aristotle on Comedy: Towards a Reconstruction of Poetics II*, London: Duckworth.

Jenkin, Guy [sitcom writer] (2005), interview with author, 18 October.

Jenkins, Ron (1994), *Subversive Laughter: The Liberating Power of Comedy*, New York: Free Press.

Jessop, Bob (1994), 'Post-Fordism and the state', in Ash Amin (ed.), *Post-Fordism: A Reader*, Oxford and Cambridge: Blackwell, pp. 251–79.

Jhally, Sut and Justin Lewis (1992), *Enlightened Racism: The Cosby Show, Audiences and the Myth of the American Dream*, Boulder, CO: Westview Press.

Johnson, Catherine and Rob Turnock (2005), *ITV Cultures: Independent Television Over Fifty Years*, Maidenhead: Open University Press.

Johnson, Victoria E. (2008), *Heartland TV: Prime Time Television and the Struggle for U.S. Identity*, New York and London: New York University Press.

Johnson-Woods, Toni (2007), *Blame Canada! South Park and Contemporary Culture*, New York and London: Continuum.

Jones, Gerard (1992), *Honey, I'm Home! Sitcoms: Selling the American Dream*, New York: St. Martin's Press.

Jones, Jeffrey P. (2006), 'A cultural approach to the study of mediated citizenship', *Social Semiotics*, 16: 2, pp. 365–83.

Kane, Pat (2004), *The Play Ethic: A Manifesto for a Different Way of Living*, London: Macmillan.

Kant, Immanuel ([1790] 1931), *Critique of Judgment*, trans. J. H. Bernard, London: Macmillan.

Kaye, Peter (2007), 'Writing music for quality TV: an interview with W. G. "Snuffy" Walden', in Janet McCabe and Kim Akass (eds), *Quality TV: Contemporary American Television and Beyond*, London and New York: I. B. Tauris, pp. 221–7.

Kerr, Paul (1984), 'The making of (the) MTM (show)', in Jane Feuer, Paul Kerr and Tise Vahimagi (eds), *MTM: 'Quality Television'*, London: BFI, pp. 61–98.

Keslowitz, Steven (2006), *The World According to the Simpsons: What Our Favourite TV Family Says about Life, Love and the Perfect Donut*, Naperville, IL: Sourcebooks.

Kilborn, Richard (2000), 'The docu-soap: a critical reassessment', in John Izod and Richard Kilborn with Matthew Hibberd (eds), *From Grierson to the Docu-Soap: Breaking the Boundaries*, Luton: University of Luton Press, pp. 111–19.

King, Geoff (2002), *Film Comedy*, London: Wallflower Press.

King, Geoff (2005), *The Spectacle of the Real: From Hollywood to 'Reality TV' and Beyond*, Bristol: Intellect.

Klein, Sheri (2007), *Art and Laughter*, London and New York: I. B. Tauris.

Kompare, Derek (2004), 'Extraordinarily ordinary: the Osbournes as an American family', in Susan Murray and Laurie Ovelletre (eds), *Reality TV: Remaking Television Culture*, New York and London: New York University Press, pp. 139–48.

Koolstra, Cees M. and Nicole Lucassen (2004), 'Viewing behavior of children and TV guidance by parents: a comparison of parent and child reports', *Communications* 29: 2, pp. 179–98.

Kubey, Robert (2004), *Creating Television: Conversations with the People Behind 50 Years of American TV*, Mahwah, NJ and London: Lawrence Erlbaum.

Kuipers, Giselinde (2006), 'Television and taste hierarchy: the case of Dutch television comedy', *Media, Culture and Society*, 28: 3, pp. 359–78.

Lacey, Nick (2000), *Narrative and Genre: Key Concepts in Media Studies*, Basingstoke: Palgrave Macmillan.

Lacey, Stephen (1995), *British Realist Theatre: The New Wave in its Context, 1956–1965*, London and New York: Routledge.

Langford, Barry (2005), *Film Genre: Hollywood and Beyond*, Edinburgh: Edinburgh University Press.

Leavis, F. R. (1933), *Mass Civilisation and Minority Culture*, Cambridge: Minority Press.

Legman, Gershon ([1968] 2006), *Rationale of the Dirty Joke: An Analysis of Sexual Humor*, New York, London, Toronto and Sydney: Simon & Schuster.

Leverette, Marc, Brian L. Ott and Cara Louise Buckley (eds) (2008), *It's Not TV: Watching HBO in the Post-Television Era*, New York and London: Routledge.

Levine, J. B. (1976), 'The feminine routine', *Journal of Communication*, 26: 3, pp. 173–5.

Lewis, Paul, Christie Davies, Giselinde Kuipers, Rod A. Martin, Elliott Oring and Vistor Raskin (2008), 'The Muhammad cartoons and humor research: a collection of essays', *Humor: International Journal of Humor Research*, 21: 1, pp. 1–46.

Lewisohn, Mark (2003), *The Radio Times Guide to TV Comedy*, 2nd edn, London: BBC Worldwide.

Limon, John (2000), *Stand-Up Comedy in Theory, or, Abjection in America*, Durham, NC and London: Duke University Press.

Lipman, Steve (1991), *Laughter in Hell: The Use of Humor During the Holocaust*, Northvale, NJ and London: Jason Aronson.

Lipsitz, George (2003), 'Why remember *Mama*? The changing face of a woman's narrative', in Joanne Morreale (ed.), *Critiquing the Sitcom: A Reader*, Syracuse, NJ: Syracuse University Press, pp. 7–24.

Littlewood, Jane and Michael Pickering (1998), 'Heard the one about the white middle-class heterosexual father-in-law? Gender, ethnicity and political correctness in comedy', in Stephen Wagg (ed.), *Because I Tell a Joke or Two: Comedy, Politics and Social Difference*, London and New York: Routledge, pp. 291–312.

Livingstone, Sonia, Peter Lunt and Laura Miller (2007), 'Citizens and consumers: discursive debates during and after the Communications Act 2003', *Media, Culture and Society*, 29: 4, pp. 613–38.

Longhurst, Brian, Greg Smith, Gaynor Bagnall, Garry Crawford and Miles Ogborn, with Elaine Baldwin and Scott McCracken (2008), *Introducing Cultural Studies*, 2nd edn, Harlow: Pearson.

Lotz, Amanda D. (2008), 'On "television criticism": the pursuit of the critical examination of a popular art', *Popular Communication*, 6: 1, pp. 20–36.

Lovell, Terry (1982), 'A genre of social disruption?', in Jim Cook (ed.), *BFI Dossier 17: Television Sitcom*, London: British Film Institute, pp. 19–31.

Lury, Karen (2005), *Interpreting Television*, London: Hodder.

McCabe, Janet and Kim Akass (eds) (2007), *Quality TV: American Television and Beyond*, London: I. B. Tauris.

McCabe, Janet and Kim Akass (2008), 'It's not TV, it's HBO's original programming: producing quality TV', in Marc Leverette, Brian L. Ott and Cara Louise Buckley (eds), *It's Not TV: Watching HBO in the Post-Television Era*, New York and London: Routledge, pp. 83–93.

McCann, Graham (2006), *Spike and Co: Inside the House of Fun with Milligan, Sykes, Galton and Simpson*, London: Hodder & Stoughton.

McCrum, Stephen [sitcom producer] (2005), interview with author, 28 June.

Macdonald, Chrissie (2002), *That's Anarchy! The Story of a Revolution in the World of TV Comedy*, Hartwell, Vic.: Sid Hurva Publishers.

McDonald, Paul (2000), *The Star System: Hollywood's Production of Popular Identities*, London: Wallflower.

McEachern, Charmaine (1999), 'Comic interventions: passion and the men's movement in the situation comedy, *Home Improvement*', *Journal of Gender Studies*, 8: 1, pp. 5–18.

McGhee, Paul E. (1979), *Humor: Its Origin and Development*, San Francisco, CA: W. H. Freeman and Company.

McLuhan, Marshall (1964), *Understanding Media: The Extensions of Man*, London: Routledge & Kegan Paul.

Malik, Sarita (2002), *Representing Black Britain: Black and Asian Images on Television*, London: Sage.

Marc, David (1989), *Comic Visions: Television Comedy and American Culture*, London, Sydney and Wellington: Unwin Hyman.

Marc, David (1996), *Demographic Vistas: Television in American Culture*, revised edn, Philadelphia, PA: University of Pennsylvania Press.

Mardles, Paul (2007), 'My media: Lee Mack', *The Guardian*, 8 October, Media Section, p. 6.

Marriott, Stephanie (2007), *Live Television: Time, Space and the Broadcast Event*, London, Thousand Oaks, CA, New Delhi and Singapore: Sage.

Martin, Nancy San (2003), 'Must see TV: programming identity on NBC Thursdays', in Mark Jancovich and James Lyons (eds), *Quality Popular Television: Cult TV, the Industry and Fans*, London: British Film Institute, pp. 32–47.

Mayhew-Archer, Paul [sitcom writer] (2005), interview with author, 22 July.

Medhurst, Andy (2007), *A National Joke: Popular Comedy and English Cultural Identities*, London and New York: Routledge.

Medhurst, Andy and Lucy Tuck (1982), 'The gender game', in Jim Cook (ed.), *BFI Dossier 17: Television Sitcom*, London: British Film Institute, pp. 43–55.

Mellencamp, Patricia (1992) *High Anxiety: Catastrophe, Scandal, Age and Comedy*, Bloomington and Indianapolis, IN: Indiana University Press.

Meredith, George (1897), *An Essay on Comedy*, Westminster: Archibald Constable.

Miller, Jeffrey S. (2000), *Something Completely Different: British Television and American Culture*, Minneapolis, MN and London: University of Minnesota Press.

Mills, Brett (2004), 'Comedy vérité: contemporary sitcom form', *Screen*, 45: 1, pp. 63–78.

Mills, Brett (2005), *Television Sitcom*, London: British Film Institute.

Mills, Brett (2007), '"Yes, it's war!": Chris Morris and comic acceptability', in Laura Mulvey and Jamie Sexton (eds), *Experimental British Television*, London: Routledge, pp. 180–94.

Mills, Brett (2008a), 'Paranoia, paranoia, everybody's coming to get me: *Peep Show*, sitcom and the surveillance society', *Screen*, 49: 1, pp. 51–64.

Mills, Brett (2008b), 'After the interview', *Cinema Journal*, 47: 2, pp. 148–53.

Mintz, Larry (1985), 'Situation comedy', in Brian G. Rose (ed.), *TV Genres: A Handbook and Reference Guide*, Westport, CT: Greenwood Press, pp. 107–29.

Mirzoeff, Nicholas (2008), *Seinfeld*, London: British Film Institute.

Mittell, Jason (2001), 'A cultural approach to television genre theory', *Cinema Journal*, 40: 3, pp. 3–24.

Mittell, Jason (2004), *Genre and Television: From Cop Shows to Cartoons in American Culture*, New York and London: Routledge.

Mittell, Jason (2008), 'Genre study – beyond the text', in Glen Creeber (ed.), *The Television Genre Book*, 2nd edn, London: British Film Institute, pp. 9–13.

Moffatt, Steven [sitcom writer] (2005), interview with author, 2 November.

Moran, Albert and Justin Malbon (2006), *Understanding the Global TV Format*, Bristol and Portland: Intellect.

Morreale, Joanne (2003), 'Sitcoms say goodbye: the cultural spectacle of *Seinfeld*'s last episode', in Joanne Morreale (ed.), *Critiquing the Sitcom: A Reader*, Syracuse, NY: Syracuse University Press, pp. 274–85.

Morreall, John (1983), *Taking Laughter Seriously*, Albany, NY: State University of New York Press.

Morreall, John (ed.) (1987), *The Philosophy of Laughter and Humour*, Albany, NY: State University of New York Press.

Morris, Jonathan S. (2008), '*The Daily Show with Jon Stewart* and audience attitude change during the 2004 party conventions', *Political Behavior*, 30: 4, pp. 553–72.

Mosley, Ivo (ed.) (2000), *Dumbing Down: Culture, Politics and the Mass Media*, Thorverton: Imprint Academic.

Mulkay, Michael (1988), *On Humour: Its Nature and Its Place in Modern Society*, Cambridge: Polity Press.

Murdock, Graham (2003), 'Back to work: cultural labor in altered times', in Andrew Beck (ed.), *Cultural Work: Understanding the Cultural Industries*, London and New York: Routledge, pp. 15–36.

Murray, Susan (2005), *Hitch Your Antenna to the Stars: Early Television and Broadcast Stardom*, New York and London: Routledge.

Murray, Susan and Laurie Ouellette (eds) (2004), *Reality TV: Remaking Television Culture*, New York and London: New York University Press.

Nathan, David (1971), *The Laughtermakers: A Quest for Comedy*, London: Owen.

Neale, Steve (1980), *Genre*, London: British Film Institute.

Neale, Steve (2000), *Genre and Hollywood*, London and New York: Routledge.

Neale, Steve and Frank Krutnik (1990), *Popular Film and Television Comedy*, London and New York: Routledge.

Nelson, Robin (2007), *State of Play: Contemporary 'High-End' TV Drama*, Manchester: Manchester University Press.

New Zealand Herald, The (2005), 'Jumping up and down over pogo Pope', *The New Zealand Herald*, 5 June, p. 8.

Nichols, Bill (1991), *Representing Reality: Issues and Concepts in Documentary*, Bloomington, IN: Indiana University Press.

Nickson, Susan [sitcom writer] (2005), interview with author, 26 July.

Nielsenwire (2008), 'More US viewers, households for 2008–9 season', found at http://blog.nielsen.com/nielsenwire/media_entertainment/us-viewers-households-up-sligtly-in–2008–09-tv-season/.

Nolan, David (2006), 'Media, citizenship and governmentality: defining "the public" of public service broadcasting', *Social Semiotics*, 16: 2, pp. 221–42.

Normal, Henry [sitcom writer and producer] (2006), interview with author, 22 March.

Nye, Simon [sitcom writer] (2005), interview with author, 20 May.

Ofcom (2004), *Ofcom Review of Public Television Broadcasting: Phase 1 – Is Television Special?*, London: Ofcom.

Ofcom (2007a), *Ofcom Broadcasting Bulletin: Issue Number 80*, London: Ofcom.

Ofcom (2007b), *Ofcom Broadcasting Bulletin: Issue Number 81*, London: Ofcom.

Ofcom (2008a), *The Communications Market 2008*, London: Ofcom.

Ofcom (2008b), *Ofcom's Second Public Service Broadcasting Review – Phase 1: The Digital Opportunity*, London: Ofcom.

Olson, Beth and William Douglas (1997), 'The family on television: evaluation of gender roles in situation comedy', *Sex Roles*, 36: 5/6, pp. 409–27.

Open Society Institute (2005), *Television Across Europe: Regulation, Policy and Independence*, Budapest: EU Monitoring and Advocacy Program in association with Network Media Program.

Palmer, Jerry (1987), *The Logic of the Absurd: On Film and Television Comedy*, London: British Film Institute.

Palmer, Jerry (1994), *Taking Humour Seriously*, London and New York: Routledge.

Parker, Robin (2007), 'Focus: 360 degree commissioning', *Broadcast*, 13 September, pp. 24–5.

Paul, William (1994), *Laughing, Screaming: Modern Hollywood Horror and Comedy*, New York: Columbia University Press.

Paulos, John Allen (1980), *Mathematics and Humor*, Chicago, IL: University of Chicago Press.

Paulos, John Allen (2000), *I Think Therefore I Laugh: The Flip Side of Philosophy*, London: Penguin.

Peacock, Stephen (2006), 'In between *Marion and Geoff*', *Journal of British Cinema and Television*, 3: 1, pp. 115–21.

Pearson, Roberta (2005), 'The writer/producer in American television', in Michael Hammond and Lucy Mazdon (eds), *The Contemporary Television Series*, Edinburgh: Edinburgh University Press, pp. 11–26.

Pearson, Roberta E. and Máire Messenger-Davies (2003), '"You're not going to see that on TV": *Star Trek – The Next Generation* in Film and Television',

in Mark Jancovich and James Lyons (eds), *Quality Popular Television: Cult TV, the Industry and the Fans*, London: British Film Institute, pp. 103–17.

Petley, Julian (2006), 'Public service broadcasting in the UK', in Douglas Gomery and Luke Hockley (eds), *Television Industries*, London: BFI, pp. 42–5.

Pidd, Helen (2008), 'First "satcom" causes laughter all the way up the M6', *The Guardian*, 3 May, p. 13.

Pinsky, Mark (2001), *The Gospel According to the Simpsons: the Spiritual Life of the World's Most Animated Family*, Phoenix, AZ: Westminster John Know Press.

Plato ([360 BCE] 1975), *Philebus*, trans. J. C. B. Gosling, Oxford: Clarendon Press.

Plowman, Jon [Head of BBC Comedy] (2005), interview with author, 8 June.

Polan, Dana (2007), 'Cable watching: HBO, *The Sopranos*, and discourses of distinction', in Sarah Banet-Weiser, Cynthia Chris and Anthony Freitas (eds), *Cable Visions: Television Beyond Broadcasting*, New York and London: New York University Press, pp. 261–83.

Pollio, H. R. and J. W. Edgerly (1976), 'Comedians and comic style', in Antony J. Chapman and Hugh C. Foot (eds), *Humour and Laughter: Theory, Research and Applications*, London: John Wiley, pp. 215–42.

Porter, Laraine (1998), 'Tarts, tampons and tyrants: women and representation in British comedy', in Stephen Wagg (ed.), *Because I Tell a Joke or Two: Comedy, Politics and Social Difference*, London and New York: Routledge, pp. 65–93.

Postman, Neil (1986), *Amusing Ourselves to Death: Public Discourse in the Age of Show Business*, London: Heinemann.

Potter, W. James (2008), *Media Literacy*, 4th edn, Los Angeles, London, New Delhi and Singapore: Sage.

Provine, Robert R. (2000), *Laughter: A Scientific Investigation*, London: Penguin.

Pugsley, Peter (2007), 'At home in Singaporean sitcoms: *Under One Roof, Living with Lydia* and *Phua Chu Kang*', *M/C Journal*, found at http://journal.media-culture.org.au/0708/09-pugsley.php.

Purdie, Susan (1993), *Comedy: the Mastery of Discourse*, Hemel Hempstead: Harvester Wheatsheaf.

Putterman, Barry (1995), *On Television and Comedy: Essays on Style, Theme, Performer and Writer*, Jefferson, NC: McFarland.

Radcliffe-Brown, A. R. (1952), *Structure and Function in Primitive Society: Essays and Addresses*, London: Cohen & West.

Raskin, Victor (1985), *Semantic Mechanisms of Humor*, Dordrecht: Reidel.

Redmond, Sean (2007), 'Intimate fame everywhere', in Su Holmes and Sean Redmond (eds), *Framing Celebrity: New Directions in Celebrity Culture*, London: Routledge, pp. 37–63.

Riegert, Kristina (ed.) (2007), *Politicotainment: Television's Take on the Real*, New York: Peter Lang.

Ritchie, Graeme (2004), *The Linguistic Analysis of Jokes*, London and New York: Routledge.

Rivero, Yeidy M. (2002), 'Erasing blackness: the media construction of race in *Mi Familia*, the first Puerto Rican situation comedy with a black family', *Media, Culture and Society*, 24: 4, pp. 481–97.

Rixon, Paul (2003), 'The changing face of American television programmes on British screens', in Mark Jancovich and James Lyons (eds), *Quality Popular Television: Cult TV, the Industry and Fans*, London: British Film Institute, pp. 48–61.

Rixon, Paul (2006), *American Television on British Screens: A Story of Cultural Interaction*, Basingstoke: Palgrave Macmillan.

Roberts, Graham (2006), 'BBC Worldwide', in Douglas Gomery and Luke Hockley (eds), *Television Industries*, London: BFI, pp. 34–5.

Roberts, Jennifer and Michael Dietrich (1999), 'Conceptualizing professionalism: why economics needs socialism', *American Journal of Economics and Sociology*, 58: 4, pp. 977–98.

Romero, Eric J., Carols J. Alsua, Kim T. Hinrichs and Terry R. Pearson (2007), 'Regional humor differences in the United States: implications for management', *Humor: International Journal of Humor Research*, 20: 2, pp. 189–201.

Rowe, Kathleen (1990), 'Roseanne: Unruly woman as domestic goddess', *Screen*, 31: 4, pp. 408–19.

Rowe, Kathleen (1995), *The Unruly Woman: Gender and the Genres of Laughter*, Austin, TX: University of Texas Press.

Rubin, A. M. (1981), 'An examination of television viewing motivations', *Communication Research*, 8: 2, pp. 141–65.

Saarinen, Leena (2007), 'Comedy machine: interactive comedy as a rule-based genre', *Digital Creativity*, 18: 3, pp. 143–50.

Santo, Avi (2008), 'Para-television and discourses of distinction: the culture of production at HBO', in Marc Leverette, Brian L. Ott and Cara Louise Buckley (eds), *It's Not TV: Watching HBO in the Post-Television Era*, New York and London: Routledge, pp. 19–45.

Saunders, Anna (2005), '*Popetown* plea goes to higher authority', *The Dominion Post*, 23 September, p. 9.

Scheurer, Timothy E. (2008), *Music and Mythmaking in Film: Genre and the Role of the Composer*, Jefferson, NC and London: McFarland.

Schoch, Richard (2007), *The Secrets of Happiness: Three Thousand Years of Searching for the Good Life*, London: Profile.

Schopenhauer, Arthur ([1819] 1907), *The World as Will and Idea, Volume 1*, trans. R. B. Haldane and J. Kemp, London: Kegan Paul, Trench, Trübner & Co.

Screech, M. A. (1997), *Laughter at the Foot of the Cross*, London: Penguin.

Sedita, Scott (2005), *The Eight Characters of Comedy: A Guide to Sitcom Acting and Writing*, London: Atides Publishing.

Seidman, Steve (1981), *Comedian Comedy: A Tradition in Hollywood Film*, Ann Arbor, MI: UMI Research Press.

Sharpe, Robert (1975), 'Seven reasons why amusement is an emotion', *Journal of Value Enquiry*, 9: 2, pp. 201–3.

Silberg, Jon (2008), 'Laugh factory', *American Cinematographer*, July, pp. 64–7.

Silk, M. S. (2000), *Aristophanes and the Definition of Comedy*, Oxford: Oxford University Press.

Smith, Anthony (ed.) (1995), *Television: An International History*, Oxford: Oxford University Press.

Smith, Graham [Head of Comedy at Five] (2006), interview with author, 13 January.

Sparks, Colin and John Tulloch (eds) (2000), *Tabloid Tales: Global Debates Over Media Standards*, Lanham, IHD and Oxford: Rowman & Littlefield.

Spencer, Herbert (1911), *Essays on Education and Kindred Subjects*, London: Everyman.

Spigel, Lynn (1992), *Make Room for TV: Television and the Family Ideal in Postwar America*, Chicago, IL and London: University of Chicago Press.

Spigel, Lynn (2001), *Welcome to the Dreamhouse: Popular Media and Postwar Suburbs*, Durham, NC and London: Duke University Press.

Stabile, Carol A. and Mark Harrison (eds) (2003), *Prime Time Animation: Television Animation and American Culture*, London and New York: Routledge.

Staiger, Janet (2000), *Blockbuster TV: Must-See Sitcoms in the Network Era*, New York: New York University Press.

Steemers, Jeanette (2004), *Selling Television: British Television in the Global Marketplace*, London: British Film Institute.

Stober, JoAnne (2007), 'Vaudeville: the incarnation, transformation, and resilience of an entertainment form', in Charles R. Acland (ed.), *Residual Media*, Minneapolis, MN and London: University of Minnesota Press, pp. 133–55.

Stokoe, Elizabeth (2008), 'Dispreferred actions and other interactional breaches as devices for occasioning audience laughter in television sitcoms', *Social Semiotics*, 18: 3, pp. 289–307.

Strelitz, Larry Nathan (2002), 'Media consumption and identity formation: the case of the "homeland" viewers', *Media, Culture and Society*, 24: 4, pp. 459–80.

Tankel, Jonathan David and Keith Murphy (1998), 'Collecting comic books: a study of the fan and curatorial consumption', in Cheryl Harris and Alison Alexander (eds), *Theorizing Fandom: Fans, Subculture and Identity*, Cresskill, NJ: Hampton Press, pp. 55–68.

Taylor, Rod (1994), *The Guinness Book of Sitcoms*, Middlesex: Guinness.

Thompson, Ethan (2008), 'iWant my TweenTV: *iCarly*, Sitcom 2.0', *FlowTV*, found at http://flowtv.org/?p=1597.

Thompson, Kristin (2003), *Storytelling in Film and Television*, Cambridge, MA and London: Harvard University Press.

Thompson, Robert J. (1996), *Television's Second Golden Age: From Hill Street Blues to ER*, New York: Continuum.

Thornborrow, Joanna (2001), '"Has it ever happened to you?": talk show stories as mediated performance', in Andrew Tolson (ed.), *Television Talk Shows: Discourse, Performance, Spectacle*, Mahwah, NJ and London: Lawrence Erlbaum, pp. 117–37.

Thornham, Sue and Tony Purvis (2005), *Television Drama: Theories and Identities*, Basingstoke: Palgrave Macmillan.

Timberg, Bernard M. (2002), *Television Talk: A History of the TV Talk Show*, Austin, TX: University of Texas Press.

Tudor, Andrew (1970), 'Genre: theory and mispractice in film criticism', *Screen*, 11: 6, pp. 33–42.

Tueth, Michael V. (2005), 'Breaking and entering: transgressive comedy on television', in Mary M. Dalton and Laura L. Linder (eds), *The Sitcom Reader: America Viewed and Skewed*, Albany, NJ: State University of New York Press, pp. 25–34.

Tunstall, Jeremy (1993), *Television Producers*, London and New York: Routledge.

Turnbull, Sue (2008), 'Mapping the vast suburban tundra: Australian comedy from Dame Edna to *Kath and Kim*', *International Journal of Cultural Studies*, 11: 1, pp. 15–32.

Turner, Chris (2005), *Planet Simpson: How a Cartoon Masterpiece Documented an Era and Defined a Generation*, Cambridge, MA: Da Capo Press.

Turner, Graeme (1990), *British Cultural Studies: An Introduction*, 2nd edn, London and New York: Routledge.

Turner, Graeme (2001), 'Genre, hybridity and mutation', in Glen Creeber (ed.), *The Television Genre Book*, London: British Film Institute, p. 6.

Turner, Janice (2006), 'Trades unions in broadcasting', in Douglas Gomery and Luke Hockley (eds), *Television Industries*, London: BFI, pp. 75–7.

Ursell, Gillian (2006), 'Working in the media', in David Hesmondhalgh (ed.), *Media Production*, Maidenhead: Open University Press, pp. 133–71.

Van Gelder, Lawrence (2006), 'German Catholics protest MTV's *Popetown*', *New York Times*, 11 April, Section E, p. 2.

Van Gelder, Lawrence (2007), 'Lithuanian court allows *Popetown* broadcast', *New York Times*, 4 January, Section E, p. 2.

Vertue OBE, Beryl [sitcom producer and Chairman of Hartswood Productions] (2005), interview with author, 21 June.

Wachman, Joshua S. and Rosalind W. Picard (2001), 'Tools for browsing a TV situation comedy based on content specific attributes', *Multimedia Tools and Applications*, 13: 3, pp. 255–84.

Wagg, Stephen (1998), 'At ease, Corporal: social class and the situation comedy in British television, from the 1950s to the 1990s', in Stephen Wagg (ed.), *Because I Tell a Joke or Two: Comedy, Politics and Social Difference*, London and New York: Routledge, pp. 1–31.

Wall, David (2007), 'Tony Hancock and the cultural landscapes of post-war Britain', *Journal of British Cinema and Television*, 4: 2, pp. 235–52.

Ward, Paul (2005), *Documentary: the Margins of Reality*, London: Wallflower.

Watson, Mary Ann (1985), 'Television criticism in the popular press', *Critical Studies in Mass Communication*, 2: 1, pp. 66–75.

Weinstein, Simcha (2006), *Up, Up and Oy Vey! How Jewish History, Culture and Values Shaped the Comic Book Superhero*, Baltimore, MD: Leviathan.

Weisfeld, Glenn E. (2006), 'Humor appreciation as an adaptive esthetic emotion', *Humor: International Journal of Humor Research*, 19: 1, pp. 1–26.

Wells, Paul (2002), *Animation and America*, Edinburgh: Edinburgh University Press.

White, Allon (1993), *Carnival, Hysteria and Writing: Collected Essays and Autobiography*, Oxford: Clarendon Press.

Wickberg, Daniel (1998), *The Sense of Humor: Self and Laughter in Modern America*, Ithaca, NY and London: Cornell University Press.

Wiliam, Sioned [Controller of Comedy at ITV] (2005), interview with author, 8 June.

Williams, Raymond (1974), *Television: Technology and Cultural Form*, London: Routledge.

Williamson, Lisa (2008), 'Challenging sitcom conventions: from *The Larry Sanders Show* to *The Comeback*', in Marc Leverette, Brian L. Ott and Cara Louise Buckley (eds), *It's Not TV: Watching HBO in the Post-Television Era*, New York and London: Routledge, pp. 108–22.

Wilmut, Roger and Peter Rosengard (1989), *Didn't You Kill My Mother-in-Law?*, London: Methuen.

Wimer, David J. and Bernard C. Beins (2008), 'Expectations and perceived humor', *Humor: International Journal of Humor Research*, 21: 3, pp. 347–63.

Winn, Marie (1985), *The Plug-In Drug*, New York and Harmondsworth: Penguin.

Winston, Brian (2000), *Lies, Damn Lies and Documentaries*, London: British Film Institute.

Wolfe, Gary K. (1979), *The Known and the Unknown: The Iconography of Science Fiction*, Kent, OH: Kent State University Press.

Wolff, Jurgen with L. P. Ferrante (1996), *Successful Sitcom Writing: How to Write and Sell for TV's Hottest Format*, revised edition, New York: St. Martin's Press.

Wright, John (2006), *Why is That So Funny? A Practical Exploration of Physical Comedy*, London: Nick Hern.

Zijderveld, Anton C. (1982), *Reality in a Looking-Glass: Rationality Through an Analysis of Traditional Folly*, London, Boston and Henley: Routledge & Kegan Paul.

Zillmann, Dolf (2000), 'Humor and comedy', in Dolf Zillmann and Peter Vorderer (eds), *Media Entertainment: The Psychology of its Appeal*, Mahwah, NJ and London: Lawrence Erlbaum, pp. 37–57.

Zook, Kristal Brent (1999), *Color by Fox: The Fox Network and the Revolution in Black Television*, New York and Oxford: Oxford University Press.

Zurawik, David (2003), *The Jews of Primetime*, Hanover, NH and London: University Press of New England.

Index

ABC, 117

Absolutely Fabulous, 52, 53, 57, 109, 125

According to Bex, 143

According to Jim, 117–8

Achter, Paul, 29

ACMA (Australian Communications and Media Authority), 114, 117–18

Addison, Chris, 143

adult animation, 31, 90–2

After You've Gone, 44–5, 79, 127, 143

Akass, Kim 29, 133

All in the Family, 126

Allen, Melanie, 51

Allen, Robert C., 75

'Allo 'Allo!, 96

alternative comedy, 79, 125

Altman, Rick, 48

America's Funniest Home Videos, 141

Amin, Ash, 68

Amos 'n' Andy, 82

Amusing Ourselves to Death, 27

Anderson, Benedict, 47

Ang, Ien, 103, 106, 108

Are You Being Served?, 109

Aristophanes, 5

Aristotle, 5, 77–8, 81, 82, 98

Armstrong, Stephen, 67

Arrested Development, 25, 27, 129–32

Askey, Arthur, 20

audiences, 16–17, 25, 28, 32–3, 42, 44–5, 48, 85, 87–8, 93, 95–6, 98–9, 103, 115, 124–7, 134, 141, 142, 145

citizens/consumers, 115–16

confused responses, 111–13

effects, 104

emotional responses, 6–7, 100–2, 112

expectations, 5, 7–8, 13, 17, 26, 28, 33–4, 47, 54, 59, 83, 98, 100, 102, 107, 111, 115–16, 121, 127

younger audiences/children, 32, 66, 90–2, 116–19, 136–8

Auslander, Philip, 14

authorship, 34, 133

Baby Cow, 50, 67

Bakhtin, Mikhail, 78–9, 122

Ball, Lucille, 37

Band Waggon, 19

Bardoel, Johannes, 115–16

Barker, Ronnie, 21, 38, 53, 95

Barron, Fred, 143

Battles, Kathleen, 97

Baynham, Peter, 138

BBC, 19, 20, 32, 36, 44–5, 46, 52, 52–3, 55, 56, 64–6, 69, 115, 120–1, 137–8, 143

BBC iPlayer, 138

BBC Radio, 4 140

BBC Switch, 137–8

BBC1, 53, 79, 143–4

BBC2, 18, 36, 52, 121
BBC3, 32, 37, 52–3, 134, 137
BBC4, 52
BBC7, 140–1
Beaty, Bart, 144
Beavis and Butt-Head, 90
Bedtime, 32
Benidorm, 52
The Benny Hill Show, 109
Berle, Milton, 20
Bewitched, 107
The Big Bang Theory, 25
Bignell, Jonathan, 42, 129
The Bill, 15
Billig, Michael, 5, 78
The Black Adder, 38, 109
Blackadder Goes Forth, 8, 109
Bodroghkozy, Aniko, 107
Bond, James, 110
Bonner, Frances, 4
Bordwell, David, 133
Bottle Boys, 52
Bourdieu, Pierre, 63, 73, 133–4
Bourdon, Jérôme, 14
Brabazon, Tara, 105
Branston, Gill, 24
Brass Eye, 138
Bread, 12, 129
British Academy Television Awards, 31
British Comedy Awards, 31, 46
British national identity, 64, 109–13
broadcasting, 13–19, 65–7, 80, 84, 88, 92, 135
 audience(s) *see* separate entry
 domesticity, 19–23, 35, 36, 42–3, 127, 141
 liveness, 14–15
 nationally defined, 16, 19, 51, 65–7, 81, 108, 114, 122, 144–5
 public service broadcasting *see* separate entry
 seriality, 17, 35, 60, 97

Brunsdon, Charlotte, 106
Brydon, Rob, 67
Burke, Kathy, 21
The Burns and Allen Show, 35
Bussman, Jane, 138
Butterflies, 11, 13, 22

camp, 97, 107
'carnivalesque', 11, 79, 117, 122
Carrie and Barry, 1, 58
Carrivick, Gareth, 8, 75–6, 148
Carry On . . ., 53–4
catchphrases, 96, 98, 135
Celebrity Big Brother, 136
Central Missouri State University / University of Central Missouri, 108–10
Černjul, Vanja, 130
Chalk, 34
Channel 4, 18, 33, 52, 67–8, 69, 79, 118–19, 124, 132
Channel Seven, 118
chat shows, 40
Cheers, 18, 22, 33, 121
children's television, 26, 47
Clack, Boyd, 148
Clarke-Jervoise, Sophie, 24–5, 53, 60, 61–3, 72, 143, 148
class, representation of, 52, 98, 106, 111, 125, 128
Clone, 137
Come Back Mrs Noah, 22
'comedian comedy', 38
comedy
 'clown genre', 37
 comedic mode, 8, 37, 40
 national differences, 89–90
 social role, 12, 48, 64–8, 81, 87–8, 98–9, 111
Comedy Central, 8, 47
comedy drama, 31–3, 34, 60
comedy of distinction, 134–6, 142, 144
Comedy Playhouse, 53
comedy vérité, 128–9

comic impetus, 5–8, 23, 25, 49, 55, 58, 75–6, 92–3, 96–7, 100, 102, 117, 129, 130–1, 139, 141
comic relief, 7
Comic Visions, 3
Coogan, Steve, 50, 67
Cook, William, 16
Corner Gas, 144
Coronation Street, 15
Cosby, Bill, 38, 95
The Cosby Show, 10–11, 13, 18, 106–7, 121
Coupling, 34, 46, 109
Creating Humor, 51
Creating Television, 51
Creeber, Glen, 24
Critchley, Simon, 5
CSI: Crime Scene Investigation, 129–30
cue theory, 38, 85, 92–9, 102, 112
'category-routinised joking', 95–6
'logonomic system', 96–7
'setting-specific joking', 95–6
'cultural capital', 12, 63, 133–6, 144
The Cup, 121
Curb Your Enthusiasm, 46, 52
Curtis, Barry, 5, 38, 43, 103

Dad's Army, 142
The Daily Show, 29–30
Daisy Power, 138–9
Dallas, 108
The Danny Thomas Show see Make Room for Daddy
Dare, Bill, 53, 58, 60, 70, 124, 148
Dave, 46–7, 137
Davies, Christie, 5
Davis, Wendy, 144
The Day Today, 29–30, 109
Dead Ringers, 47
Deal or No Deal, 100–1
Dee, Jack, 46
Descartes, René, 77–8
Desmond's, 52
Deuze, Mark 68

d'Haenens, Leen, 115–16
Dhoest, Alexander, 4, 144
Diff'rent Strokes, 125
dinnerladies, 142–3
Doctor Who, 52, 144
documentary, 26, 41, 44, 47, 48, 86, 93, 94, 95–6, 106, 128–9
Dooley, Brian, 50, 54, 148
Dossa and Joe, 121
Doty, Alexander, 107
The Drew Carey Show, 12, 15
Driving School, 41–2
Drop the Dead Donkey, 125
drugs, representation of, 118–9
Druzhnaia Semeika, 144
The Dustbinmen, 125
DVD, 17, 18, 19, 34, 45, 46, 67, 124
Dyer, Richard, 4, 134–5

E4, 118–19
Early Doors, 22, 54, 129
Eco, Umberto, 94
Educating Archie, 20
Elton, Ben, 142
entertainment, 10, 26–7, 30, 41, 43, 51, 64–8, 78–9, 117, 124, 126, 135, 144
ER, 15
Everybody Hates Chris, 130–1
Everybody Loves Raymond, 12, 95
Extras, 135–6

Face to Face, 21
'fact/fiction divide', 42
The Fall and Rise of Reginald Perrin, 7–8
Family Guy, 82–3, 90, 132
Farley, Rebecca, 91–2
The Fast Show, 139
Father Knows Best, 21
Father Ted, 109, 143
Fawlty, Basil, 37
Fawlty Towers, 36, 57, 109, 143
FCC (Federal Communications Commission), 114, 116

Feuer, Jane, 75
Fine, Gary, 94
Five, 54
Flight of the Conchords, 104, 133
The Flintstones, 26, 90
flow, 18
Fox, 52, 132–3
Frasier, 12, 121
French, Dawn, 22, 38
Fresh!, 137
Freud, Sigmund, 5, 88, 91–2, 111
Freund, Karl, 39
Friday Night Live, 79
Friends, 33, 46, 93, 102, 121, 125
frog, dissecting, 8, 145–6
Fry, William F. , 51, 84, 122

Gavin and Stacey, 31–2, 50, 53, 128, 137
Gehring, Wes D. , 37
gender, 78
 domesticity, 10
 humour as gendered, 47
 representation of, 10–11, 21–2, 79, 125, 139
 'unruly woman', 10, 22
genre
 'cultural category', 44, 99, 145
 genre studies, 11–12, 24–6, 93, 126–7, 136, 145
 industry category *see* industry
 'textualist assumption', 75, 123
Geraghty, Christine, 133
Gervais, Ricky, 135–6
Get Smart, 12
Gillespie, Marie, 107
Girls Who Do . . ., 22
Gitlin, Todd, 51
Glenn, Phillip J. , 5, 101
The Good Life, 36, 52
Grace Under Fire, 22
Gray, Jonathan, 10, 27, 46, 131
The Green, Green Grass, 143
Green Wing, 52, 54, 132
Griffin, Jeffrey, 112

Grote, David, 23
'gut instinct', 71–2

Habermas, Jürgen, 64
Hamilton, Andy, 32, 55–6, 60–1, 66, 72, 148
Hancock's Half-Hour, 35–6, 45
Hancock, Tony, 21
Handelman, Don, 95–6
Happy Days, 12
Hardware, 1
Harrison, Mark, 31
Hartley, John, 43
Harvey, Sylvia, 67
Hat Trick, 67
Hawkinson, James, 130
Hazlitt, William, 88
HBO, 52, 107, 133
Health and Efficiency, 54
hegemony, 30
Heller, Dana, 4, 144
Hesmondhalgh, David, 74
Het Eiland, 144
Higson, Charlie, 70, 127, 148
Hill, Annette, 106
Hilton, Paris, 86
Hilton-Morrow, Wendy, 97
Hobbes, Thomas, 77
Hobson, Dorothy, 67–8, 106
Hodge, Robert, 96–7
Home Improvement, 12
Honey I'm Home!, 3
Horan, Dermot, 29
horror, 84–5
Hot Metal, 34
How Do You Want Me?, 1
How Not to Live Your Life, 137
Human Remains, 50
Humor: International Journal of Humor Studies, 9
humour, methods of examination
 anthropology, 5, 21, 122
 linguistics, 5, 76, 84
 philosophy, 5, 9, 13, 31
 psychoanalysis, 5

psychology 9, 31, 76
sociology, 5, 21, 76, 91
humour theory, 9, 76–7
 comic failure, 58–9, 94
 cue theory *see* separate entry
 incongruity theory *see* separate
 entry
 joking relationships *see* separate
 entry
 laughter *see* separate entry
 pleasures of humour, 78, 82,
 87–8
 relief theory *see* separate entry
 social role of humour, 78, 80,
 87–9, 92, 122
 superiority theory *see* separate
 entry

I Dream of Jeannie, 107
I Love Lucy, 22, 39, 139
iCarly, 139–40, 144
Ideal, 32, 133
If You See God, Tell Him, 34
I'm Alan Partridge, 47
*I'm Bland… Yet My Friends are
 Krazy!*, 39
In Living Color, 52
In Loving Memory, 90
In Sickness and in Health, 80
incongruity theory, 9, 82–8, 98–9,
 130, 132
 surprise, 86–7
independent production companies,
 50, 67–8, 73
Indiana University, Kokomo, 108,
 110–3
industry
 'casualization', 55–7, 60, 67–8
 genre as industry category, 51–2,
 99, 114, 145
 independent production
 companies *see* separate entry
 labour, 55, 57, 64, 67, 72, 73
 producers/producing *see* separate
 entry

multi-channel era, 52–5, 103, 114,
 125, 133–4, 136–7, 143–4
unrepresentativeness, 81–2
working practices, 55–61, 126
writers/writing *see* separate entry
interviews/interviewing, 2, 25, 51,
 126, 147–50
Invasion of the Bodysnatchers, 132
'invisible' television, 127
Is It Legal?, 1
ITC (Independent Television
 Commission), 116
The IT Crowd, 79, 143
It's Garry Shandling's Show, 36
ITV, 36, 52, 55, 56, 64, 124–5

The Jack Benny Program, 35
Jackson, Todd, 8
Jason, David, 21
Jekyll, 52
Jenkin, Guy, 148–9
Jerry Springer – the Opera, 120–1
Jewish comedy, 13, 82
Jhally, Sut, 106–7
Johnson, Catherine, 36
Joking Apart, 34
joking relationships, 15, 91
Jones, Gerard, 3
Jones, Griff Rhys, 67
Jones the Film, 67
Julia, 107, 125
The Junkies, 138–9
Just Good Friends, 128
Jyllends-Posten, 120–1

Kant, Immanuel, 82, 84–5
Kapferer, Bruce, 95–6
Kath and Kim, 144
Kaye, Peter, 133
Keeping Up Appearances, 109–10
Kelly Monteith, 36–7
Kilborn, Richard, 41
Kompare, Derek, 42
Kress, Gunther, 96–7
Krutnik, Frank, 40

Kubey, Robert, 51
The Kumars at No. 42, 40–1
Kuipers, Giselinde, 4, 62

Lab Rats, 121, 143
Lacey, Nick, 37–40, 126
Lane, Carla, 22
Langford, Barry, 27
The Larry Sanders Show, 40–1, 52, 133
Last of the Summer Wine, 6, 12
The Late Show with David Letterman, 40
laugh track, 28, 31, 34, 48, 61–2, 81–2, 85, 93, 95, 99, 101, 103–7, 114, 128–9, 131, 135, 139
laughter, 5, 10, 28, 75, 76–81, 101
Lead Balloon, 46
The League of Gentlemen, 90
Lear, Norman, 57
Leavis, F. R. , 63
Lewis, Justin, 106–7
Lewisohn, Mark, 3, 29, 35, 36
Liddiment, David, 124
Linehan, Graham, 143
Little Britain, 32, 53, 139
Little Mosque on the Prairie, 104
Livingstone, Sonia, 115
Lost, 130
The Love Boat, 83
Love Soup, 34
Lumsden, Lucy, 143
Lury, Karen, 129
Luv, 22

McCabe, Janet, 29, 133
McCrum, Stephen, 59, 60, 149
McGhee, Paul E. , 94
McGrath, Rory, 67
Mack, Lee, 143
Mad About You, 12
Make Room for Daddy/The Danny Thomas Show, 12
Mama, 82
Marc, David, 3

Marion and Geoff, 50, 95, 105, 128
Married . . . with Children ,132
The Mary Tyler Moore Show, 126
*M*A*S*H*, 7, 12–13, 105–6, 125
Mayhew-Archer, Paul, 60, 134, 149
Medhurst, Andy, 89, 103
Meet the Huggetts, 20
Meldrew, Victor, 37
Men Behaving Badly (UK and USA), 1, 125
Meredith, George, 78
The Mighty Boosh, 50, 133, 137
Miller, Jeffrey S., 57
Mind Your Language, 36
Mintz, Larry, 28–9
Mr Bean, 109
Mr Charity, 53–4
Mr Deity, 138
The Mistress, 22
Mitchell, Warren, 80
Mittell, Jason, 26, 75
Mixed Blessings, 128
mock-documentary, 128, 144–5
Moffat, Steven, 34, 52, 55, 69, 73, 127, 149
The Monkees, 12
Monty Python, 109–10
Morley, David, 106
Morreall, John, 5
MTV, 120
Mulkay, Michael, 94
multi-channel era *see* industry
Mulville, Jimmy, 67
Murder Most Horrid, 34
Murdoch, Richard, 20
Murdoch, Rupert, 132
Murdock, Graham, 68
Murphy Brown, 125
music-hall, 35, 103, 124
My Dead Dad, 90
My Family, 12–13, 52, 62, 79, 127, 129, 136, 143
My Mother the Car, 90
My Name is Earl, 122, 130, 132

My Two Dads, 125
Myers, Mike, 109–10

Nathan, David, 20
national identity, representation of, 79, 108
Nationwide, 106
naturalism *see* realism
NBC, 18, 111–12, 121–2, 125
Neale, Steve, 27, 40
Never Mind the Buzzcocks, 47
'new lad', 1, 125
news, 19, 26–7, 29, 66, 93, 94, 104, 129
Nice Day at the Office, 22
Nickson, Susan, 15, 60, 66, 105, 149
Nighty Night, 22, 32, 129, 133
No Place Like Home, 129
No Problem!, 52
Normal, Henry, 50, 65, 67–8, 70–1, 149
Not Going Out, 143
Nye, Simon, 1, 51–2, 55, 58–9, 60, 66, 69, 149

O'Donoghue, Denise, 67
Ofcom (Office of Communications), 33, 44–5, 114–19
The Office (UK and USA), 12, 22, 27, 39, 53, 54, 57, 67, 89, 95–6, 104–5, 110–12, 122, 125, 128
On the Buses, 12, 36, 52
One Foot in the Grave, 12, 33, 34, 86–7, 90, 125
online sitcom, 138–9
Only Fools and Horses, 12, 36, 52, 98–9, 125
Ordinary Television, 4
'Orrible, 121
The Osbournes, 42–3, 85–6, 94

Palmer, Jerry, 84–5, 94
Paramount Comedy, 47, 54
Parkinson, 40
parody, 31, 39, 83

Paulos, John Allen, 5, 94
Peep Show, 12, 39–40, 52, 79, 132, 136
performance, 6, 14, 27, 35, 37, 43, 48, 76, 93, 95, 99, 101, 111–12, 128, 135–6, 142–4
The Peter Serafinowicz Show, 138
Petley, Julian, 67
Phillips, Sally, 138
Picard, Rosalind W. , 43
Plato, 77, 98
play theory, 87
pleasure(s) *see* humour theory *or* sitcom
Plowman, Jon, 53, 57–8, 66, 100, 126, 149
Police Squad!, 83
Popetown, 120–1
Porridge, 36, 143
Postman, Neil, 27
postmodernity, 43, 105
Potter, W. James, 43
Powers, Austin, 109–10
Press Gang, 33–4
Pride, 52
producers/producing, 50, 54, 55–60, 73, 75, 88, 99, 124–7, 138, 141
professionalism, 68–72
Provine, Robert, 101
Pugsley, Peter, 4
public service broadcasting (UK) , 4, 64–5, 79, 88, 89, 115–16, 122, 134, 135, 137, 143
'public sphere', 64, 115
Pulling, 32, 129, 137
Purdie, Susan, 94

'quality' television, 44, 105, 124, 130–1, 133–6, 142
Quantick, David, 138
Question Time, 17
quiz shows, 19, 129

race, representation of, 10, 13, 36, 52, 78–80, 82, 106–7

Radcliffe-Brown, A. R., 89
Radio Times Guide to TV Comedy, 3, 29
The Rag Trade, 12, 125
Raskin, Victor, 5, 84
ratings, 12, 125
realism/naturalism 24–5, 27, 29, 30, 35, 63, 91, 102, 128–30, 135, 136
reality television, 35, 43, 44, 85–6, 100–1, 106, 124, 126, 130, 140
Red Dwarf, 22, 38, 47, 109
Redmond, Sean, 20
regulations, 27, 33, 44–5, 66–8, 78, 88, 114–21
relief theory, 9, 88–92, 98–9, 111
 Freud, Sigmund *see* separate entry
religion, representation of, 120–1
The Ren and Stimpy Show, 90
Renwick, David, 34
Respectable, 54
reviews/reviewers, 61–4, 126, 127, 143
Rhey, Ashlie, 138
Rising Damp, 12, 36, 52, 143
Richie, Nicole, 86
Ritchie, Graeme, 5, 84
Rivero, Yeidy M. , 4
Rivers, Joan, 21
Rob Brydon's Annually Retentive, 37, 129
Roc, 52
Roman's Empire, 132
Roseanne, 13, 22, 38
Rosen, Arnie, 84
The Royle Family, 6, 20, 36, 52, 53, 125

Saarinen, Leena, 141
The Sarah Silverman Program, 25, 38
Saturday Live, 79
The Saturday Night Armistice, 138
The Savages, 1
Saxondale, 50, 121

scheduling, 32, 34, 44–5, 79, 95–6, 115, 117–19, 121–2, 124
Scheurer, Timothy E. , 38
Schopenhauer, Arthur, 83–5
science fiction, 38
Screech, M. A. , 78
Scrubs, 12, 122, 130–2
Sean's Show, 38
Seinfeld, 13, 18, 39
Serafinowicz, Peter, 138
seriousness, 10, 26, 78, 86, 88, 93, 110, 122, 135
Seven of One, 53
Sex and the City, 29–30, 33, 40
sex and sexuality, representation of, 10, 97, 107, 117–18
Shakespeare, William, 27
Sharpe, Robert, 101
Shay, Carly, 139
The Shining, 132
shooting style, 14, 25, 36, 38–40, 75, 93, 95–6, 99, 101, 127–36
 editing, 39, 61, 76, 85–6, 93, 128, 130–1
 'three-headed monster', 39–40, 41, 95, 127
Silberg, Jon, 130
The Simple Life, 85–6
Simpson, Bart, 90
Simpson, Homer, 37
The Simpsons, 31, 82, 90–2, 132
sitcom
 audiences *see* separate entry
 broadcasting *see* separate entry
 canon/classic, 12, 36, 45
 Christmas specials, 33
 cultural value, 27, 48
 'dead', 2, 124–7, 135, 145
 definition, 24–35, 85
 global, 4, 66–7, 108, 128, 144–5
 hybridity, 40–3, 48–9, 85–6, 94
 music, 38, 76, 85, 131, 133
 offence, 2, 17, 44–5, 90–1, 94–5, 97, 116–21, 123
 origins, 35

pleasures, 6, 41, 60, 87–8, 121–3, 126, 134, 144
'rules', 57–60
social role, 64–9, 77, 87–8, 90, 92, 97, 106, 122–3, 125
shooting style *see* separate entry
'traditional', 6, 12, 16, 28, 31, 48, 62, 99, 104, 127, 129–36, 139–46
sitkom, 144
Six Feet Under, 90
sketch shows, 58, 121, 139
Smack the Pony, 138
Smith, Graham, 54, 72, 149
Smith, Mel, 67
The Smoking Room, 129
So Haunt Me, 90
Soap, 128, 129
soap opera, 19, 30, 38, 41, 101–2, 106, 128
Solo, 22
Sorry!, 12
South Park, 31, 90, 138
South Park: Bigger, Longer and Uncut, 90
Spaced, 52, 132
Spencer, Herbert, 88
Speight, Johnny, 80
Spigel, Lynn, 19
Spin City, 22
Sports Night, 105
Stabile, Carol A. , 31
Staiger, Janet, 13
stand-up comedy, 16–17, 36–7, 58, 115
Stephenson, Jessica, 143
Steptoe and Son, 20, 36, 45, 52, 57, 109
stereotypes, 10, 79, 97, 117
The Strange World of Gurney Slade, 29–30
Strawberry Café, 144
Strictly Come Dancing, 144
Studio 60 on the Sunset Strip, 133
Suburban Shootout, 54
Sullivan, Rebecca, 144

Summer Heights High, 89, 95, 128
superiority theory, 9, 77–82, 98
 Aristotle *see* separate entry
 Plato *see* separate entry
Surgical Spirit, 124
Surrealism, 84
swearing, 44–5, 90–1
Sykes, 45

Take It From Here, 20
TalkBack, 67
Tate, Catherine, 21
technology, 19, 61, 114, 124, 129, 136–42
Terry and June, 12
That's So Raven, 25
theatricality, 14, 27, 103, 128, 131, 135, 144
30 Rock, 122, 130–1
The Thin Blue Line, 142
The Thing, 132
thirtysomething, 133
This Morning, 16
Till Death Us Do Part, 20, 80, 109
TLC, 54
To the Manor Born, 52
Torchwood, 53
tragedy, 7, 78
trailers/promotional material, 33, 93, 115, 139, 142
Trexx and Flipside, 137
Tuck, Lucy, 103
Turnbull, Sue, 4, 144
Turner, Janice, 68
Turnock, Rob, 36
24, 130
Two and a Half Men, 12–13, 125, 127
230 Miles of Love, 140
Two Pints of Lager and a Packet of Crisps, 15, 54, 59, 134

Ugly Betty, 32–3
UK/USA differences and similarities, 3, 56, 57, 73, 105–6, 108–13, 119, 144

UKTV, 46–7, 137
unruly woman *see* gender
Up the Elephant and Round the Castle,
 52
Up the Garden Path, 124
Upstaged, 137
Ursell, Gillian, 68

vaudeville, 35, 124
Vertue OBE, Beryl, 70, 149
The Vicar of Dibley, 12, 36
violence, 88, 90, 92, 110, 116–17

The War at Home, 118–19
Wachman, Joshua S., 43
Waiting for God, 90
The Wall, 137
*We Can Be Heroes: Finding the
 Australian of the Year,* 104
Weisfeld, Glenn E., 101
*Whatever Happened to the Likely
 Lads?,* 125
White, E. B., 8, 145–6
Who Killed the Sitcom?, 124
Whoops Apocalypse, 34

Whose Line is it Anyway?, 109
Wild West, 1
Wiliam, Sioned, 24–5, 56, 58, 61, 63,
 126, 135, 149
Will and Grace, 10–11, 15, 33, 39, 45,
 97
Williams, Raymond, 18
Williamson, Lisa, 52
Wolff, Jurgen, 84
Wood, Victoria, 21, 142–3
Wright, John, 84
writers/writing, 56–61, 72, 73, 88,
 92–3, 136, 142–4

The X–Factor, 41–2, 100–1, 144

Yes, Minister, 36
Yes, Prime Minister, 36
Yo Soy Betty, La Fea, 32–3
YouTube, 138, 140
The Young Ones, 79, 109
You've Been Framed, 141

Zook, Kristal Brent, 132–3
Zucker, Jeff, 126